Railways and Rural Life

S W A Newton and the Great Central Railway

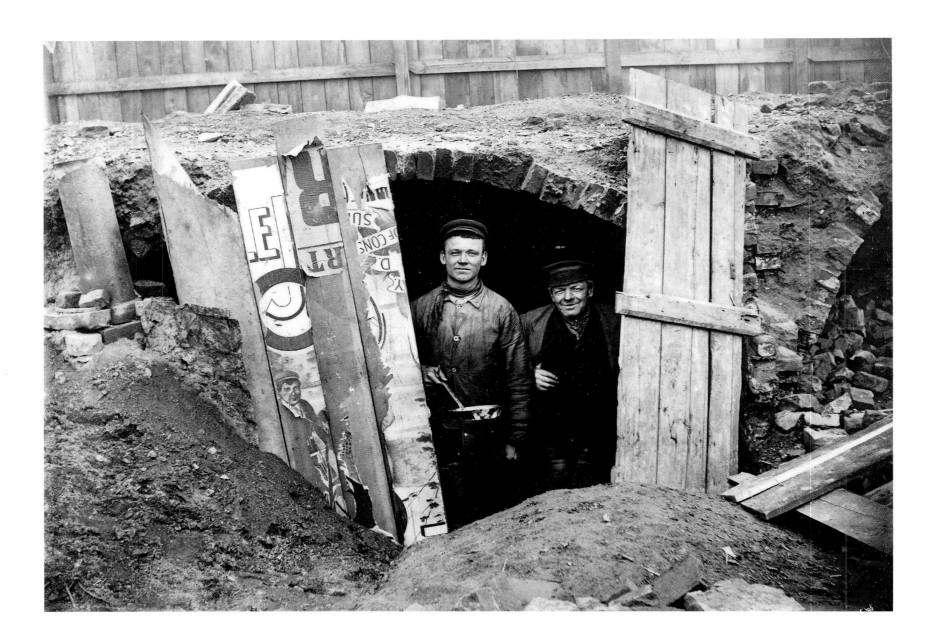

Railways and Rural Life

S W A Newton and the Great Central Railway

Gary Boyd-Hope and Andrew Sargent

ENGLISH HERITAGE

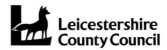

Leicestershire
County Council

Published by English Heritage, Isambard House, Kemble Drive, Swindon SN2 2GZ www.english-heritage.org.uk

English Heritage is the Government's statutory advisor on all aspects of the historic environment.

The reference numbers for the images are noted in square brackets in the captions. Reference numbers that are prefixed with L are reproduced by permission of the Record Office for Leicestershire, Leicester & Rutland; reference numbers that are prefixed by AA, BB or OP are reproduced by permission of English Heritage.NMR. Every effort has been made to trace copyright holders and we apologise in advance for any unintentional omissions, which we would be pleased to correct in any subsequent edition of the book.

First published 2007
10 9 8 7 6 5 4 3 2 1

ISBN 978 185074 959 2
Product code 51193

British Library Cataloguing in Publication Data
A CIP catalogue record for this book is available from the British Library.

Edited and brought to publication by René Rodgers, English Heritage Publishing
Design by www.Mark-Simmons.com
Printed in England by Butler and Tanner

Acknowledgements

The authors would like to thank their many colleagues in English Heritage and the Record Office for Leicestershire, Leicester & Rutland without whose contributions this volume would not have been possible. Staff of the Heritage Motor Centre at Gaydon, Warwickshire, kindly identified the car on page 110. The staff of STEAM – Museum of the Great Western Railway, Swindon, and of Lambeth Palace Library were most helpful in providing access to materials. Sharon Boyd-Hope proofread part of the text. John Vallender created the maps of the railway line. Publication was managed by René Rodgers of English Heritage Publishing.

Contents

Forewords

I am delighted that English Heritage and the Record Office for Leicestershire, Leicester & Rutland have come together to bring this most important collection of photographs to a wider audience. The nation's heritage gains immeasurably from partnerships such as this.

The London Extension of the Great Central Railway, opened in 1899, has been dubbed 'the last main line' and was a late flowering of the golden age of railway construction in Britain. Although never as 'great' as its rivals, the Great Central was driven by a great ambition: to link Manchester with Paris by rail, a vision that was only finally realised in 1994 with the opening of the Channel Tunnel.

I first came across S W A Newton's remarkable photographs in 1961 when, as a young curator, I helped to catalogue his collection, later publishing a book on the contractors' locomotives engaged in the building of the line itself. The bulk of Britain's railway network was built before photography had become widespread, but through the youthful enthusiasm of Sydney Newton we possess a unique and extraordinary record of the building of a main line railway and of the human landscape through which it was cut. His photographs form a comprehensive record of every stage and detail of construction, from Nottinghamshire, through Leicester and Rugby, to Marylebone. They can be compared with John Cooke Bourne's outstanding series of lithographs of the construction of the London & Birmingham more than 60 years before and the record of the building of the Channel Tunnel Rail Link a century later.

In publishing this book it is also particularly fortunate that Sydney Newton's grandson, Nigel Newton, has been able to contribute a personal reminiscence of his grandfather. We are most grateful to him.

Sir Neil Cossons
Chairman, English Heritage, 2000–2007

On behalf of Leicestershire County Council I am delighted to echo Sir Neil Cossons' pleasure at bringing this new collection of Sydney Newton's photographs into print.

Newton's unique record of the building of the Great Central Railway's London Extension – 'the last main line' – has now been publicly available through the museums, and latterly the Record Office for Leicestershire, Leicester & Rutland, for half a century. These photographs have always aroused immense interest and selections have appeared in a number of books (not least Sir Neil's own) and other publications. In 2004 new technology enabled the majority of the collection to be made accessible in ways previously undreamed of. Through the County Council-led and New Opportunities Fund (Big Lottery)-funded *Three Centuries of Transport* consortium, a website was created featuring around 1,750 of Sydney Newton's photographs, together with virtual exhibitions and stories about the building and history of the Great Central Railway's London Extension. In a parallel development English Heritage has made the 3,900 or so glass negatives from the firm of Alfred Newton & Son held by the National Monuments Record available on its *ViewFinder* website.

Despite the revolution in digital access to Newton's work, well-produced, high-quality photographic reproductions still hold a unique attraction. The present book unites the strands of Sydney Newton's railway, topographical and 'social' photography, together with glimpses of the man himself, into an extremely attractive package. The County Council is very happy to be a partner in the latest initiative to bring this unique part of our shared visual heritage to wider audiences.

Mr David Parsons
Leader, Leicestershire County Council

S W A Newton – a personal reminiscence

'Here it isn't!' This was one of the sayings heard by a little boy in the company of his grandfather while waiting at the bus stop at Branting Hill on the outskirts of Leicester. They were waiting for the bus from Markfield to take them into the city after a visit to the boy's grandparents. The boy would turn expectantly, scanning the empty distance only to have his hopes dashed when no bus appeared. With a downcast expression he would turn around to see a mischievous grin on the old, bespectacled face and a twinkle in his grandfather's eye. Once again he had tricked him, as he so often delighted in doing.

At the tender age of seven I enjoyed these moments spent with a greatly loved grandfather. He doted on me and loved to regale me with tales of the 'olden days' of bygone Leicester and other places up and down the country. One story he told was of a monkey that somehow appeared on a rooftop and was throwing slates down upon the gathering crowd below. This bizarre situation was brought to an abrupt conclusion by a certain 'Uncle Joe', who shot the monkey. The question 'Who shot the monkey?' became a household saying in the Newton family.

The time which left the greatest impression on my mind was when my grandfather and I set out together to visit all the churches in Leicester. He was someone who deeply appreciated 'lovely' things and particularly liked beautiful architecture, and as well as being a photographer, he also enjoyed painting landscapes. I loved these times of exploring historic buildings together and there was a special mutual enjoyment of the atmosphere we both felt in many of the churches.

I can see that this appreciation of things was carried through into his photographic work. He was a man who had a great interest in the epic changes that were taking place during his lifetime and wanted somehow to record these events. One outcome of this wish was the S W A Newton Collection, a unique record in the unfolding story of railway history. My hope is that a full appreciation of this many-faceted personality can be enjoyed by all who come into contact with his photography.

Nigel Newton
Grandson of S W A Newton

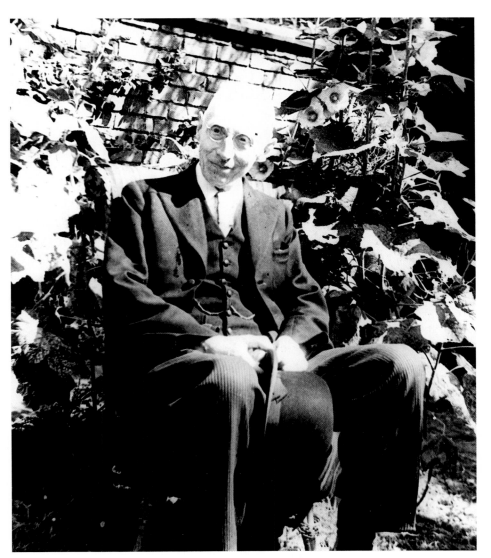

S W A NEWTON, *c* 1947 (photographed by I Gotheridge)

This is my grandfather as I remember him. His style of dress, with the bowler hat and pinstripe trousers, was his trademark and many people remember him dressed in such a way. [L1176]

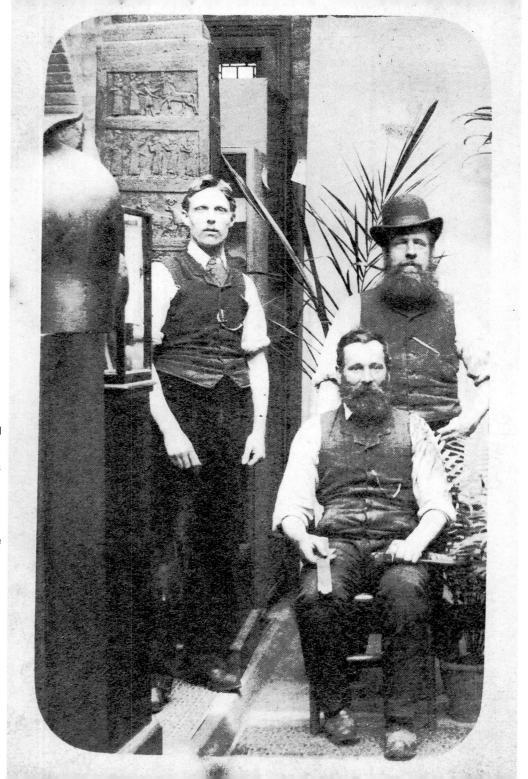

**ALFRED
NEWTON
& SON,** *c* 1900
Alfred Newton &
Son was the official
photographer to
Leicester Museums
and the group is
surrounded here
by some of the
artefacts they were
commissioned to
record. The young
man on the left of
this photograph is
S W A Newton.
It is believed that
the seated man is
Alfred Newton
himself. [L3272]

Introduction

This book is a tribute to S W A Newton, who lovingly recorded the construction and development of the Great Central Railway's London Extension and the communities – both navvy and rural – that were found along its route. Sydney Walter Alfred Newton was born in Leicester in 1875. His father, Alfred, ran a small photographic business in Belvoir Street and the family lived in rooms above the shop. Unfortunately, a fire in an adjacent factory caused a wall to collapse on the Belvoir Street premises and the Newton family and business were forced to relocate to 17 King Street. As the 19th century drew to a close, photography was still novel and exclusive; it was not until George Eastman introduced the 'Kodak' camera in 1888 that photography began to take its first steps towards the mass audience. This novelty meant that Alfred did a roaring trade as a portrait photographer. However, this was not his only line of business and for many years Alfred Newton & Son was the official photographer to Leicester Museums, helping to record and document many objects and artefacts.

The young Sydney joined the family firm in the early 1890s, shortly before work began on the construction of the London Extension, and the early story of the Great Central Railway (GCR) is closely linked with Sydney Newton. He was fascinated by the idea of this new railway carving its way through the heart of England and, when work on the railway began in 1894, Sydney took it upon himself to record the work in progress. Contrary to popular belief, he was never the official photographer of the GCR, but his own enthusiasm

MAP OF MARYLEBONE STATION AND GOODS YARD

As a thank you for granting him permission to visit their works, Newton gave each contractor an album illustrating the construction of their section. Each album was bound in red leather and lettered in gold leaf, and contained hand-drawn maps of the contract limits together with the best of the photographs. This map is taken from the album for Contract No. 7, which was presented to J T Firbank, who was responsible for that section of line. It shows that Newton was not only an accomplished photographer but also a talented draughtsman. [L3465]

for this momentous engineering scheme led to the creation, at his own expense, of a truly magnificent photographic archive. He did, however, have official sanction and, at the completion of the railway, he gave each contractor a photograph album in thanks for their cooperation.

By rail, bicycle and on foot, Sydney travelled the length of the London Extension as the construction progressed and photographed every aspect of its creation. He captured the giant steam excavators, the quaint contractors' locomotives, the hundreds of bridges, the cuttings and stations, and also the navvies themselves whose labour drove the line through the countryside. Indeed, the workmen often wanted photographs of themselves and Sydney would help to offset the costs of his journey by selling these pictures to the navvies and engineers.

Sydney Newton remained in photography for the rest of his life and the business stayed in the King Street shop until around 1950. He was married at 39 and at the age of 45 became a father for the first and only time. For many years he lived on Victoria Park Road, Leicester, in a house that he named 'Finmere' after one of the stations on the London Extension. After selling the King Street shop, he moved to a smaller house at Branting Hill in Groby (near Leicester) before moving to be with his son, with whom he shared his name. He died in 1960 at Beverley, East Yorkshire, at the age of 85 years, having lived almost his entire life in and around Leicester.

The Great Central Railway's London Extension

There can be no denying that the Great Central Railway's London Extension, which ran between Annesley Junction in Nottinghamshire and

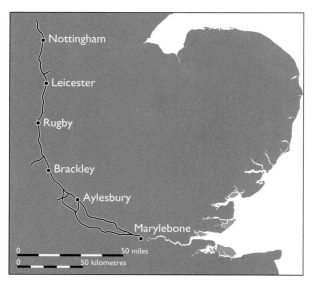

The route of the GCR's London Extension from Annesley Junction to Marylebone Station.

London Marylebone, had a short but colourful history. It started its brief life as part of the East Manchester, Sheffield & Lincolnshire Railway (MSLR) and ended its days under the control of British Railways; in between it became part of the GCR and the London & North Eastern Railway (LNER).

The line was conceived by Sir Edward Watkin as part of a route linking Manchester with Paris via a tunnel beneath the English Channel. Watkin was already a director of several railway companies – including the MSLR (which ran east–west across the Midlands), the Metropolitan Railway (which ran from Baker Street, London, to Quainton Road, just north of Aylesbury in Buckinghamshire) and the South Eastern Railway (which covered Kent with a terminus at London Bridge) – and it seemed like a natural step to link the three railways with a new main line. Unfortunately the idea was

about 40 years too late, as Britain's railway boom had long since passed. The route left a junction on the MSLR at Annesley, then ran south through Nottingham, Loughborough, Leicester, Rugby and Brackley, before joining up with the Metropolitan at Quainton Road. However, the Midland and London & North Western Railways already served the major population centres along the route and the new line was always considered to be something of a white elephant as the country already had several routes into London from the north.

The new line was built as a series of seven contracts, each of which covered a length of the route. These were awarded to the contractor who had put in the most competitive tender for the construction of that section of the railway and each contractor provided men, tools, machinery and materials. The contracts were:

- Contract No. 1 (Annesley Junction to East Leake): awarded to Logan & Hemingway of Market Harborough
- Contract No. 2 (East Leake to Aylestone): awarded to Henry Lovatt of Wolverhampton
- Contract No. 3 (Aylestone to Rugby): awarded to Topham, Jones & Railton of Westminster
- Contract No. 4 (Rugby to Woodford Halse): awarded to T Oliver & Son of Horsham
- Contract No. 5 (Woodford Halse to Brackley): awarded to Walter Scott & Co of Newcastle-upon-Tyne
- Contract No. 6 (Brackley to Quainton Road): awarded to Walter Scott & Co of Newcastle-upon-Tyne
- Contract No. 7 (Canfield Place (London) to the terminus at Marylebone): awarded to J T Firbank of London Bridge.

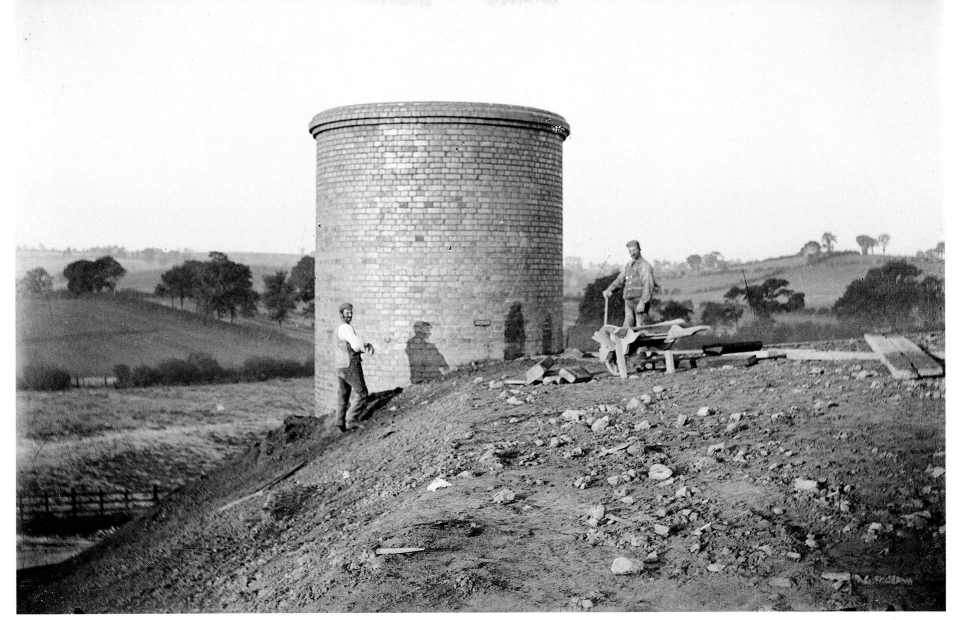

VENTILATION SHAFT NORTH OF CHARWELTON, NORTHAMPTONSHIRE, *c* 1897

Two navvies stand next to a ventilation shaft for the 3,000yd-long Catesby Tunnel. These shafts were necessary to allow the smoke and steam generated by the locomotives to escape. [AA97/05785]

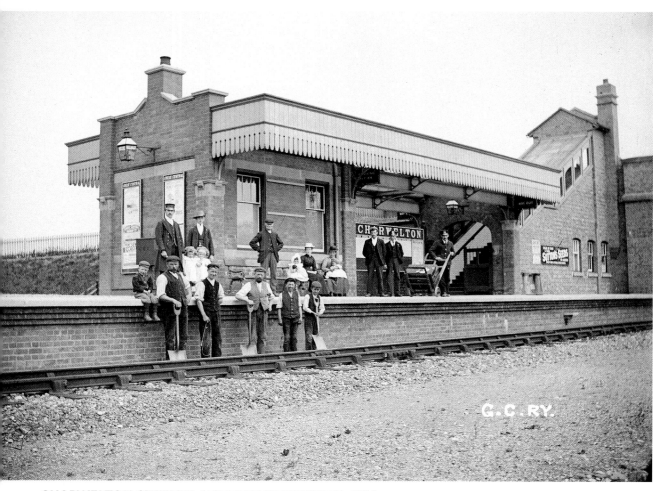

CHARWELTON STATION, NORTHAMPTONSHIRE, 1900

Station staff, navvies and passengers are pictured at Charwelton Station. When this photograph was taken the line had only been open for a year. [AA97/05433]

To save money, the plans for the new London Extension had originally included sharing tracks with the Metropolitan Railway from Quainton Road to the Metropolitan's London terminus at Baker Street. However, it was quickly realised that this station was not able to handle the additional traffic, so the plans for the GCR were altered to incorporate its own new flagship terminus at Marylebone (awarded as Contract No. 7).

The London Extension was officially opened on 9 March 1899, following a day of celebration at Marylebone, though the first public trains did not begin to operate until 15 March. The first train carried just four people, while the second only managed to fill 14 seats. Quite simply, the new railway was a latecomer and the new GCR would have to work hard to win traffic from its rivals. To do this, it needed motive power and rolling stock that would make the railway attractive, so in 1901 the company appointed John G Robinson as its Chief Mechanical Engineer, charging him with the task of producing a fleet of fast and powerful locomotives.

Fast trains were not enough though and, in 1902, Samuel Fay joined the fold as GCR's General Manager. It was Fay's unenviable task to turn the company's perilous finances around and make the GCR a force to be reckoned with. Fay introduced a policy of heavy marketing and promotion, which proved to be effective and, while never a threat to its rivals' existence, the London Extension managed to hold its own against its competitors. Fay then turned his attention to the train services operated by the company and by the start of the First World War these services had been noticeably accelerated in both timing and efficiency.

This increase in speed was partially down to the construction of a new main line that bypassed the twisting Metropolitan Railway section of the London Extension. This 'Alternative Route' was built in conjunction with the Great Western Railway (GWR) and took the GCR out of London on a sweeping curve, passing through High Wycombe and Princes Risborough before leaving the GWR at Ashendon and rejoining the old London Extension at Grendon Underwood. A branch line was also built from Woodford Halse to Banbury to connect with the GWR main line.

Life slowed down on the railway during the First World War as much of the workforce was conscripted to the armed forces. To keep the trains running, women were employed to fill many of the gaps, but changes to routine were nevertheless inevitable. If railway life was turned upside down by the war, even bigger changes were to follow. The post-war government decided to group Britain's 123 independent railway systems into four 'super' railway companies. The 'Big Four' were born at the start of 1923 and the GCR was absorbed into the new London & North Eastern Railway.

During the Second World War the government took over the running of the railways. This had appeared a success, so in 1947 Britain's railways were nationalised. The London Extension became part of British Railways Eastern Region, until in 1958 the London Midland Region took over the running of the route. The 'Midland' was the London Extension's old rival and, with it in control, the fate of the London Extension was sealed. In line with the recommendations set out by the now infamous Dr Beeching, the Midland began the systematic run down of the old Great Central line. The intermediate stations were closed in 1963

and freight services were withdrawn shortly afterwards. As part of the run down, well-maintained locomotives were replaced by old and worn out machines that endeavoured to maintain an efficient service. The end was now in sight.

On 6 September 1966, the London Extension was truncated, leaving only a diesel multiple unit service operating between Nottingham Arkwright Street and Rugby Central. To the north and south, the line was ripped up and the buildings demolished. The new service struggled on until 5 May 1969 when it was replaced by a bus service. On that day, 70 years after it had opened, the GCR's London Extension was closed for good. After the closure, the bulldozers and scrap men were quick to move in. Much of the track was lifted for reuse or scrap, and many of the old buildings and structures had been razed by the mid-1980s. Only a century after it had been built, much of Sir Edward Watkin's dream had gone.

Fortunately, even before the route had closed, thoughts had already turned to the possibility of preserving a section of Britain's last main line. By 1973, the Main Line Steam Trust had begun simple operations in the confines of Loughborough Central Station. Today, the operation has grown into one of the country's leading preserved lines. A partner group is also working to restore the line between Ruddington and Loughborough, with the ultimate goal of linking Nottingham and Leicester once again. At Quainton Road Station, where the London Extension met the Metropolitan Railway, the Buckinghamshire Railway Centre has set up home to preserve a piece of this much-lamented line. Elsewhere, the Alternative Route that bypassed the slow Metropolitan section by running through High Wycombe is still being

operated by Chiltern Trains and even part of the London Extension is still in use between Marylebone and Aylesbury.

As for the stations, Nottingham Victoria has been replaced by a shopping centre, while Leicester Central is now an industrial park. The booking hall at Brackley is used to replace car tyres and Rugby Central survives as a platform only. Many of the country stations, such as those at Ashby Magna, Finmere and Lutterworth, are no longer with us and railway communities like Woodford Halse are still feeling the loss of the line. However, much of the route's formation can still be seen as it cuts across the countryside and, with talk of reopening a section south of Rugby for freight trains, we may yet see trains once again operating over the old London Extension.

The navvy community

Along with recording the development of the London Extension, Newton also photographed the navvy community that worked on the construction of the line. A huge itinerant labour force was required during the later 18th and 19th centuries to build first the canals, then the railways, and for other major civil engineering works. The word 'navvy' was a corruption of 'navigator' and originally referred to those employed in digging the canals (or inland navigations). For most of this period navvies lived in notoriously poor conditions as many employers were reluctant to accept the burden of housing their workforce. A turning point came in 1846 when the Select Committee on Railway Labourers reported on their findings, after which legislation started to address this social problem and popular opinion began to change. By the time the London

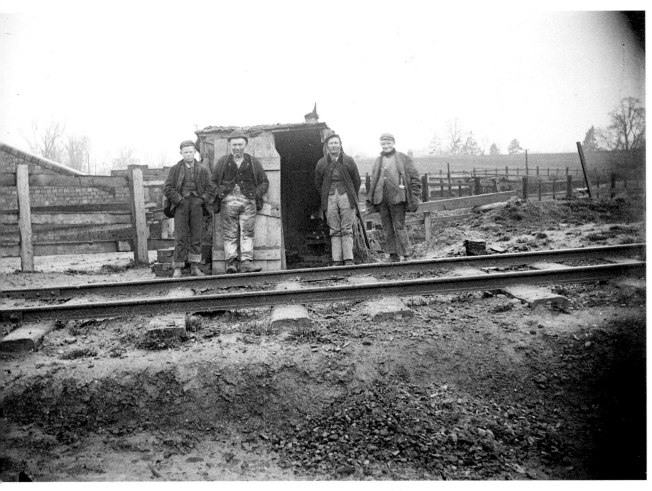

NAVVIES NEAR CHARWELTON, NORTHAMPTONSHIRE, 1900
These navvies have built themselves a makeshift shelter for their meal breaks. The line boasted 'Rapid Travel in Luxury', though life for the navvies was hard. [AA97/05786]

Extension was built conditions had improved considerably. The contractors on the GCR built temporary settlements for the navvies and their families consisting of simple prefabricated huts, often with allotment gardens, which offered the navvy communities a relatively decent level of accommodation. Boarding houses were also provided for single men, though many would still have preferred to find lodgings nearby. The main settlements along the line were at Calvert, Brackley, Helmdon, Woodford Halse, Catesby and Cosby, though huts could be found all along the route while many men lodged in nearby towns. Newton recorded rare views of these temporary settlements, providing a rounded picture of the Extension project. Navvies were comparatively well paid and his photographs show that many of the huts were furnished to a high standard when compared to the homes of the urban and rural working classes. Little trace of these temporary settlements survives.

Being a shifting group on the margins of society, navvies acquired a reputation for being wild, immoral and godless, and particularly for being prone to drunkenness and poaching:

> Gathered out of all ranks and conditions of society, strangers amongst strangers, when they have come into any new neighbourhood they have been regarded with suspicion, and shunned as wild, lawless men.
>
> (*First Annual Report of the Navvy Mission Society*, 1877–8, p 7)

In 1877 the Navvy Mission Society was founded, one of several religious groups established in the 19th century to provide spiritual and moral

direction for navvies and their families. The Society estimated that about 40,000 men were employed as navvies on public works in England alone and that the navvy community was probably nearer 60,000 when wives and children were included. Its published objectives combined both religious and social aims:

- to promote the spiritual welfare of navvies
- to gather and publish information on the real condition of navvies
- to urge their claim to charitable help
- to be a channel for donations and to stimulate and support local welfare efforts.

The London Extension was a huge public works project, employing over 10,000 men at its peak. To meet this need, the Society worked in partnership with a new organisation, the London Railway Extension Mission, which was established in 1894 to deal solely with the Extension project. The Navvy Mission Society guaranteed a third of the stipends for the missionaries, while the contractors were all supportive, paying or contributing to stipends, providing mission rooms or offering other help in kind. The new mission employed up to 15 missionaries and a chaplain, and erected or engaged up to 22 mission rooms. These multi-purpose rooms were a focus for the life of the navvy communities and were used for Sunday schools, evening classes, primary schools and social meetings, and as reading rooms, mess rooms and shelters, as well as for Sunday and week night services. Many were prefabricated mobile structures and consequently little evidence of this extensive undertaking survives today. Newton recorded several mission rooms, missionaries and religious events along the line of the railway, capturing this ephemeral but significant aspect of the project.

After three busy years, as the project drew to completion, the men began to drift away to look for new work. Therefore the London Railway Extension Mission was wound up and in its third and final annual report (for 1897–8) it announced that its remaining assets would be made over to the Navvy Mission Society. Overall the Navvy Mission Society was pleased with its achievements, noting in its annual report, for example, that:

> It is very satisfactory to be able to say that of the 200 men on the Bulwell Section not one has come before the Magistrates during the last two years.
>
> (*Nineteenth Annual Report of the Navvy Mission Society*, 1896–7, p 45)

The London Extension was the last major railway construction project the country saw until the late 20th century. Although other major civil engineering projects continued to employ navvies, the navvy way of life soon became a thing of the past as technology replaced human muscle power.

Rural communities

As an independent agent, Newton was free to follow his interests, which extended beyond the GCR and its construction. He was interested in all areas of life and particularly the life of the countryside, photographing widely in the villages and small towns along the course of the railway. Rather than simply taking postcard views he was concerned with people. He must have been a personable young man as people seem to have been happy to pose for him and children were fascinated by his novel skills. Some of these portraits may have been taken as commissions to help fund his travels, but many can only have been intended as a personal collection. Today these pictures provide an invaluable record of rural life at the turn of the 20th century. In the golden glow of Edwardian Britain in the decades before the upheaval of the First World War these scenes may have appeared timeless to a young man in his early 20s. It is salutary to recall that the innocent boys he photographed would have been old enough to bear arms in the war and that the way of life he captured was so soon to receive a shock from which it would never recover.

Rural life before the internal combustion engine and the gentrification of villages can appear idyllic, but for agricultural labourers and their families it was hard. The lot of the rural poor was little better than that of their urban counterparts, though most families had a vegetable garden from which to supplement their diet and children could play among the woods and fields. Looking back on her childhood in a village on the Oxfordshire-Northamptonshire border in the final years of the 19th century, Flora Thompson recalls, 'in spite of their poverty and the worry and anxiety attending it, they were not unhappy, and, though poor, there was nothing sordid about their lives' (1985, p 19). Newton's photographs appear to bear out this assessment.

Newton seems to have developed an affection for the places and countryside he got to know at this time and he appears to have gone back to photograph some places on more than one occasion over a number of years. For example he first visited the Northamptonshire village of

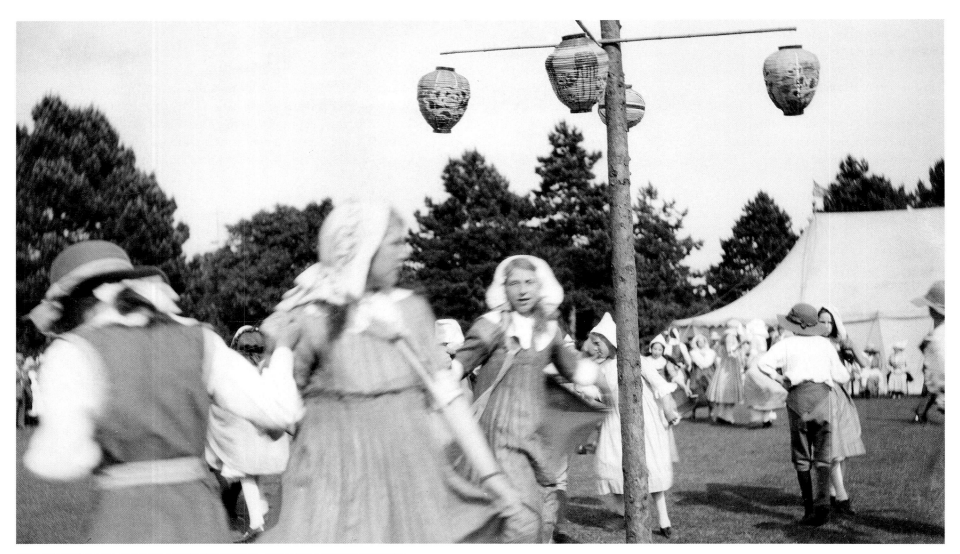

COUNTRY FAIR, UPPER BODDINGTON, NORTHAMPTONSHIRE

Newton enjoyed photographing the life of the villages and market towns through which the railway passed. Here he has captured a traditional country fair, with children in folk costume dancing around a lantern tree. [BB98/05957]

Hellidon before the 'Great Fire of Hellidon' in August 1904 and returned some time afterwards to record the damage (*see* p 85). He also recorded memorials to those who died in the First World War.

The S W A Newton Collection

Throughout Sydney Newton's later life, the glass plate negatives charting the construction of the London Extension were something of a Holy Grail amongst railway historians, yet it was not until the late 1950s that their whereabouts were made known. At that time John Daniel, a member of Leicester Museums staff, was invited for tea at Branting Hill by Newton because the old man had something to show him. After tea, Sydney took John out to his rickety wooden garden shed. Inside, stacked from floor to ceiling, were hundreds of carefully labelled cardboard boxes containing thousands of glass plate negatives. Newton told John that if the museum did not want them, then they would have to go to the tip as he was moving to Yorkshire. It did not take long for John to realise what he was looking at, and the rest, as they say, is history.

The images of the London Extension's construction, featuring the infrastructure, locomotives, machinery and navvies, became part of the Leicester Museum's collection and today are in the care of the Record Office for Leicestershire, Leicester & Rutland in Wigston Magna. The social history plates that capture village life around the railway reside in the English Heritage National Monuments Record in Swindon. Together the two collections total around 6,500 images and present a compelling and unrivalled account of social and engineering history at the end of the 19th century.

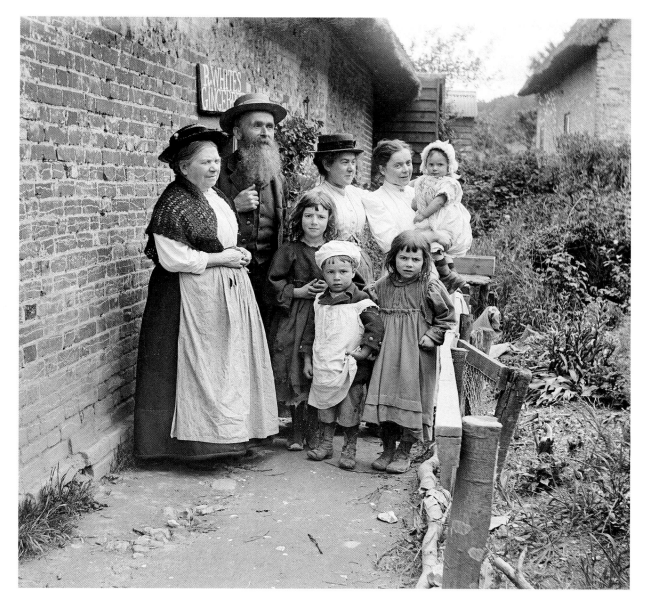

FAMILY GROUP, MONKS RISBOROUGH, BUCKINGHAMSHIRE, 1904
People seemed willing to pose for Newton. This is presumably a family group taken while the young men were out at work. The sign behind the bearded man reads 'R Whites ginger beer'. [AA97/05328]

Contract No. 1:
Annesley Junction to East Leake

Contract No. 1 started at Annesley Junction, Nottinghamshire, where it connected with the Manchester, Sheffield and Lincolnshire Railway (the parent of the GCR). It sliced through the centre of Nottingham, involving the compulsory purchase of property, digging 2,250 yards of tunnels and building nearly a mile of viaduct. This contract was awarded to Logan & Hemingway, who were responsible for construction as far as East Leake, Nottinghamshire.

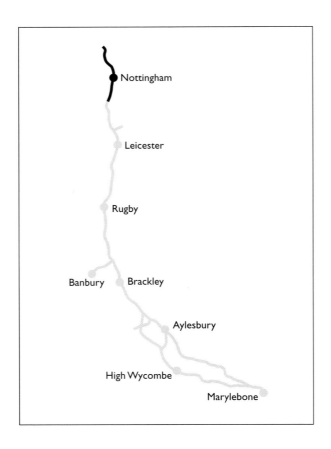

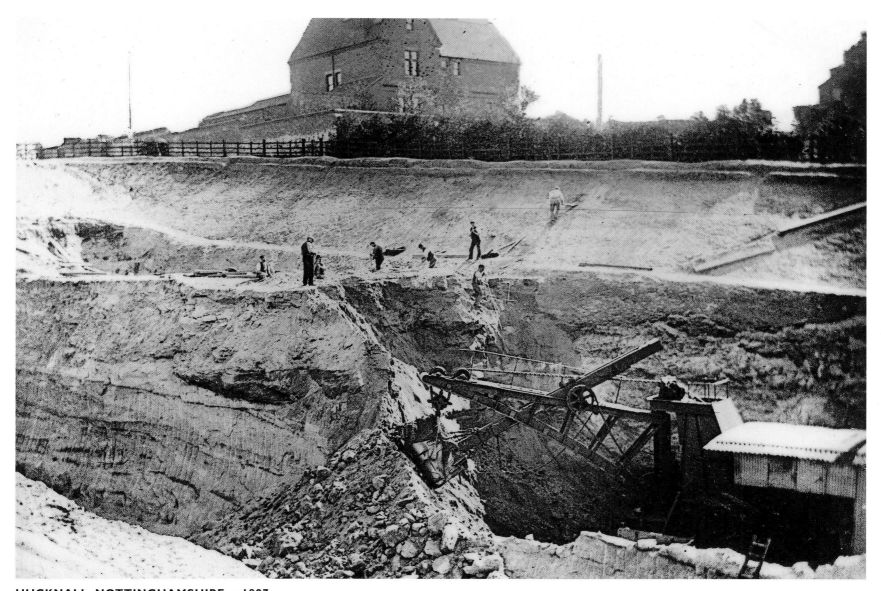

HUCKNALL, NOTTINGHAMSHIRE, c 1897

Navvies and a Dunbar-Ruston steam excavator work together on the construction of a deep cutting at Hucknall, close to the site of the station. The photograph provides a good illustration of the simple tools and crude excavation equipment that was available at the end of the 19th century. With nothing more technical than steam power and black powder at hand, it is remarkable to think that the London Extension forged its way from Nottingham to London in less than six years. The GCR was one of the first railways to make mass use of steam excavators and without them the line would probably never have been built. [L1376]

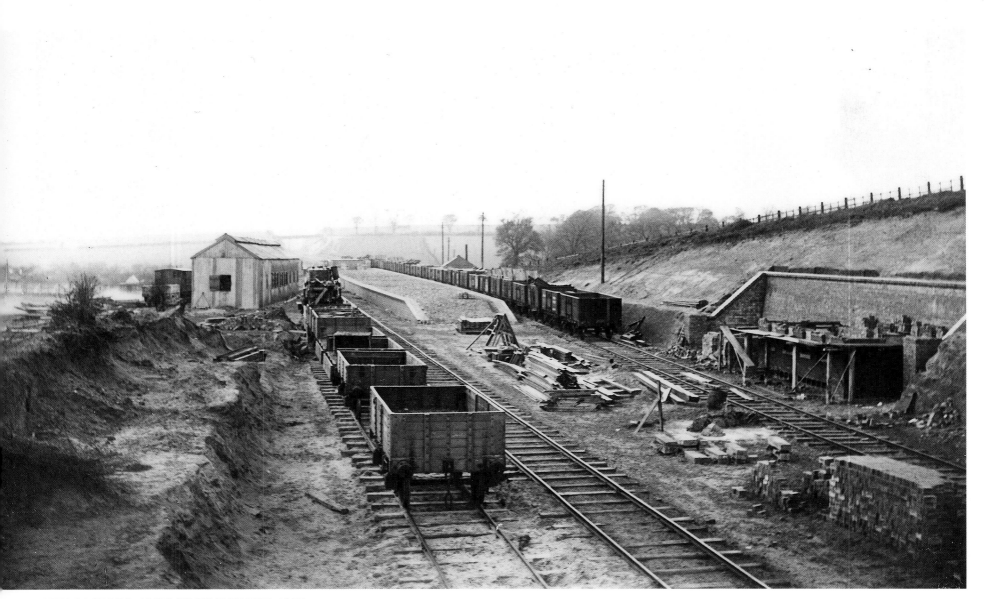

NEW BASFORD, NOTTINGHAMSHIRE, 1897

New Basford Station, like the majority of the intermediate stops between here and Calvert, featured an island-type platform. This consisted of one large platform with the railway lines running on either side of it, rather than between two single platforms as found on other lines in the country. The island-platform design helped to reduce construction costs, requiring only one booking office, waiting room and toilet block at each station. In line with Sir Edward Watkin's vision of a trans-European railway, the London Extension was built so that it could be converted to the larger continental loading gauge if Britain and Europe ever linked; the island platforms would greatly assist this conversion. [L1730]

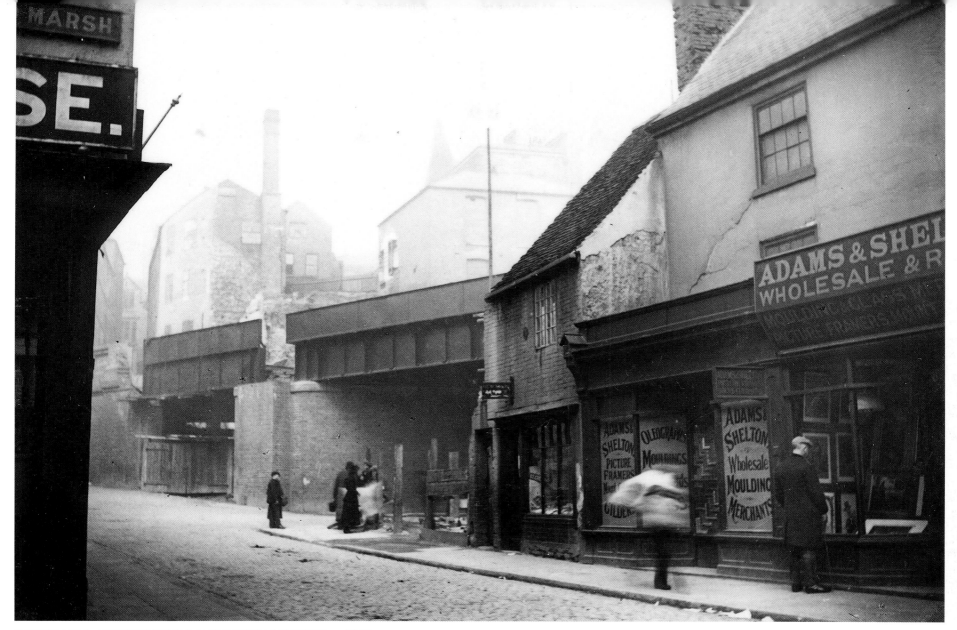

DRURY HILL, NOTTINGHAM, NOTTINGHAMSHIRE, *c* 1897

Cutting ruthlessly through the heart of Nottingham, this double-span plate girder underbridge at Drury Hill formed part of the long viaduct that carried 'the last main line' across much of the city. As with so much of the London Extension, the bridge has long been demolished; today this site is opposite the Broad Marsh Shopping Centre. Just to the north of here was Weekday Cross, where the line plunged into tunnels before emerging at Nottingham Victoria Station. [L2298]

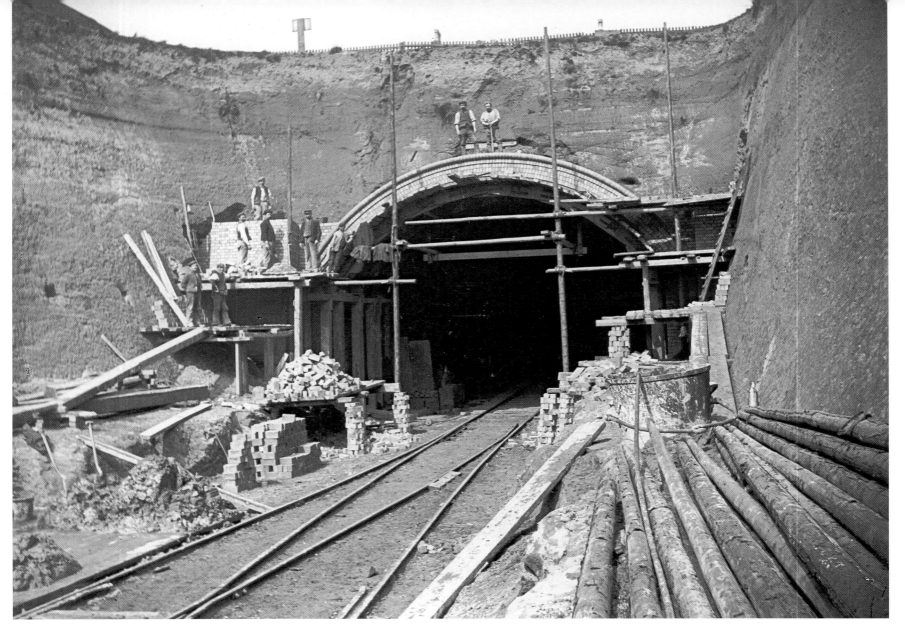

SHERWOOD RISE TUNNEL, NOTTINGHAM, NOTTINGHAMSHIRE, *c* 1897

After departing from Nottingham Victoria, northbound trains immediately passed through Mansfield Road Tunnel and emerged in this deep cutting in which Carrington Station was later constructed. The cutting was very short and the trains quickly entered the southern portal of Sherwood Rise Tunnel, seen here under construction in the late 1890s. It appears that work was progressing well, as the outer façade was under construction when Newton interrupted proceedings to capture this image. Once completed, Sherwood Rise Tunnel measured an impressive 662 yards in length, with a maximum depth of 120 feet from surface to rail level. [L3454]

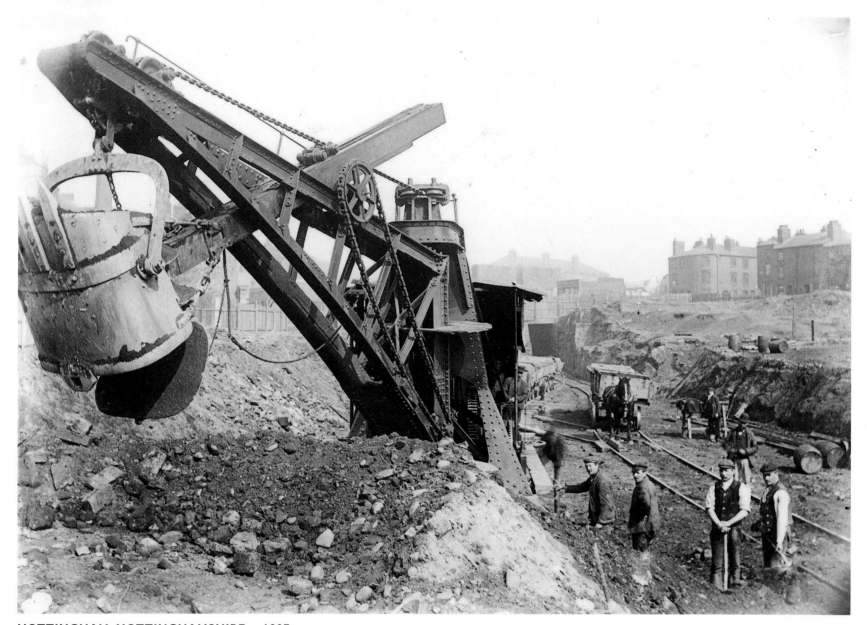

NOTTINGHAM, NOTTINGHAMSHIRE, _c_ 1897

This Dunbar-Ruston steam excavator, or steam navvy as they became known, was photographed by Newton at work in the centre of Nottingham. Although crude in appearance, these powerful excavators were invaluable assets for the contractors building the London Extension. A total of 43 such machines, most of which were built by Ruston Proctor & Co of Lincoln, were used on the construction of the GCR. Although developed by a Scottish engineer named James Dunbar, the manufacturing rights for the excavators had been acquired by Joseph Ruston in 1874. It is said that steam navvies reduced the cost of railway excavation by more than 80 per cent. [L2422]

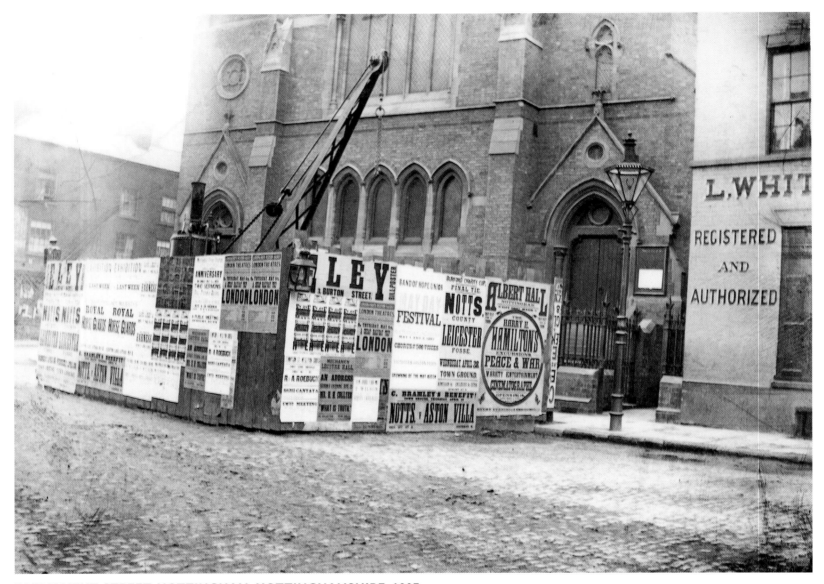

PARLIAMENT STREET, NOTTINGHAM, NOTTINGHAMSHIRE, 1897

The disruption caused by having a railway driven through an established city is evident in this photograph. It shows a steam crane at work on a tunnel shaft, hidden behind the wooden screens outside Parliament Street Baptist Chapel, just south of the site of Nottingham Victoria. The engine's distinctive vertical boiler is just visible above the hoarding that is covered by a wonderful variety of advertising posters and notices. [L2232]

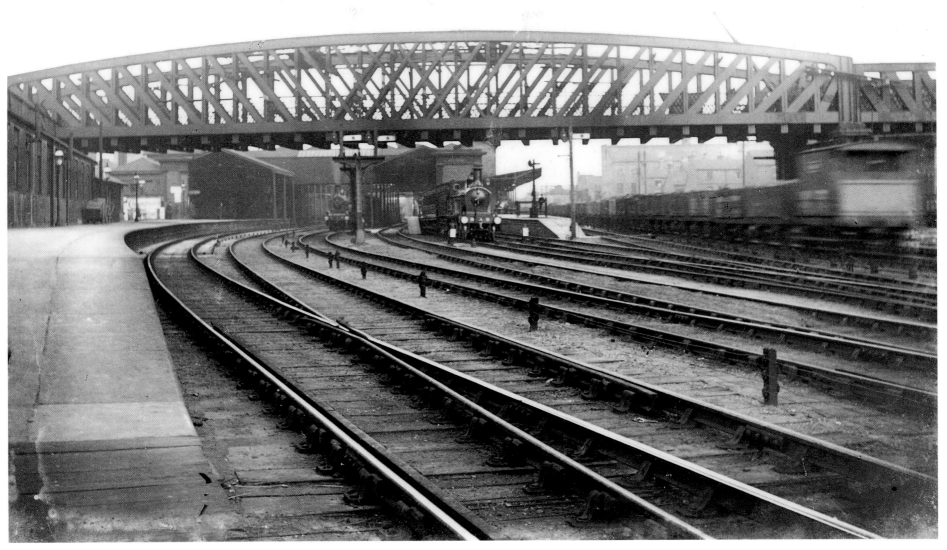

MIDLAND STATION, NOTTINGHAM, NOTTINGHAMSHIRE, *c* 1898

This impressive structure is the 120ft bowstring lattice girder bridge that carried the London Extension over the Midland Railway's station at Nottingham. Just south of this point was the GCR's Arkwright Street Station, which served as the line's northern terminus in its final years. The GCR seemed to make a habit of crossing its rivals at their stations – the London Extension crossed the Midland again at the latter's Loughborough station and then passed over the London & North Western Railway's line to London at Rugby. Was this a geographical coincidence or the canny advertising of an alternative service? [L2437]

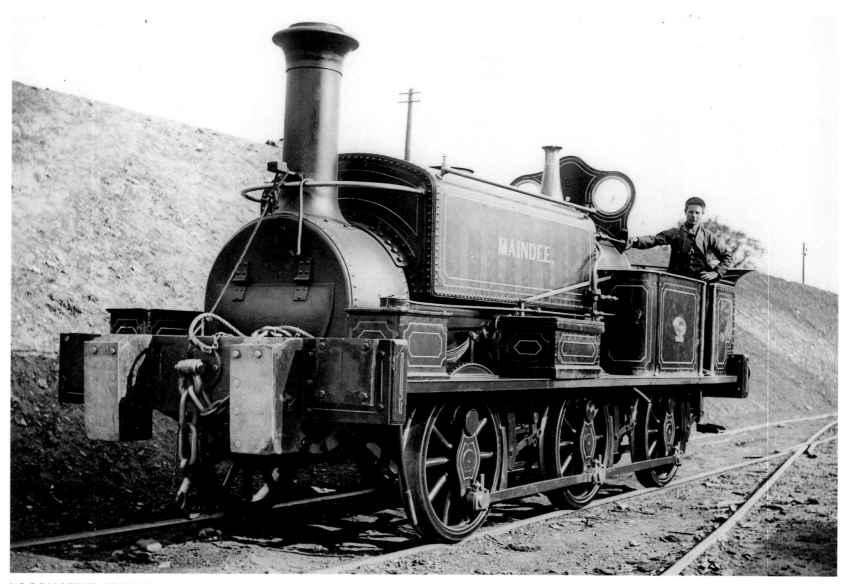

LOCOMOTIVE AT WILFORD, NOTTINGHAM, NOTTINGHAMSHIRE, MAY 1897

The Leeds firm of Manning Wardle & Co built a number of 0-6-0 saddle tank locomotives that eventually found use on the construction of the London Extension. They were ideally suited for running on the temporary, and often rough, contractors' railways, hauling vast numbers of wooden tipping wagons away for emptying or bringing in men and supplies. This example is 'K' class No. 488, *Maindee*, which was built in 1874. It is pictured in a cutting near Wilford with a lone crewmember on the open footplate. The various contractors and drivers took great pride in their locomotives, with many, including *Maindee*, having ornate lining and highly polished brass fittings. [L1043]

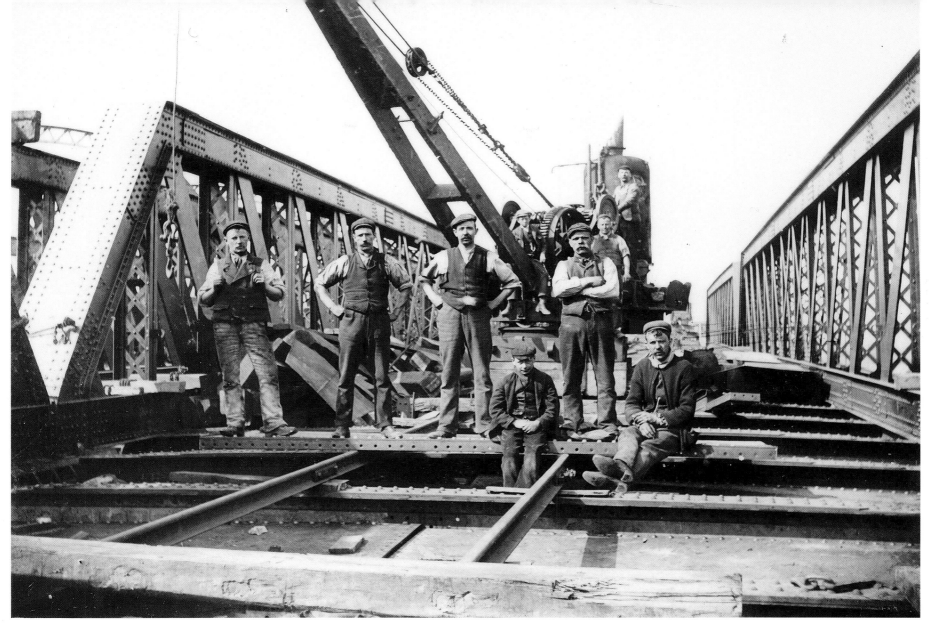

WILFORD, NOTTINGHAM, NOTTINGHAMSHIRE, c 1897

In order to cross the River Trent at Wilford, a steel-lattice girder bridge was built that consisted of three 112ft spans, each being wide enough to accommodate four lines of permanent way. In total the structure weighed in excess of 2,000 tons and was one of the largest steel bridges on the whole line. In this view, navvies – assisted by a steam crane – carry out some finishing work to the bridge decking. It is interesting to note the dress of the navvies, which was typical of those working on the whole line. One would never get away with wearing a flat cap in place of a hard hat on today's rail construction projects. [L1254]

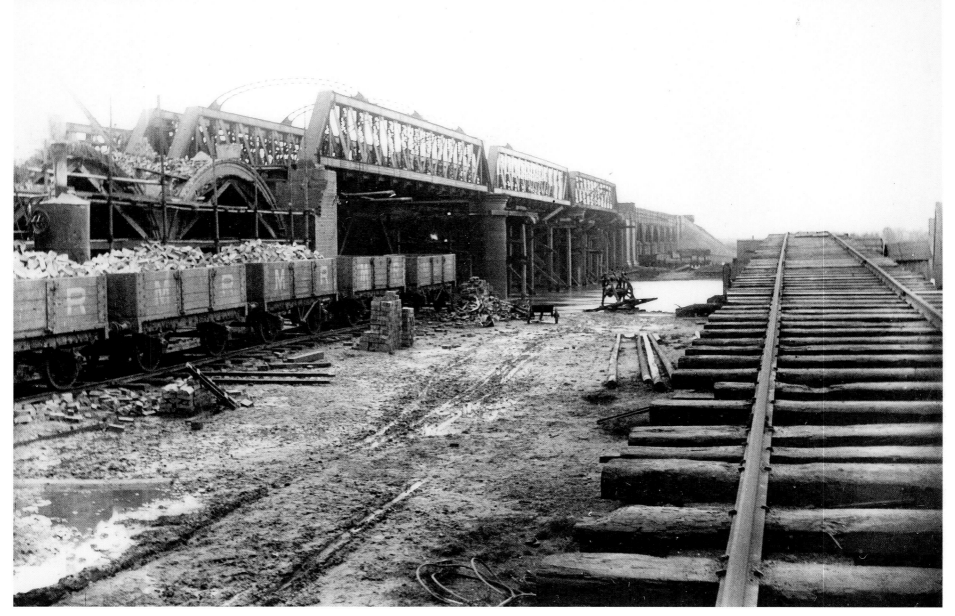

WILFORD, NOTTINGHAM, NOTTINGHAMSHIRE, DECEMBER 1896

In the handwritten notes produced to accompany his glass plate negatives, Newton describes this photograph as 'Trent Bridge looking towards Wilford, December 1896'. On the left of the picture are the beginnings of the three-arch brick approach to the viaduct which adjoined the three girder spans that crossed the River Trent. The rough-looking railway to the right is one of the ubiquitous contractors' lines, built using light rails laid on split logs, old sleepers or in some cases whatever happened to be at hand. Miles of these temporary railways were built to serve the construction sites, yet in spite of appearances, accidents were rare. [L1256]

HOTCHLEY HILL, EAST LEAKE, NOTTINGHAMSHIRE, *c* 1897

Glancing through the S W A Newton Collection one cannot fail to notice just how many photographs Newton took of humble occupation bridges, such as this fine example of a small girder underbridge near Rushcliffe Halt. Hundreds of similar structures were built along the length of the line, allowing farmers and landowners access to both sides of their property when it had been bisected by the new railway. The wing walls of this bridge still await completion and gates have been hung to prevent cattle wandering. The distinctive iron-lattice parapet was typical of those on many of the bridges on the London Extension. [L1837]

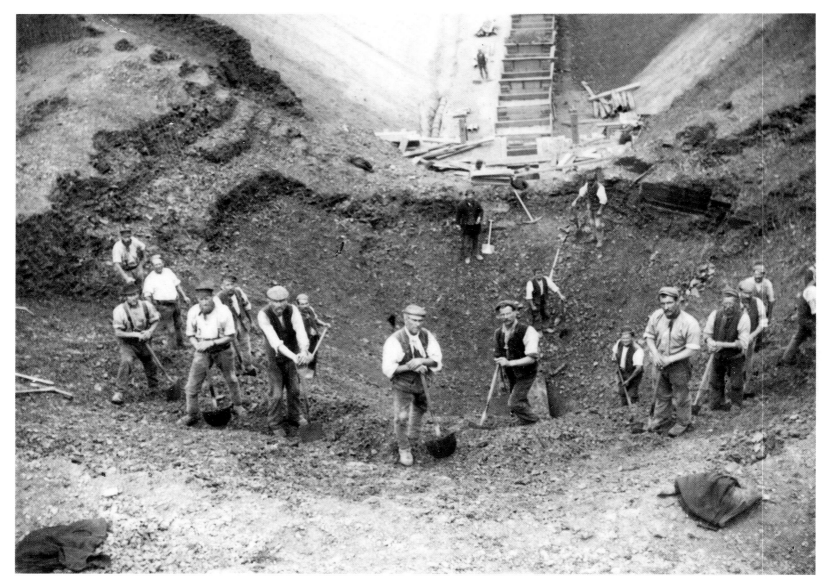

EAST LEAKE, NOTTINGHAMSHIRE, *c* 1897

Although the construction of the London Extension made extensive use of steam power, the building of a railway remained extremely labour intensive. Getting the new line across valleys and through hillsides, and the building of bridges and stations, meant that the contractors were still required to employ huge quantities of men working with picks and shovels. Mobile diggers and excavators were still a long way off in the 1890s and the laying of the railway relied on muscle power rather than hydraulics. The navvies pictured here were working on the construction of the East Leake Tunnel. [L1843]

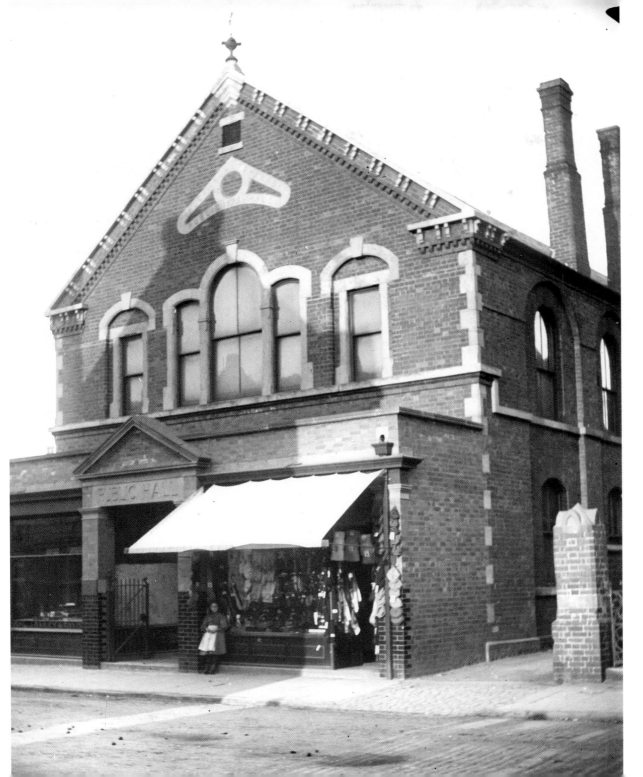

THE OLD PUBLIC HALL, HUCKNALL, NOTTINGHAMSHIRE, *c* 1897

Known simply as Hucknall since 1915, the town was previously called Hucknall Torkard through its association with the Torcard family. The Old Public Hall stands in Watnall Road. An inscription on the gable reads 'Hucknall Torkard Public Hall 1875'. Part of the ground floor was used as a shop, seen here with a white awning and a young lady in front. [L3470]

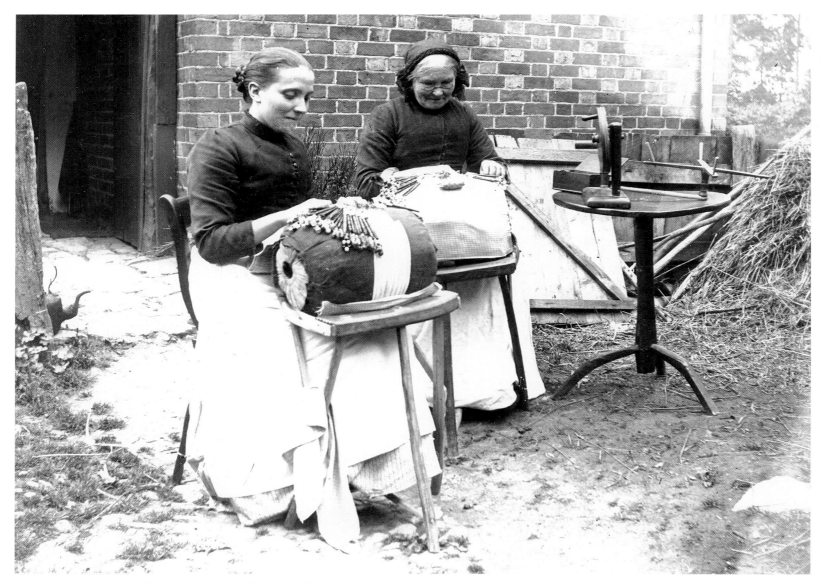

LACE MAKERS, NOTTINGHAM, NOTTINGHAMSHIRE, *c* 1900

Lace manufacture was a widespread craft in the later Middle Ages. In the early 19th century the Nottingham region became famous for lace production, which developed out of the old-established framework knitting industry. Production was often on a small scale, though by 1911 there were about 20,000 lace makers in the city. These two women are part of the famous community of pillow lace makers. [L2900]

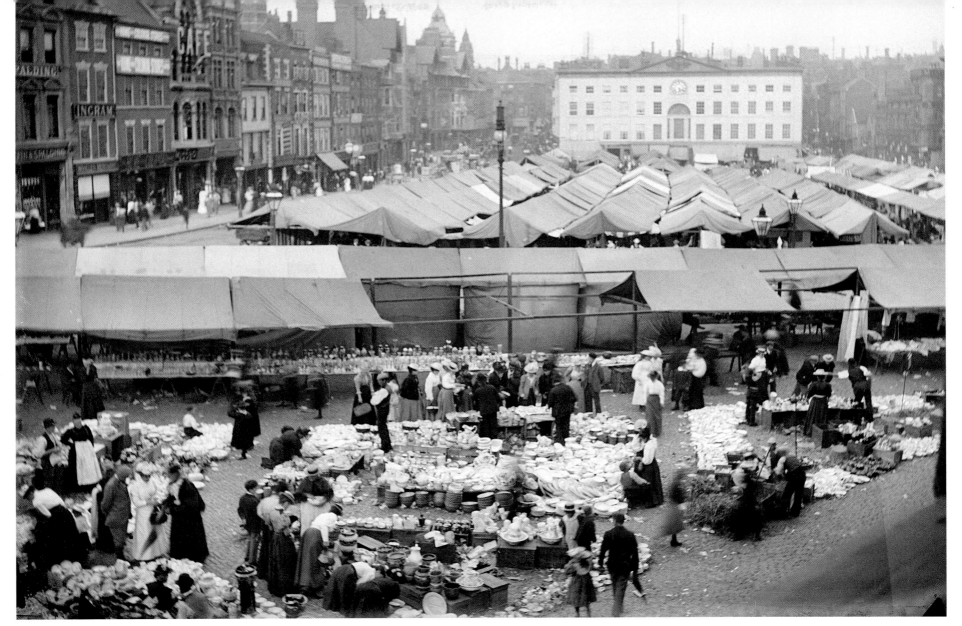

MARKETPLACE, NOTTINGHAM, NOTTINGHAMSHIRE, 1897–8

The right to hold a market was a valuable privilege for a borough. Nottingham's first Royal Charter, granted by Henry II around 1155, included the right to hold a weekly market on Friday and Saturday. The annual Goose Fair – an event of international importance – was also held in the marketplace every September. The Saturday market and Goose Fair continued to be held there until they moved to new sites in 1928. In this view the marketplace is packed with stalls. In the foreground cheap china, probably seconds, is attracting considerable attention. The Exchange of 1724–6, which commands the marketplace in this photograph, was demolished in the early 20th century to make way for a new Council House and other improvements. [AA97/05221]

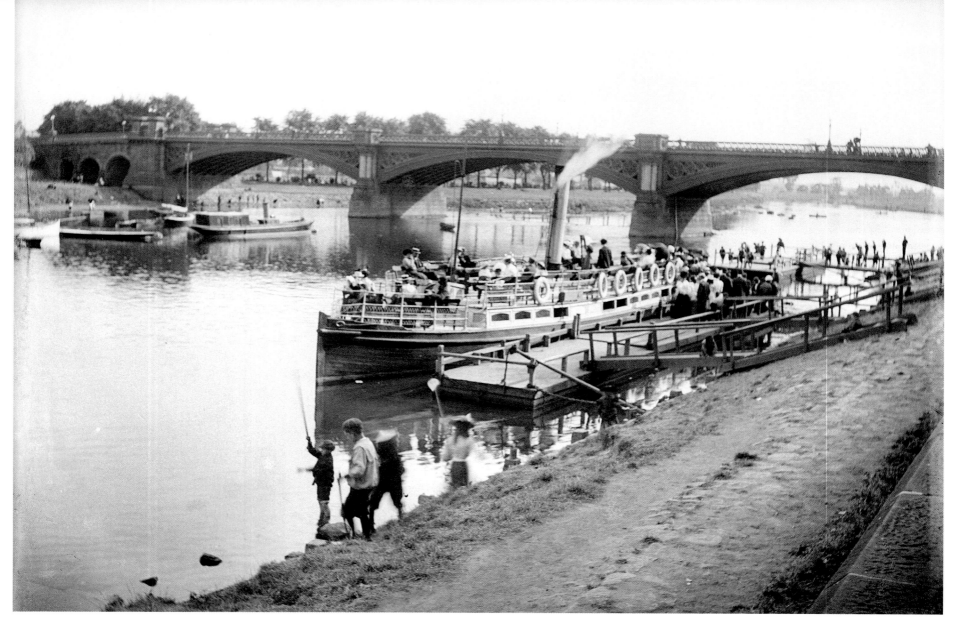

RIVER TRENT, NOTTINGHAM, NOTTINGHAMSHIRE, 1897–8

Holidaymakers embark on a pleasure steamer on the River Trent at the southern edge of Nottingham while local boys fish in the foreground. The Trent Bridge, which gave its name to the neighbouring cricket ground, was built in 1871 by M O Tarbotton, Corporation Engineer, replacing a medieval structure. [AA97/06047]

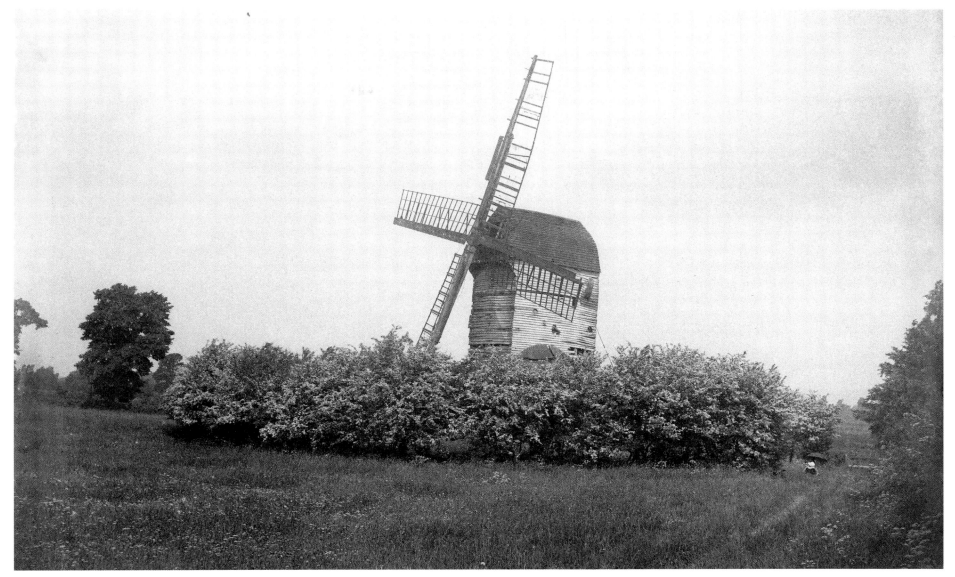

POST MILL, COSTOCK, NOTTINGHAMSHIRE, 1896–1910

Water power was exploited in ancient times, but windmills were not known in England until the late 12th century. The earliest form of windmill was the post mill – the entire body of this type of mill pivots around a massive central post in order to face the wind. In some cases a structure known as a roundhouse was built beneath the body of the mill to protect the wooden trestle and to provide storage. The post mill at Costock was in poor condition when it was photographed by Newton and has since been demolished. [AA97/06055]

Contract No. 2:
East Leake to Aylestone

Awarded to Henry Lovatt of Wolverhampton, Contract No. 2 ran from East Leake, Nottinghamshire, to Aylestone, just south of Leicester. This contract would see the line cut right through the centre of Leicester, requiring the demolition of much property and the erection of a viaduct that literally spanned the town. At Swithland the railway crossed a reservoir, which was a major engineering exercise, while a short branch line was built to serve the granite quarries at Mountsorrel.

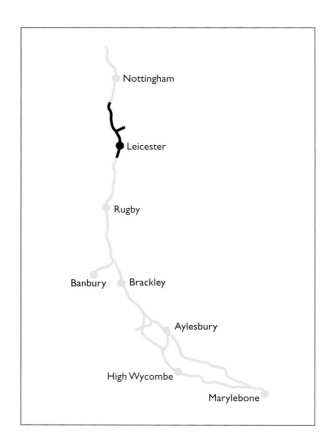

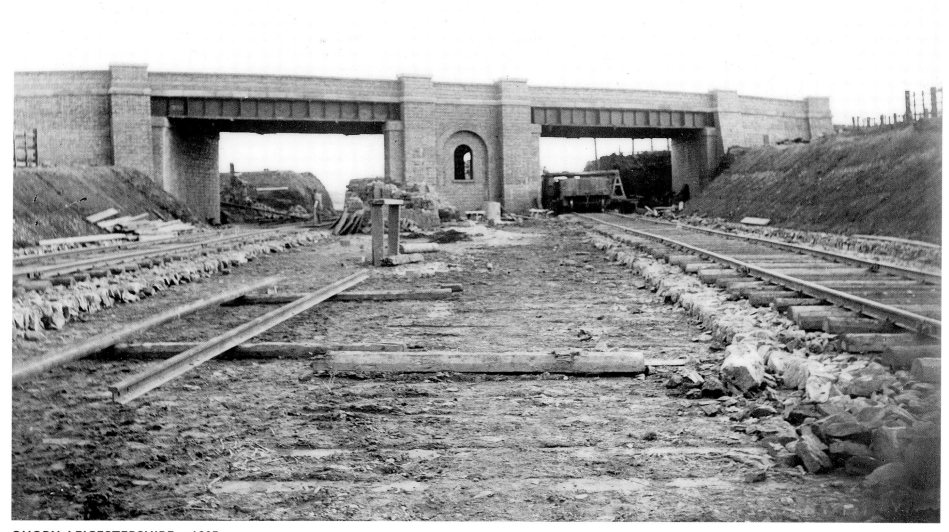

QUORN, LEICESTERSHIRE, c 1897

This double-span bridge (Bridge 342) carried the road between Quorn and Woodhouse over the appropriately named Quorn & Woodhouse Station. The station's island platform was on the far side, with access via a stairway that led down from the centre of the bridge to the platform below. Twin lines of temporary track pass beneath the bridge; these seem particularly well laid, being on ballast rather than mud. Quorn & Woodhouse is one of a handful of former stations that survive intact – it is now part of the revived GCR that runs steam-hauled trains between Leicester and Loughborough. [L1485]

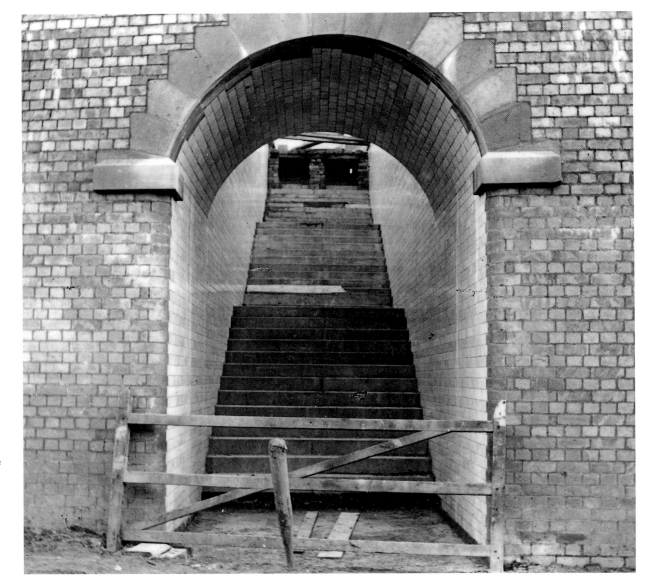

SWITHLAND, LEICESTERSHIRE, *c* 1897

The small village of Swithland is situated between Quorn and Rothley, and during the 70-year reign of the London Extension its nearest station was the one at Rothley. However, when the route was originally set out, Swithland was to have had a station of its own, access to which can be seen in this photograph. The archway was built into the southern abutment of Bridge 352 and the stairs led up to what would have been Swithland Station's island platform; however, this was never built and the plan for the station was scrapped. Instead the archway was bricked up and the station site housed a series of sidings. [L2452]

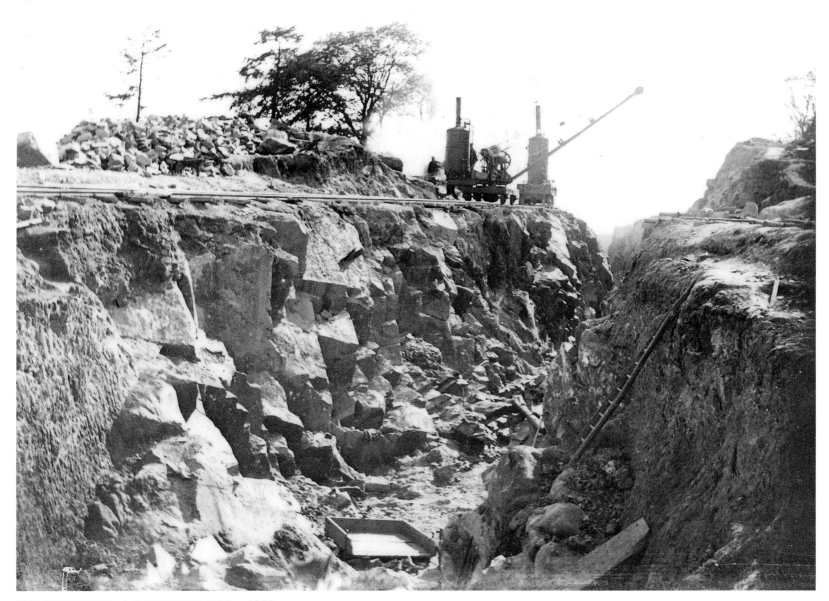

MOUNTSORREL, LEICESTERSHIRE, c 1897

This photograph was taken during construction of the Mountsorrel branch, a short single-track line that left the London Extension at Swithland before heading north-east to the Mountsorrel quarries. As this picture of a roughly hewn rock cutting testifies, significant extraction of granite was required in order to get the branch to its destination. The two precariously balanced steam cranes are at work on the contractor's temporary railway that runs along the top of the cutting wall. When the branch was completed, the quarry produce was taken down to Swithland Sidings where it was marshalled ready for dispatch. [L2812]

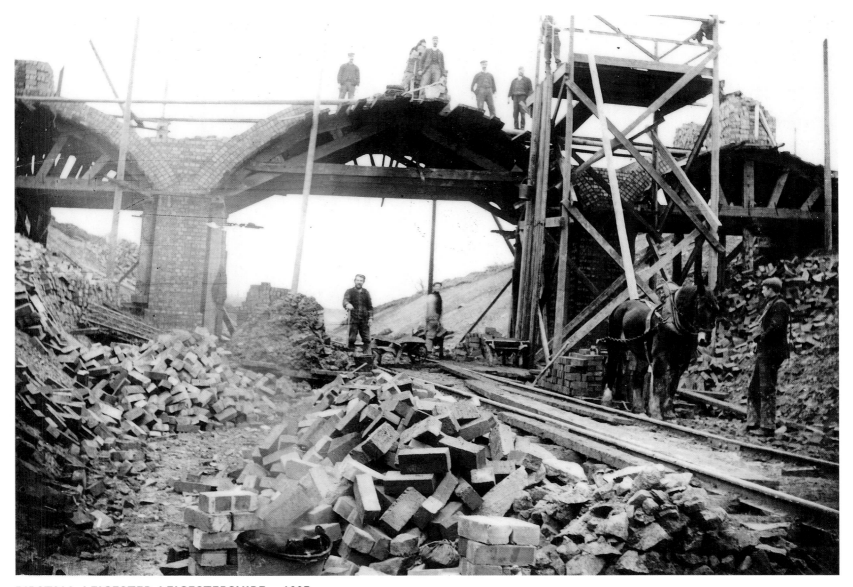

BIRSTALL, LEICESTER, LEICESTERSHIRE, c 1897

Along with the island-platform stations, the three-arch brick bridges that spanned the line were familiar sights along the entire length of the London Extension.
The double-track main line ran through the central arch and it was hoped that when traffic increased the line could be quadrupled with extra tracks running through
the two outer arches. Sadly, the increase in traffic never materialised and the line remained double track only. This photograph provides a good illustration of how
these bridges were built, especially the use of a wooden frame, or 'centring', to create the curve of the arch. [L1567]

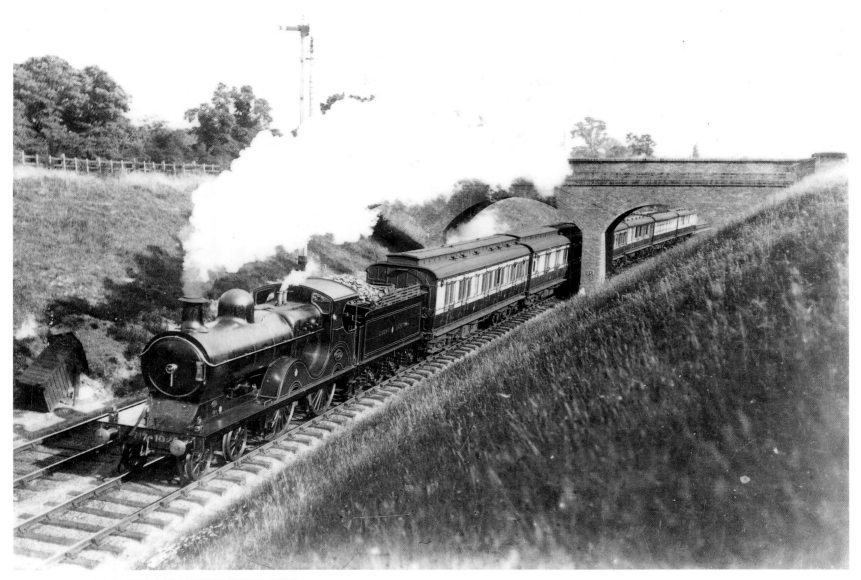

BIRSTALL, LEICESTER, LEICESTERSHIRE, 1905

The majority of the railway photographs taken by Newton feature the London Extension under construction during the late 1890s. However, living in Leicester meant that Newton could visit *his* railway whenever he wanted. This quite magnificent photograph features a John G Robinson-designed class 11B 4-4-0 running at speed through Birstall cutting with a rake of clerestory-roofed coaches. The brick-arch bridge, the plume of white smoke and the locomotive's graceful curves all combine to make this a picture postcard image from the golden age of railway travel. [L2361]

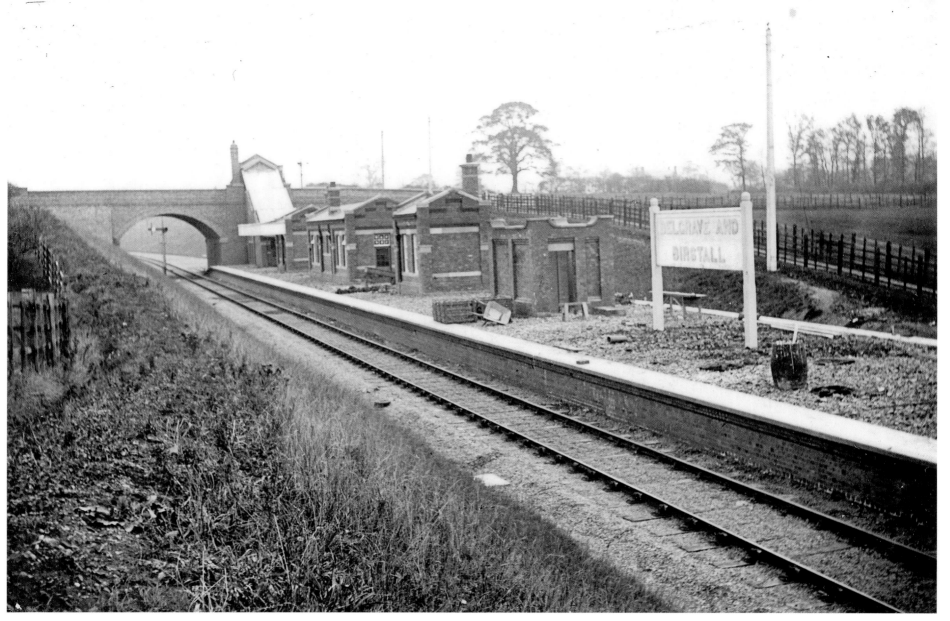

BIRSTALL, LEICESTER, LEICESTERSHIRE, c 1898

Belgrave & Birstall Station was the last stop for southbound trains before Leicester Central Station and comprised the now familiar island platform with booking office, waiting room and a gentlemen's lavatory block along its length. Unusually, Belgrave & Birstall was built with an extra building between the lavatory and the waiting room. These intermediate stations were designed by Alexander Ross, Chief Engineer of the MSLR, and became a characteristic feature of the new railway. Today the site has been revamped and renamed Leicester North, serving as the southern terminus of the Great Central Steam Railway. [L1531]

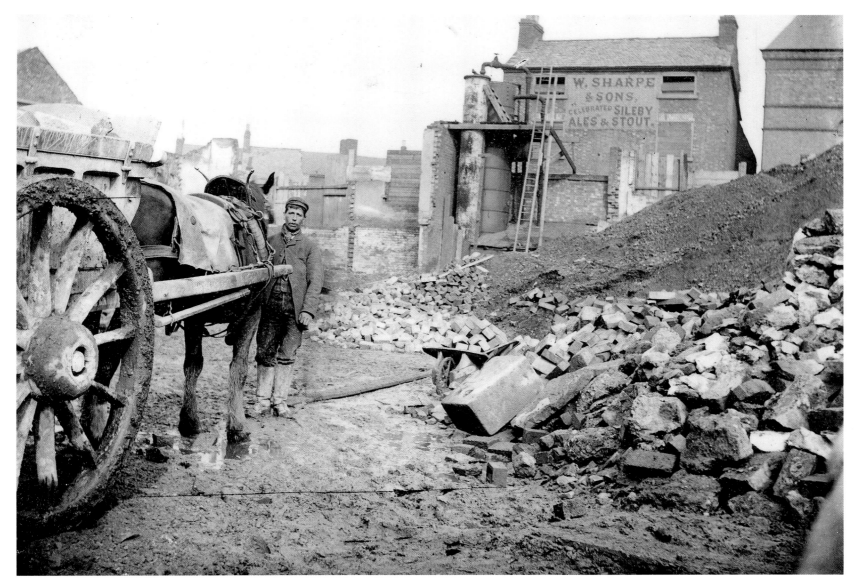

BATH LANE, LEICESTER, LEICESTERSHIRE, c 1895

This photograph shows the demolition of properties on Bath Lane to make way for the construction of Leicester Central. An advertisement for 'W Sharpe & Sons Celebrated Sileby Ales & Stout' is painted on the rear wall of a surviving building. A navvy leads a horse and cart through the rubble, which is piled up on the right, and a wheelbarrow is fully loaded with bricks ready to be taken away. [L1228]

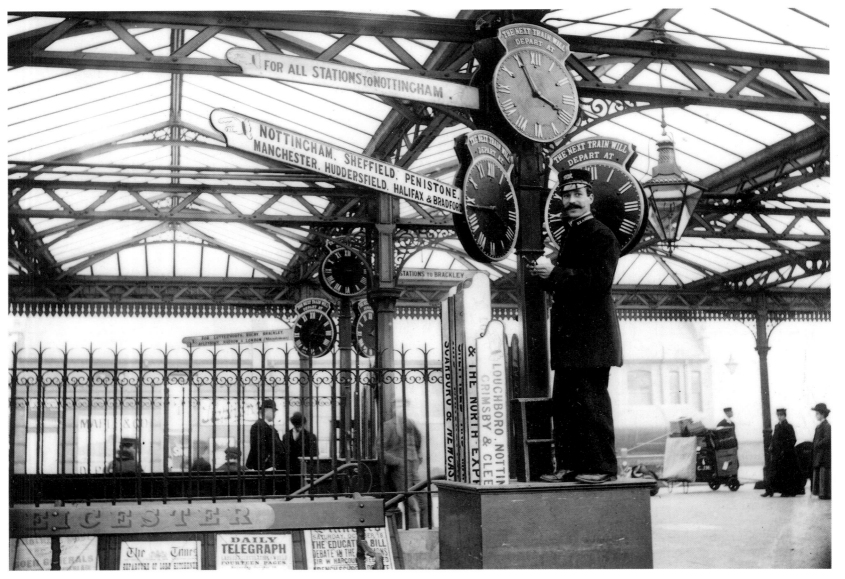

LEICESTER CENTRAL STATION, LEICESTERSHIRE, OCTOBER 1902

This photograph, taken during the working life of the GCR, is probably one of the best known in the whole collection. It illustrates an everyday scene at Leicester Central Station and shows the rather delightful method of displaying the train departure times. The gentleman setting the clocks is believed to be H G Banyard, part of a family that was associated with Leicester and the London Extension for many years. The finger boards in the rack offer a multitude of destinations that must have seemed quite exotic to Edwardian travellers, including Scarborough, Cleethorpes, Grimsby and Newcastle. [L2421]

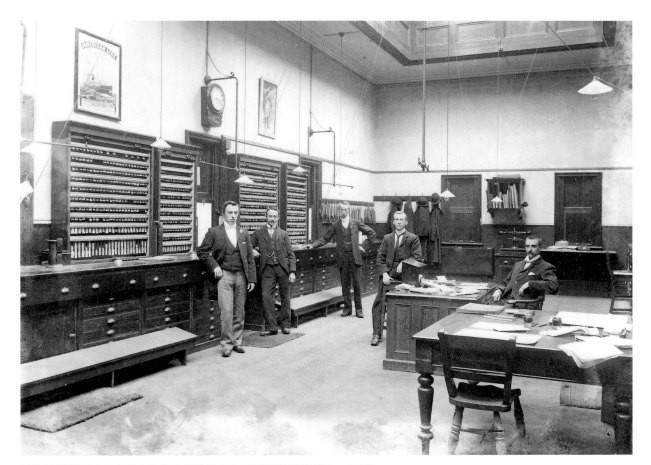

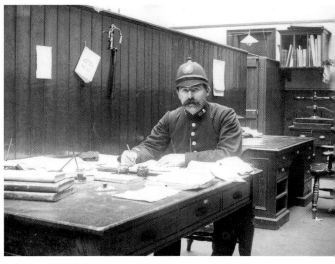

LEICESTER CENTRAL STATION, LEICESTERSHIRE, *c* 1900

PC Milburn, seen here, poses for Newton's camera at his desk in Leicester Central Station; note the handcuffs and truncheon on the wooden partition. The first railway police force was established in 1830 on the Liverpool & Manchester Railway. As the railway boom took off, many railway companies employed their own constables, often sworn in locally as Special Constables. [L1532]

LEICESTER CENTRAL STATION, LEICESTERSHIRE, *c* 1902

The booking office at Leicester Central was the heart of the station complex where all passengers and freight were dealt with. The office had a semi-glazed roof that provided considerable light, but gaslights were also installed to provide lighting for darker days and night-time working. On the walls by the ticket windows were racks of the Edmondson-type card tickets, offering destinations all over the GCR network. These were then subdivided into classes (1st and 3rd) and then by single or return journeys. Add to this the need for adult and child journeys, season tickets and privilege passes, and one gets an idea of how complex the booking clerks' jobs were. [L2402]

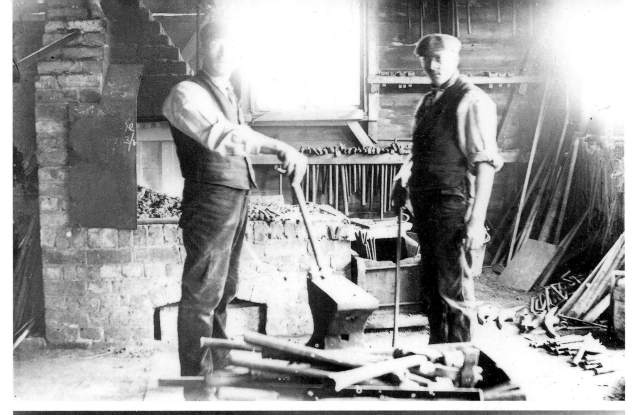

BLACKSMITHS' WORKSHOP, MOWMACRE HILL, LEICESTER, LEICESTERSHIRE, *c* 1897

The term 'navvy' covered more than just unskilled labourers. The *Sixteenth Annual Report of the Navvy Mission Society* for 1893 noted that many more skilled tradesmen such as blacksmiths, engine drivers, fitters, masons and carpenters were now employed in public works than when the Society first began. These blacksmiths pose by the hearth and anvil in a blacksmiths' shop at a contractor's depot on Mowmacre Hill. There would always be plenty of work for blacksmiths who would have made or repaired many of the tools used in the construction of the railway, from shovels to heavy machinery. The exhausting atmosphere has been well captured in these images. [L1810; L1209]

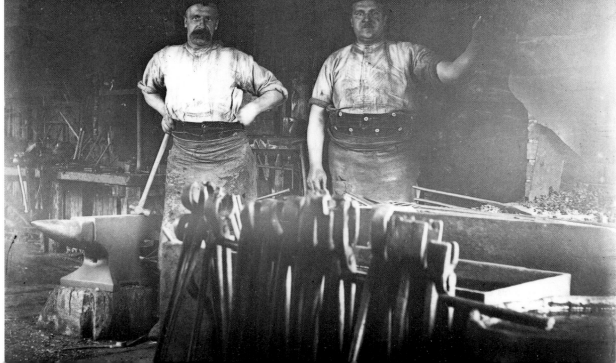

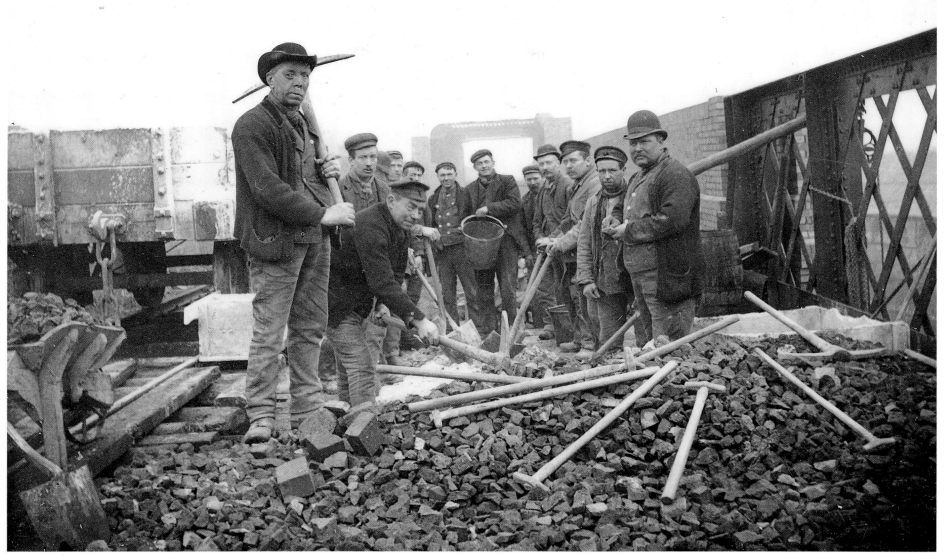

LEICESTER, LEICESTERSHIRE, *c* 1897

Navvies pause for a moment during the construction of the girder bridge near Duns Lane, Leicester. The lattice parapet to the right was part of a bridge built to cross the River Soar, while in the background is Braunstone Gate Bridge, one of several bowstring lattice girder bridges built on the London Extension. The scene provides a perfect illustration of what life was like for a navvy working on the railways and captures the spirit that Newton was trying to achieve with his photographs. The tough nature of the job is reflected in the face of the navvy on the left, while the primitive tools of the trade are displayed on the ground. [L1230]

DUNS LANE, LEICESTER, LEICESTERSHIRE, c 1898

This bridge was one of two bowstring lattice girder bridges that formed part of the Leicester Viaduct, collectively known as Bridge 374. It spanned Western Boulevard, close to the junction of Braunstone Gate and Duns Lane. Both this and the similar bridge over Northgate Street were very imposing structures and served as local landmarks. Following the closure of the London Extension in 1969 much of the viaduct was demolished, but this bridge survived to form part of the Great Central Way cycle path. Unfortunately its condition has deteriorated and it is now closed off to the public and faces demolition. [L1719]

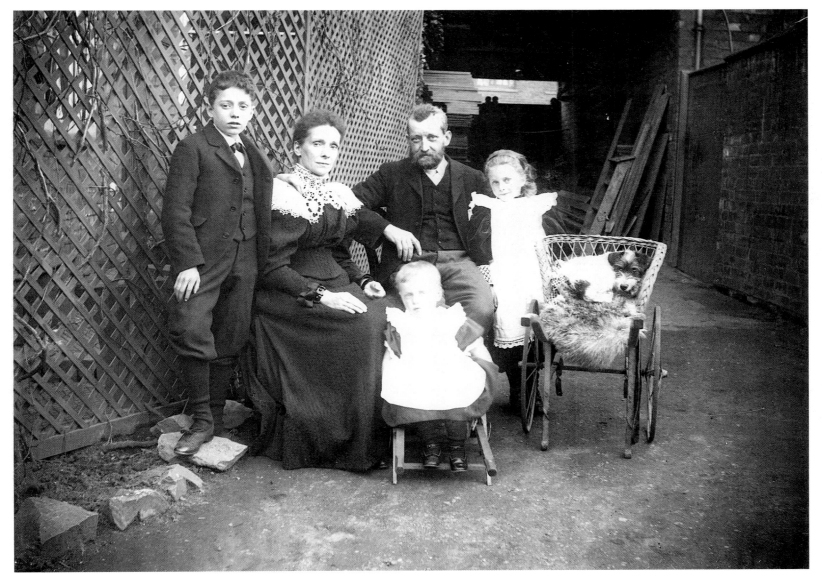

DOBSON FAMILY, STANFORD ON SOAR, NOTTINGHAMSHIRE, 1897

Newton offset the cost of his railway photography by taking commissions from locals in the towns and villages through which he passed.

This family group, complete with their dog sitting quite contentedly in the little cart, was photographed on 1 May 1897. [L3482]

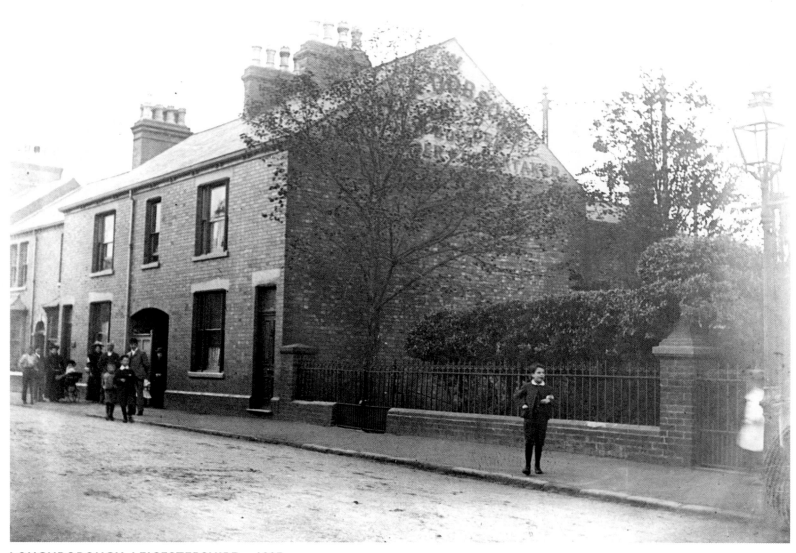

LOUGHBOROUGH, LEICESTERSHIRE, c 1897

The engineering and market town of Loughborough was already served by the Midland Railway before the GCR arrived. Here a small crowd – men dressed smartly in suits and hats, boys wearing the short trousers typical of the period and ladies sombrely attired in long coats and hats – has gathered in a residential street near Loughborough's Gas Works to watch Newton at work. There is a child in a pram towards the back of the group – prams, or perambulators, did not appear until the last decade of the 19th century. Another period feature is the advert painted high on the gable end of the terrace. [L3475]

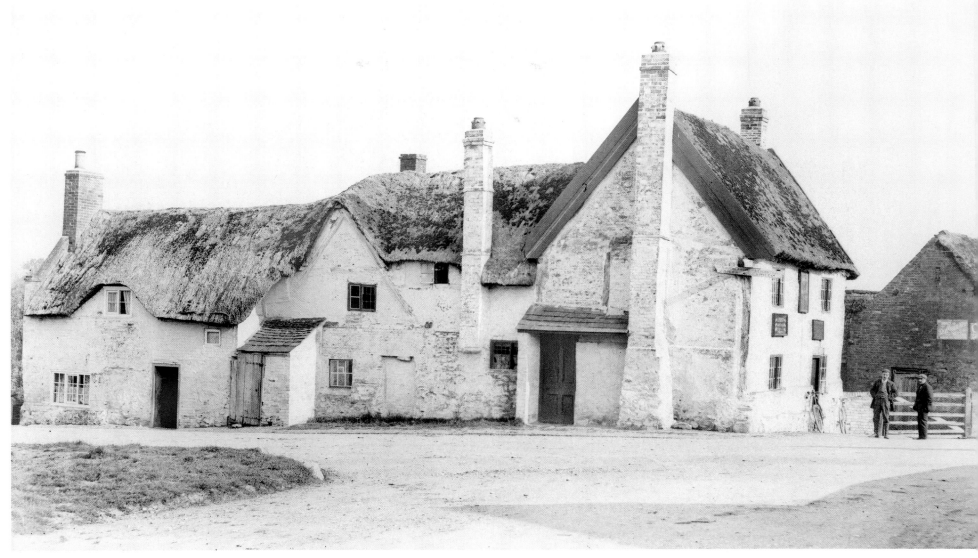

WHEATSHEAF INN, LEICESTER ROAD, THURCASTON, LEICESTERSHIRE

Two men with bicycles stand outside this traditional village inn. The notice on the wall behind them advertises Clarke's Cycles. The inn – complete with original pub sign – forms part of a rather ramshackle row of possibly 17th-century thatched brick buildings that bear evidence of a number of adaptations. [OP04318]

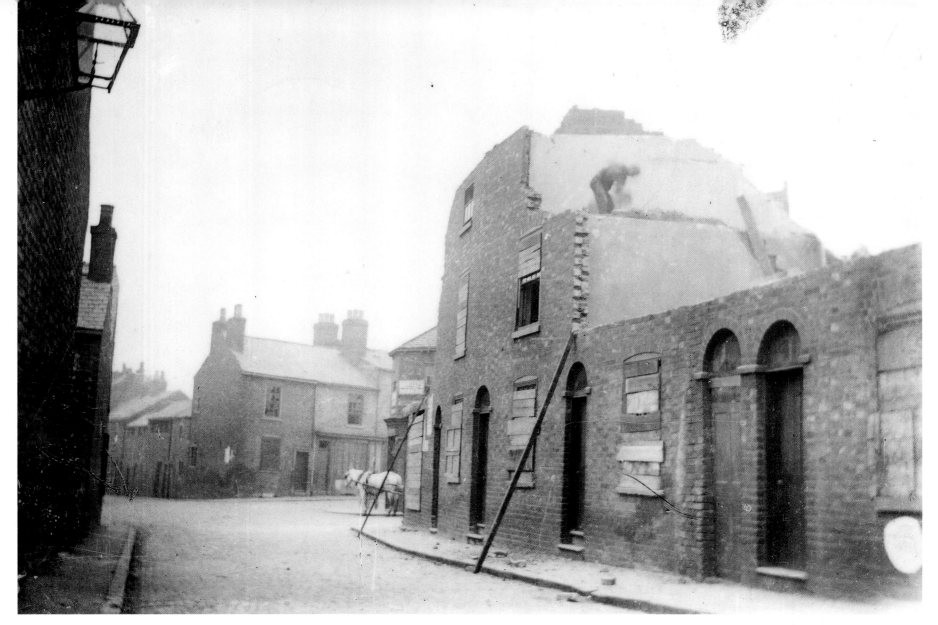

DEMOLITION IN TALBOT LANE, LEICESTER, LEICESTERSHIRE, c 1895

Carving a railway through a densely built-up area was traumatic for the local community. The railway company obtained compulsory purchase orders on all property in the direct path of the new railway and many buildings in Leicester had to come down. This house on Talbot Lane was one of countless properties to be demolished as the GCR ruthlessly forged its way across the city. Eventually this site would mark the southern end of Leicester Central Station. [L2320]

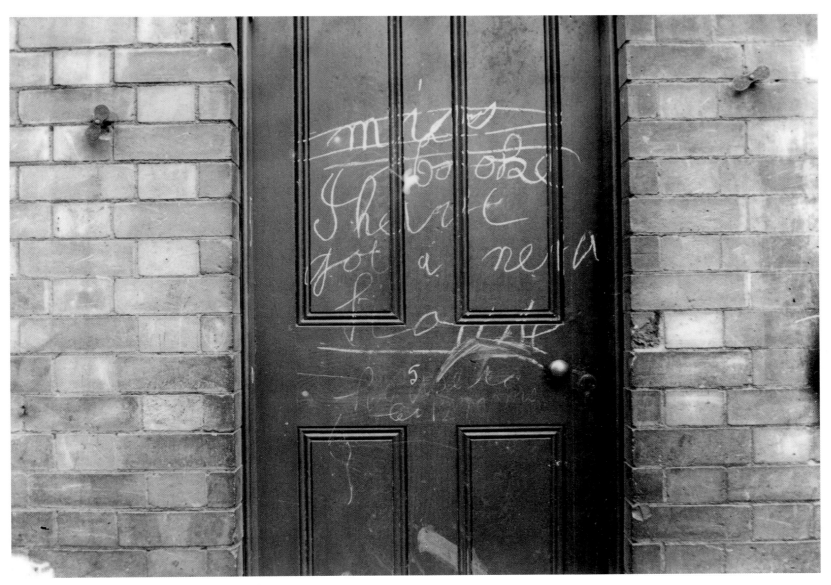

CHARLOTTE STREET, LEICESTER, LEICESTERSHIRE, c 1896

This photograph illustrates the human cost of carving the new railway through a town. The houses on the west side of Charlotte Street were demolished to make way for Leicester Central Station and this graffiti –'Miss Cooke I have got a new house' – was chalked on the door of one of these. Displaced residents were rehoused at the railway's expense, but established communities were broken up in the process. Following clearance this road ceased to exist and the station frontage occupied much of the site. [L2456]

Contract No. 3:
Aylestone to Rugby

Contract No. 3 was built by the contractors Topham, Jones & Railton and ran from Aylestone, near Leicester, to Rugby, Warwickshire. This was a very rural section of the line, with Lutterworth being the only town of any size between Leicester and Rugby. Nevertheless, the GCR saw fit to build intermediate stations at Whetstone and Ashby Magna. Prior to the opening of the London Extension, Lutterworth was served by the Midland Railway station at Ullesthorpe.

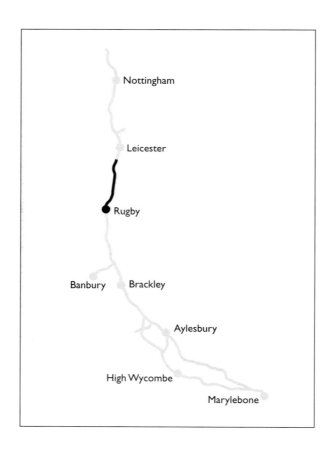

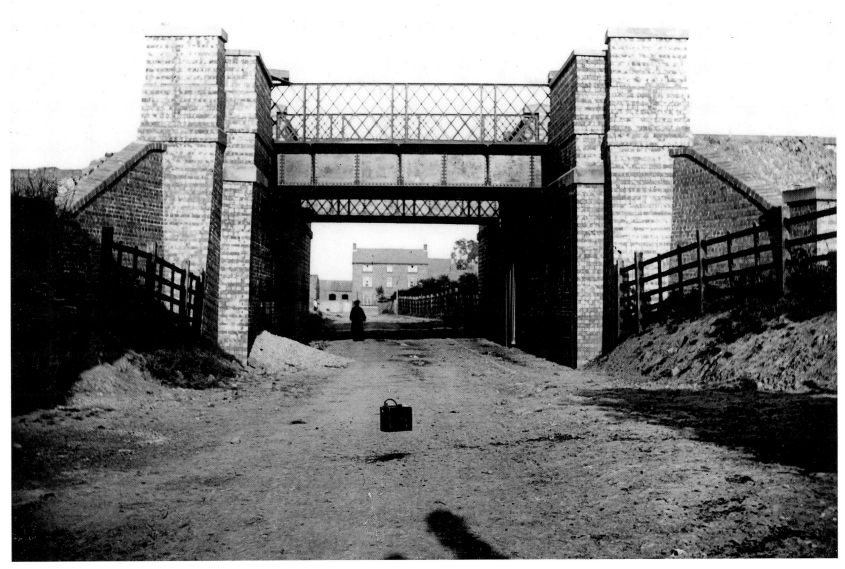

WHETSTONE, LEICESTERSHIRE, c 1897

Bridge 399 was built to carry the London Extension over what would eventually be named Station Street. The station was built to the right of the bridge, with access through a doorway and staircase in the right (southern) abutment that led up to the island platform above. This photograph is interesting because we get a glimpse of Newton himself – albeit his shadow at the base of the photograph – and his bag of tricks. Those who knew Newton remember his pinstripe suit and bowler hat, and it is clear from the shadow outline that he was wearing the bowler while taking this photograph. [L1222]

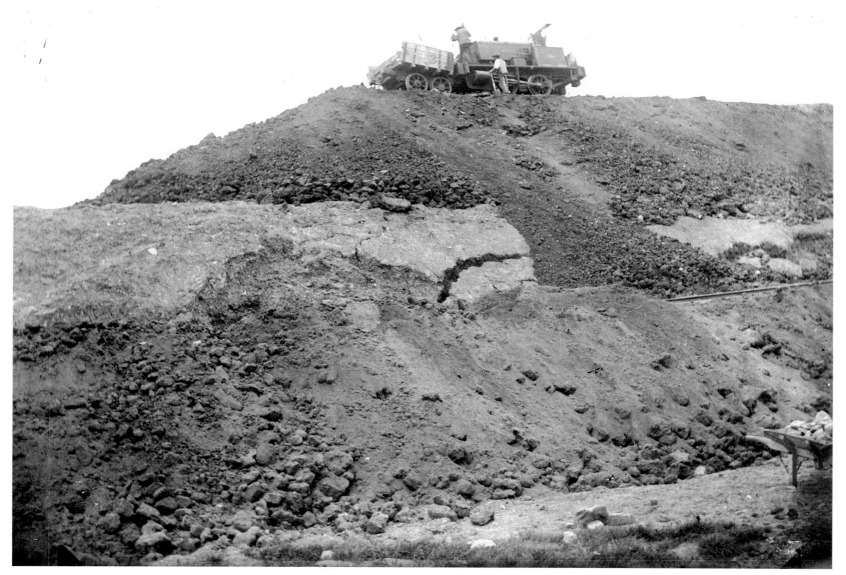

WHETSTONE, LEICESTERSHIRE, c 1897

A remarkable feature of the London Extension is that it was built to a maximum gradient of 1 in 176, which was easy for locomotives but not so easy to construct. Achieving such a smooth gradient required considerable earthworks – both deep cuttings and high embankments like this one – and the excavated spoil from the cuttings was used to form the embankments. This fascinating photograph, taken just south of the Whetstone to Littlethorpe road, illustrates the method used for creating an embankment. The Manning Wardle 0-4-0 saddle tank, running on lightly laid temporary rails, has positioned a tipping wagon at the head of the embankment and deposited its load. [L3042]

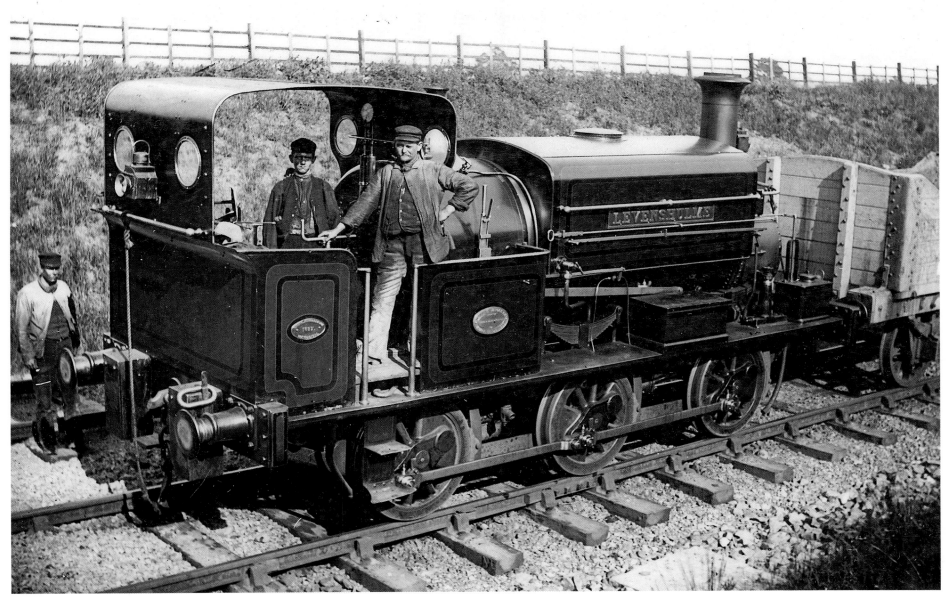

LOCOMOTIVE NEAR COSBY, LEICESTERSHIRE, JUNE 1897

The building of the London Extension not only required skilled labour but also a large amount of heavy equipment, including steam excavators, stone crushers, mortar grinders and locomotives. By pure chance, the start of construction in 1894 coincided with the opening of the Manchester Ship Canal, meaning that much of the equipment used on that project was now available for purchase. This Manning Wardle & Co 'M' class 0-6-0 saddle tank, *Levenshulme*, had previously worked on the Manchester Ship Canal contract, but was acquired for the GCR construction by Topham, Jones & Railton. [L1002]

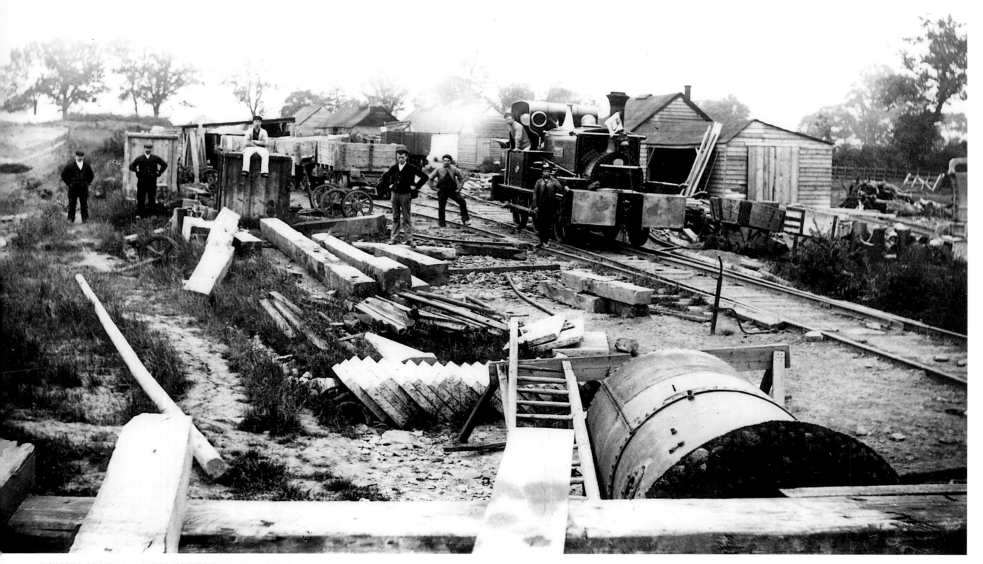

ASHBY MAGNA, LEICESTERSHIRE, *c* 1897

This is a fine portrait of one of Topham, Jones & Railton's yards near Ashby Magna. One of the numerous 0-6-0 locomotives, complete with dumb buffers and wrap-over cab, sits on the temporary railway as her crew and five navvies pause from their work to pose for Newton's camera. This yard, like most contractors' yards, contained a mishmash of materials that would eventually be used in some way on the construction of the railway. Whether it was a steam boiler, tipping wagon or a sturdy wooden support, it would find a use sooner or later. [L2418]

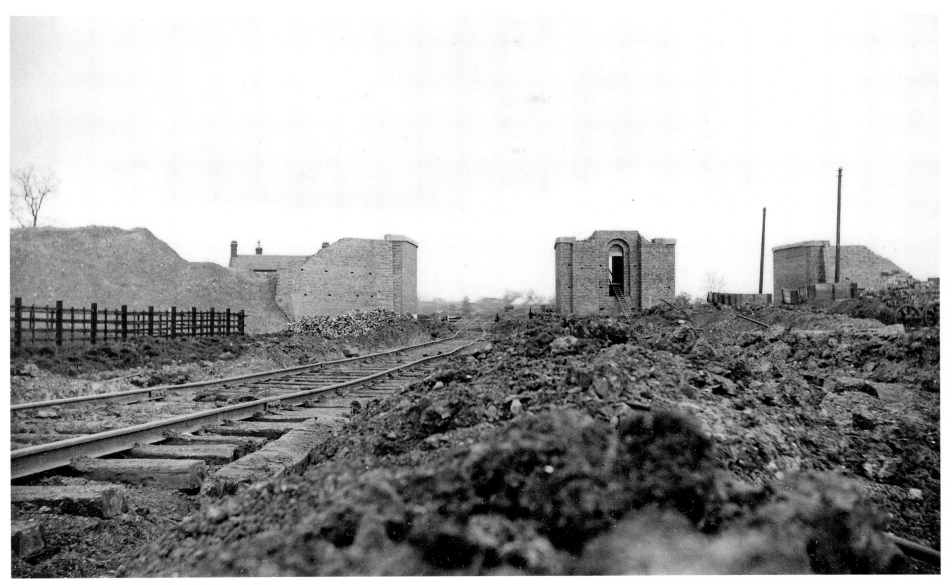

ASHBY MAGNA, LEICESTERSHIRE, *c* 1897

This view shows construction underway at Ashby Magna Station. Not only did the navvies have to build the road bridge and station, but they were also responsible for building the road. The bridge abutments can be seen on either side of the picture, with the new semi-completed road embankment coming in on the left. The structure in the centre forms the central bridge pier and could be used for storage. Newton was crouching approximately where the station platforms would end when completed – access to the platforms would have been via a staircase from the road. The scene is radically different today as the station is gone and the M1 motorway now passes immediately to the right of the picture. [L1331]

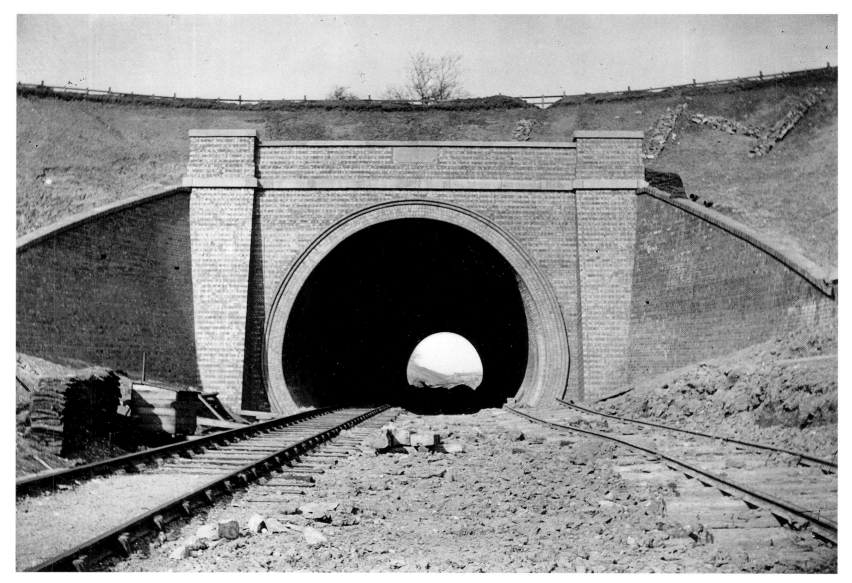

DUNTON BASSETT, LEICESTERSHIRE, *c* 1897

Dunton Bassett Tunnel, or Ashby Tunnel as it was also known, was not particularly long as tunnels go, but was a well-known feature of the London Extension in Leicestershire. It was completed in 1896 and measured 276 feet in length. This photograph presents an interesting comparison between the rough and ready contractor's railway on the right with its rails simply spiked to the sleepers and the heavier laid line on the left with the rails supported in chairs. Dunton Bassett Tunnel was located a short distance from Ashby Magna Station, hence the reason it was sometimes referred to as Ashby Tunnel. [L1324]

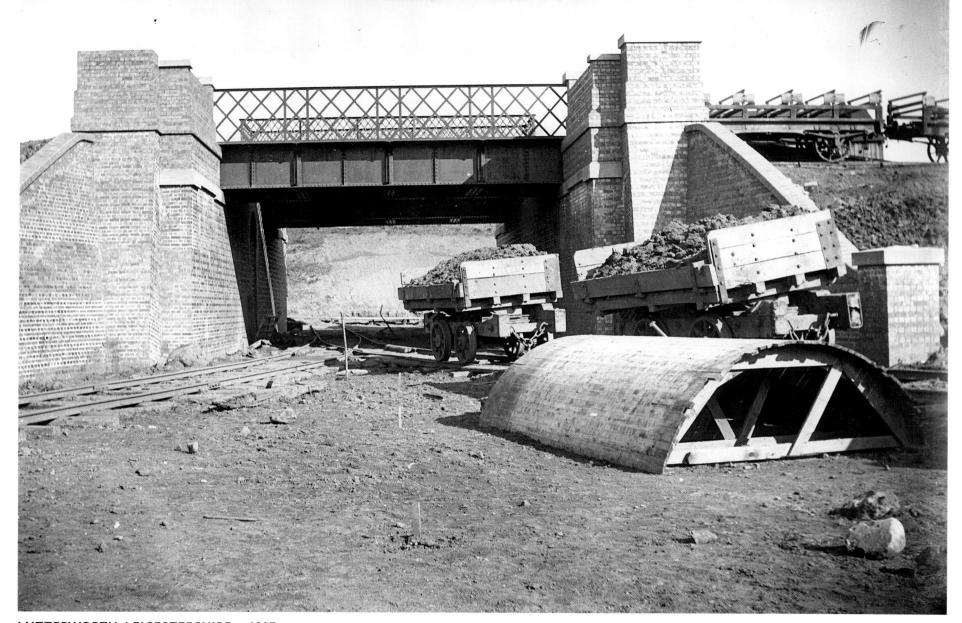

LUTTERWORTH, LEICESTERSHIRE, *c* 1897

Bridge 423 was the double-span girder bridge at the GCR's Lutterworth Station. Just visible at the centre of the left abutment is the entrance to the staircase that took passengers up to the island platform and station buildings. Lying on the ground in front of two laden tipping wagons is a boarded timber bridge centring, a temporary frame that was used to provide the shape of the brick arches on a bridge, viaduct or culvert. The wagons on the embankment appear to have been fitted with a crude form of seating. Presumably these ferried the navvies to the construction site. [L3140]

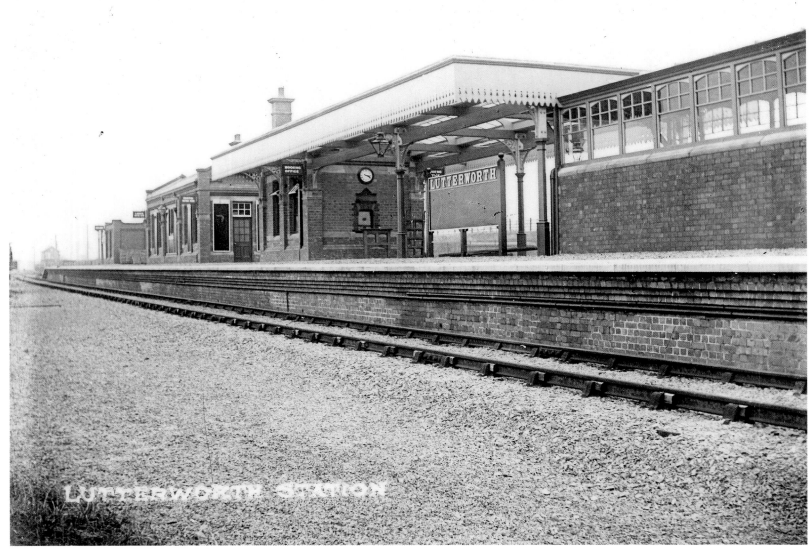

LUTTERWORTH, LEICESTERSHIRE, 1899

This is the newly completed GCR station at Lutterworth, just prior to the commencement of rail services in 1899. Once again an island platform was used to allow for the possible quadrupling of the line and the layout of the station was virtually identical to that on the other intermediate stations. Access was gained from the road below, giving Lutterworth more in common with the station at Whetstone than those at Rothley or Ashby Magna where passengers entered from a road passing over the line. The glazed structure to the right is the stairwell that led down to the road, with the booking office being situated on the far side of the canopy. Beyond that are the waiting room and gentlemen's lavatory. [L1714]

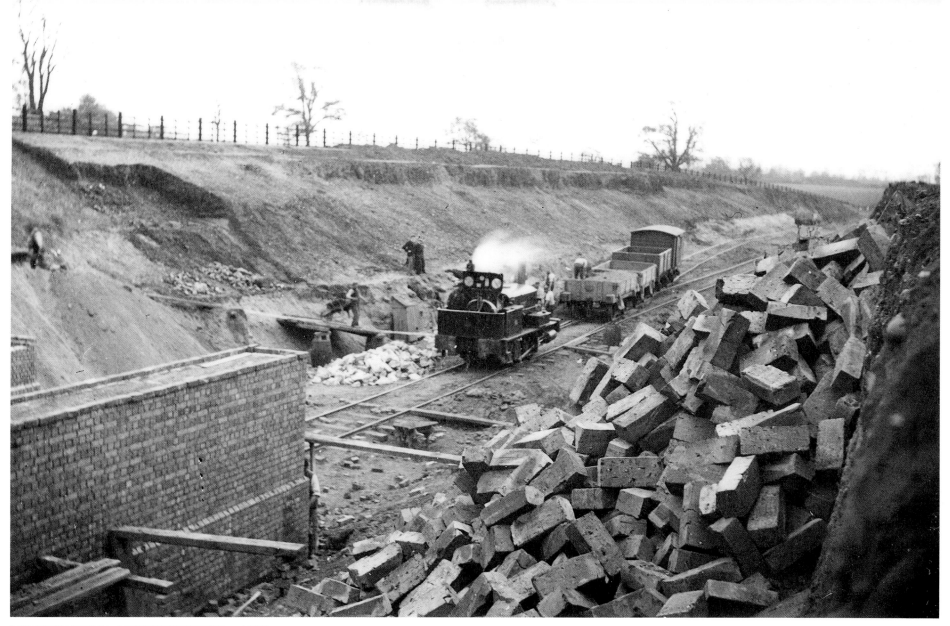

LUTTERWORTH, LEICESTERSHIRE, c 1897

Caught on camera to the south of Lutterworth, this excellent photograph shows railway construction being carried out in earnest. On the left is a brick pier that would eventually be part of the Swinford Road Bridge (No. 427) and on the right is an extremely large quantity of bricks that are required to complete the bridge. At the centre of the picture, a contractor's 0-4-0 saddle tank with a good head of steam is poised on the temporary railway to remove the small train of wagons which navvies are filling with spoil. From the look of the ditch on the locomotive's left, the navvies are laying drains. [L2786]

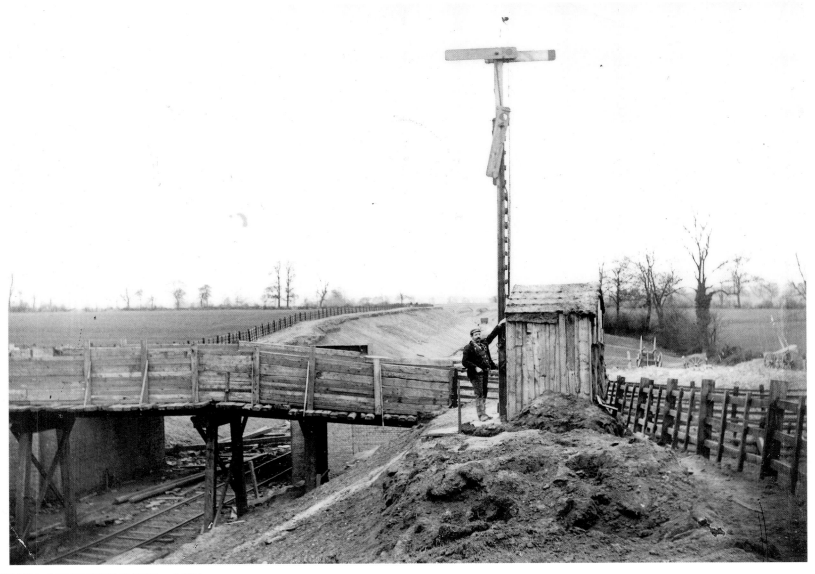

SHAWELL, LEICESTERSHIRE, c 1897

When a landowner had a railway driven across his land, he would naturally expect to still be able to access both sides of his property. Consequently, a large number of temporary wooden bridges were built to connect property or to maintain traffic on public roads and these were only dismantled when the permanent brick and steel bridges were erected. This one was on the Shawell to Churchover road to the north-east of Rugby. Sited next to the bridge is a signal cabin, used by the contractors to inform approaching supply trains that the way was clear. This signal itself is a very basic somersault type, which was often found on narrow-gauge railways across the country. [L1579]

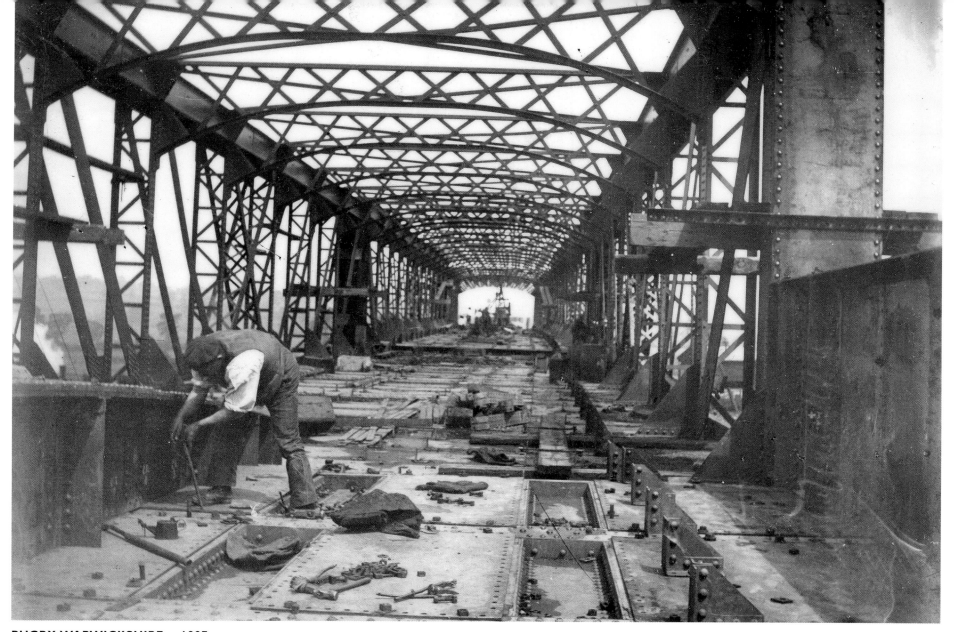

RUGBY, WARWICKSHIRE, c 1897

The complexity of the girder bridges and viaducts on the London Extension is shown to good effect in this photograph. It was taken during the construction of the lattice girder viaduct over the London & North Western Railway (LNWR) line at Rugby and shows a riveter hard at work. The deck of the bridge is littered with nuts, bolts, rivets and tools, and various wooden chocks are positioned in strategic places. The bridge was made up of three spans, two of which survive today. The fact that a structure such as this was built by men in the Victorian era is somewhat impressive. In more recent years, the bridge has become known as the Birdcage for obvious reasons. [L1339]

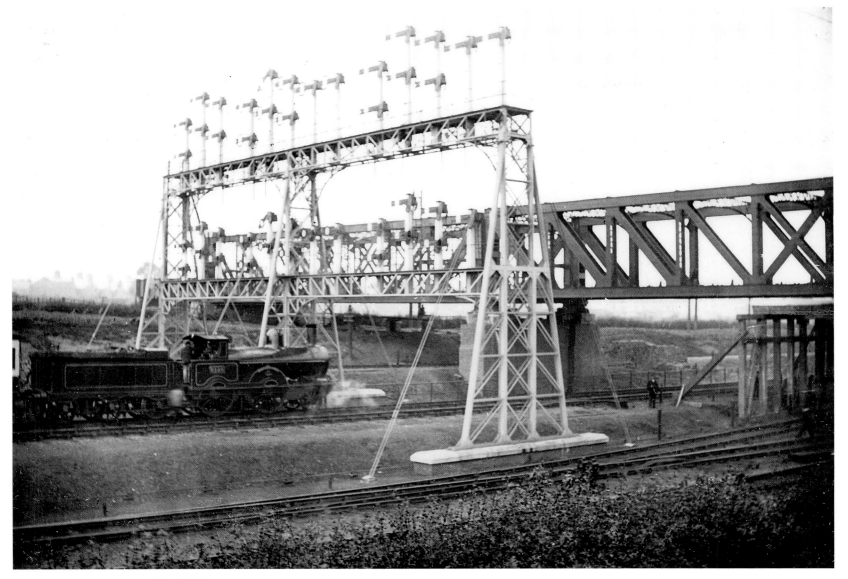

RUGBY, WARWICKSHIRE, *c* 1900

When the lattice girder Birdcage bridge was built to carry the London Extension over the LNWR's West Coast Main Line, it unfortunately obscured the view of the existing signals on the LNWR line. To rectify the problem, the GCR had to build, at its own expense, this monstrous signal gantry with its huge array of semaphore signals. It was sited next to the Birdcage bridge and remained in use until 1939. The locomotive passing beneath the gantry is one of F W Webb's 'Precedent' class 2-4-0s, which for many years dominated the LNWR expresses. [L1432]

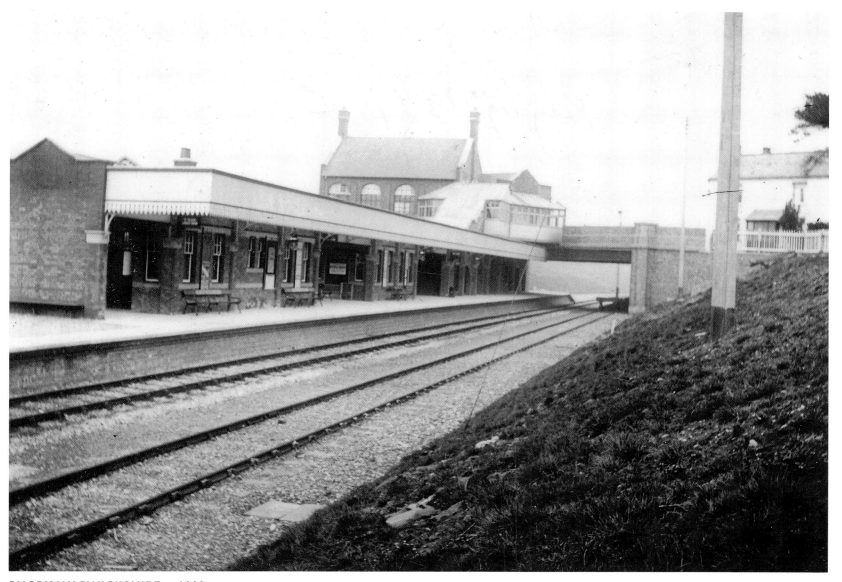

RUGBY, WARWICKSHIRE, *c* 1900

The GCR's station at Rugby displayed many of the characteristics that could be seen at other stations along the line, including an island-type platform and public access from the road above. Similar stations to Rugby Central were built at Loughborough and Brackley, these being much larger than the intermediate stations. The permanent way seems to be complete and this section of the London Extension appears ready for traffic. Today the station survives as a platform only and is part of a wildlife walk along the old track bed. [L1481]

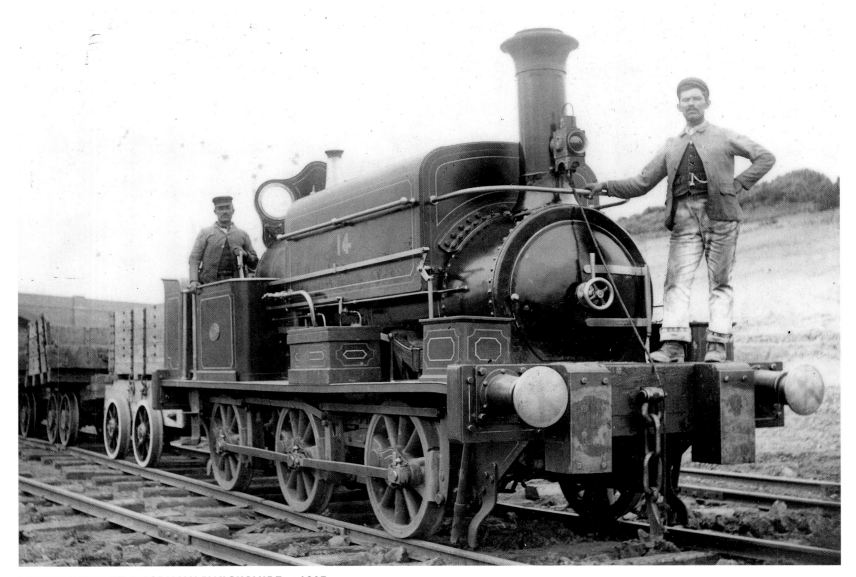

LOCOMOTIVE AT RUGBY, WARWICKSHIRE, *c* 1897

This is one of Topham, Jones & Railton's Manning Wardle 0-6-0 saddle tanks (No. 14 of 1890 vintage), which is pictured with its crew when working near the Ashlawn Road Bridge in Rugby. The locomotive's condition is typical of the contractor's fleet, having a surprisingly spotless appearance considering the nature of the work it performed. On the front buffer beam is a pair of wooden dumb buffers that were fitted to allow the locomotive to work with the wooden tipping wagons, seen coupled to the rear. Cabs were something of a luxury and the rather primitive weatherboard and spectacle plate provided little protection for the crew against the elements. [L1021]

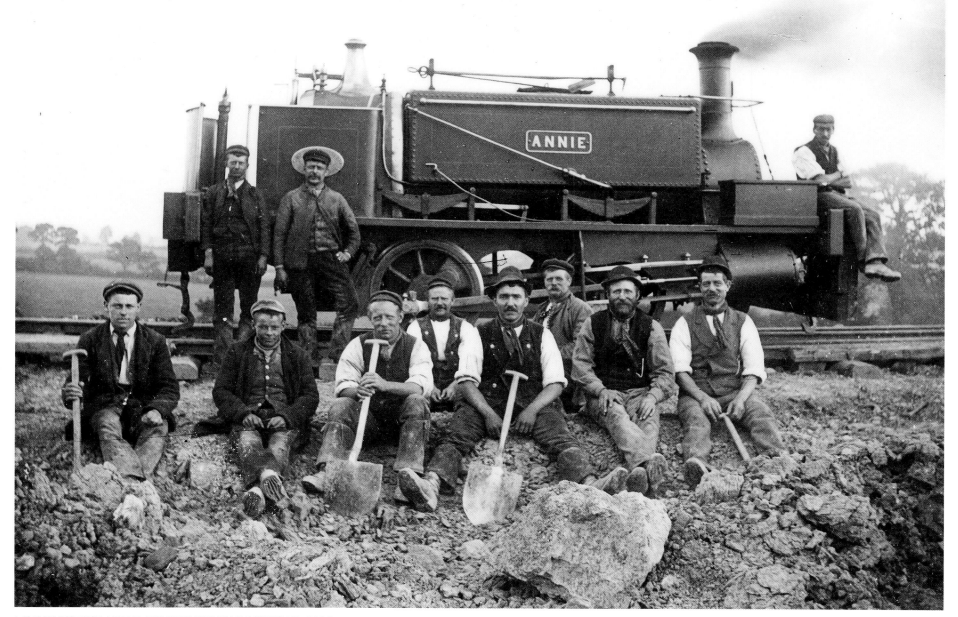

LOCOMOTIVE NEAR RUGBY, WARWICKSHIRE, 1896

Besides the numerous Manning Wardle 0-6-0 saddle tanks, several of the contractors involved with the London Extension construction also made use of outside-cylindered 0-4-0 saddle tank locomotives. One such example was *Annie*, built by the Hunslet Engine Co of Leeds and photographed at rest near Rugby with her crew and a group of resting navvies. The 0-4-0 types often found favour over the 0-6-0s due to their lighter weight and ability to traverse tight radius curves. [L2420]

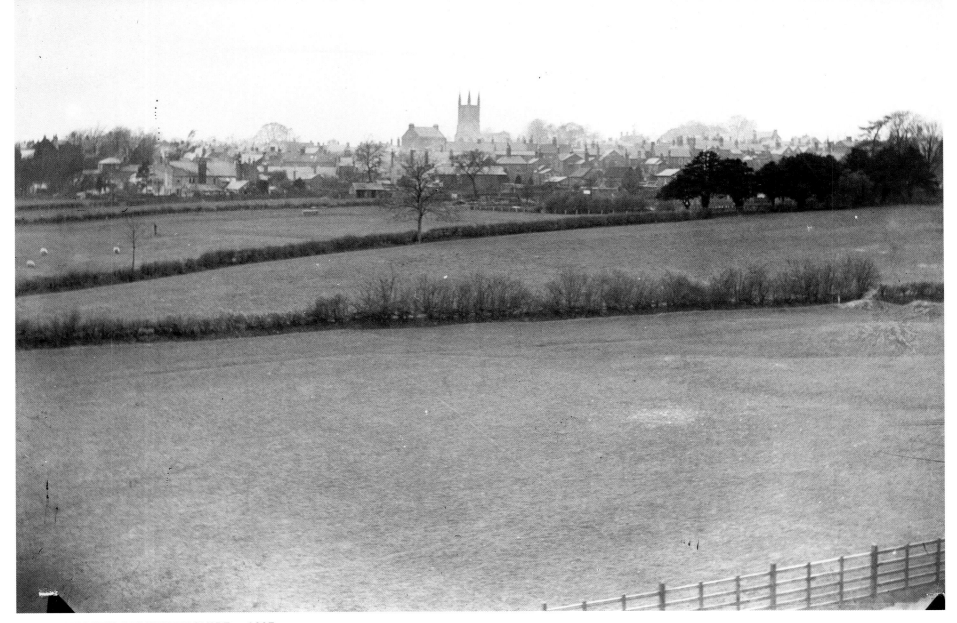

LUTTERWORTH, LEICESTERSHIRE, _c_ 1897

Taken around 1897, this is the view from an embankment of the London Extension towards Lutterworth. The tower of St Mary's Church – renowned for its association with the Bible translator John Wycliffe, who was rector between 1374 and 1384 – dominates the town. Before the GCR arrived, Lutterworth was poorly served by the station at neighbouring Ullesthorpe on the Midland Railway. [L3138]

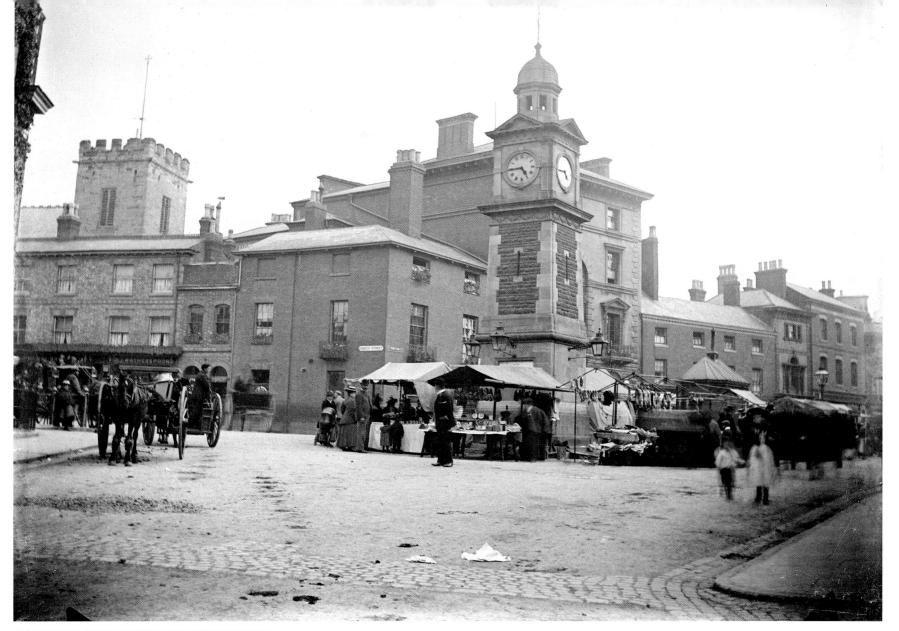

MARKETPLACE, RUGBY, WARWICKSHIRE

Stalls cluster around the clock tower – erected in 1887 to commemorate Queen Victoria's Golden Jubilee – in the centre of the marketplace. The 13th-century west tower of St Andrew's Church is visible above the roofline. [AA97/06088]

Contract No. 4:
Rugby to Woodford Halse

This section of the new line – built by T Oliver & Son – included the 3,000yd-long Catesby Tunnel, which was the longest tunnel on the line. A depot with locomotive sheds and workshops was established at the small village of Woodford (later Woodford Halse) in Northamptonshire, changing its character completely from a rural village to a miniature railway town.

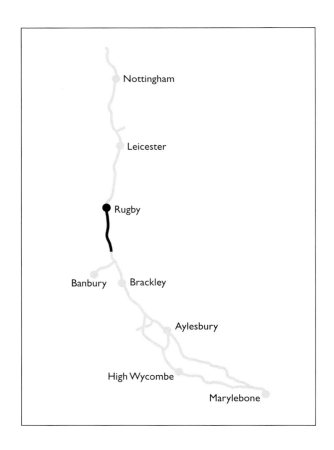

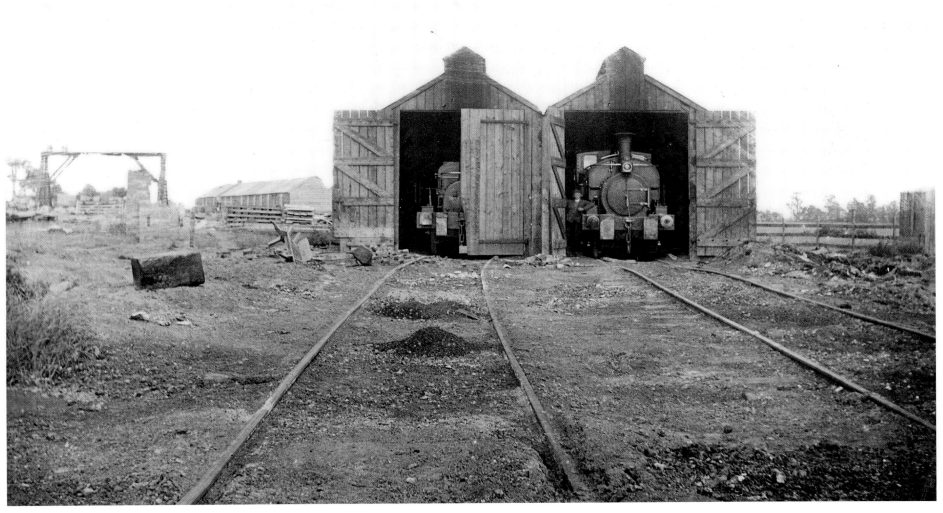

ENGINE SHEDS AT WILLOUGHBY, WARWICKSHIRE, *c* 1897

When a contractor set up a yard along their stretch of the London Extension, everything was thought of to ensure that the construction ran as smoothly and efficiently as possible. Most had their own fleet of locomotives that were used to remove spoil, shunt equipment and bring in supplies and workers. To keep these locomotives in prime condition, temporary wooden engine sheds were built to house and maintain them. Here two saddle tank locomotives sit safely under cover in the shed at T Oliver & Son's depot near Willoughby, south of Rugby. The picture provides evidence of the appalling tracks that these fine workhorses were required to work on. [L2769]

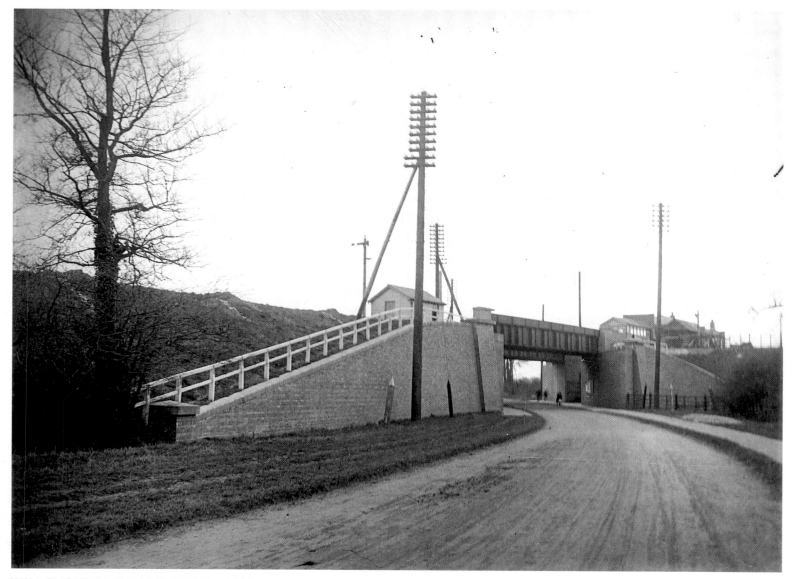

WILLOUGHBY, WARWICKSHIRE, *c* 1900

Although geographically closer to the small village of Willoughby, it was the nearby larger village of Braunston that took precedence when the station built to serve them was named Braunston & Willoughby. Another island-platform design, the station was located at a point where the London Extension crossed the London Road (which is today the A45). Two separate spans were required because the Up and Down lines split on their approach to the station to pass either side of the island platform. Passengers reached the station buildings, seen here on the right, via a flight of steps that led up from the centre of the bridge abutment. [L3028]

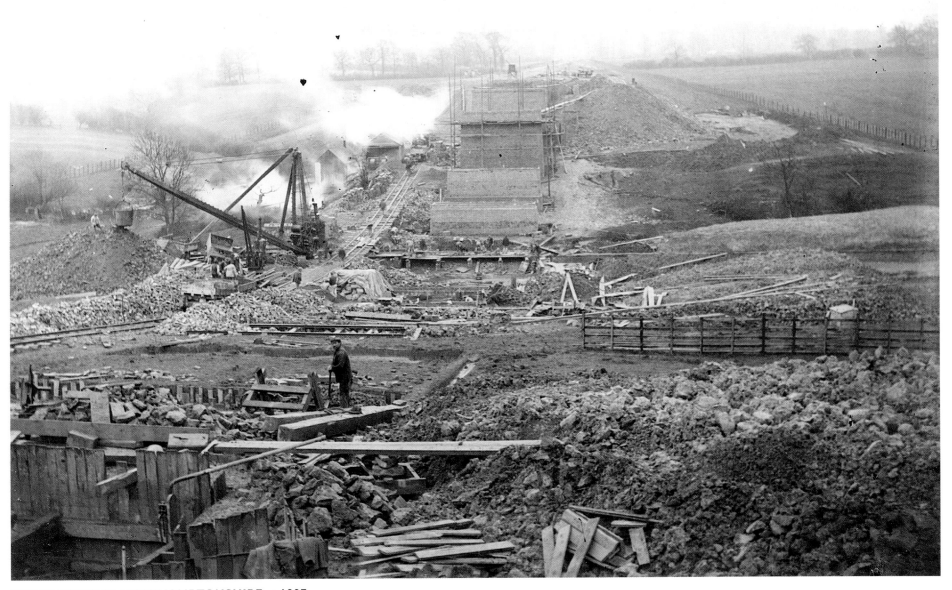

UPPER CATESBY, NORTHAMPTONSHIRE, c 1897

The 12-arch Catesby Viaduct, seen here under construction, was built to take the London Extension across the River Leam. Running beside the growing viaduct and making the steep climb up towards the course of the main line is a section of contractor's temporary railway. A scotch derrick and steam-powered jib are being used to tip the spoil, while in the foreground a single navvy has turned to face the camera. Photographs such as this are what make the S W A Newton Collection such a remarkable archive. By capturing the engineering techniques and transitional landscapes that accompany railway construction, Sydney Newton compiled a unique tribute to a part of our nation's past that other photographers had long neglected. [L3133]

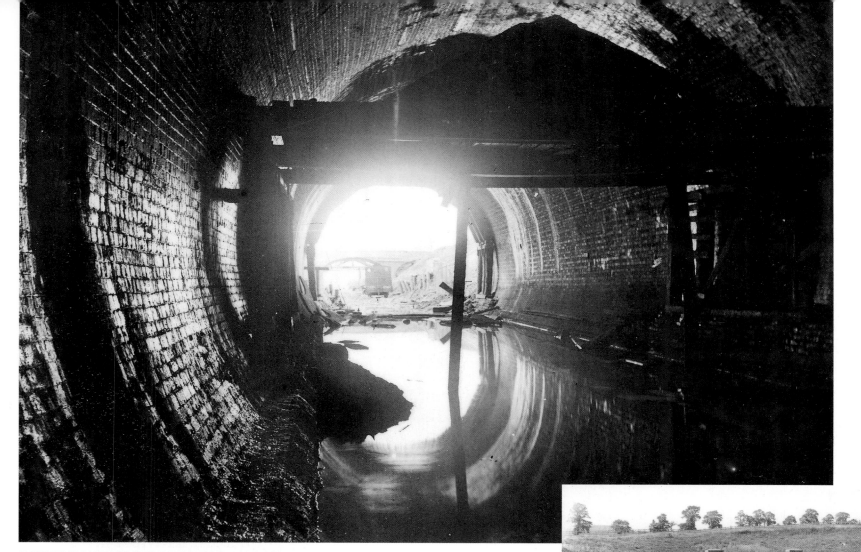

CATESBY, NORTHAMPTONSHIRE, 1897 AND c 1898

Catesby Tunnel only existed because the owner of Catesby House, Henry A Attenborough Esq, did not want to see smoke-belching trains crossing his land. He insisted that the railway tunnelled through Catesby Hill rather than excavate a cutting as originally planned. The first photograph looks south inside the tunnel during construction. For the many navvies who toiled in these wet and gloomy conditions beneath the Northamptonshire countryside, the completion of this 3,000yd-long tunnel must have been particularly satisfying. Construction took just over two years and used an estimated 30 million bricks. However, the finished tunnel was aesthetically pleasing, as this photograph of the south portal shows. The stone plaque at the centre of the parapet marks the completion of the tunnel in 1897. [L1776; L2429]

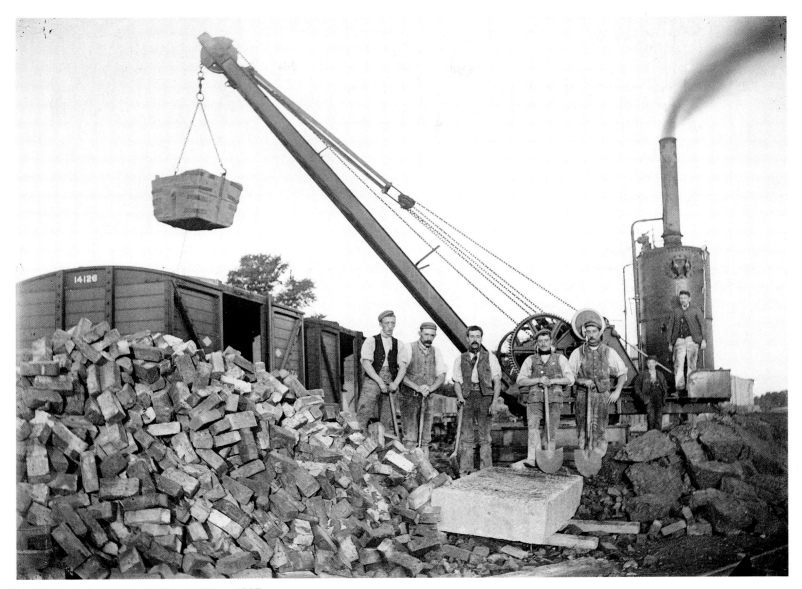

CHARWELTON, NORTHAMPTONSHIRE, *c* 1897

In this view navvies pause from their work and assemble for the camera beside a steam crane near the small village of Charwelton, just to the south of Catesby Tunnel. Around 40 of these cranes were employed along the route, as steam-powered machinery was an invaluable asset to the men responsible for the line's construction. This example has been fitted with a rudimentary wooden bucket and appears to be helping to move the vast pile of bricks in the foreground. Rail-mounted cranes were very versatile and many railway companies employed them in yards and depots, and even used larger versions in their breakdown trains. [AA97/05435]

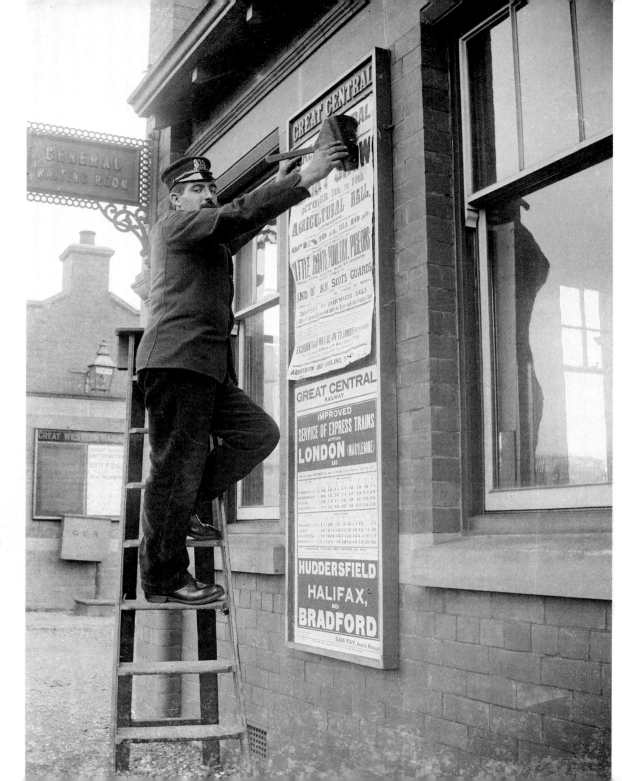

CHARWELTON, NORTHAMPTONSHIRE, 1904

Charwelton was another island platform with a single set of facilities, almost identical to those at Whetstone, Rothley and Ashby Magna. A railway employee sticks up a poster outside the waiting room advertising the county show. Another poster gives the improved timetable for the express service to London. [AA97/05211]

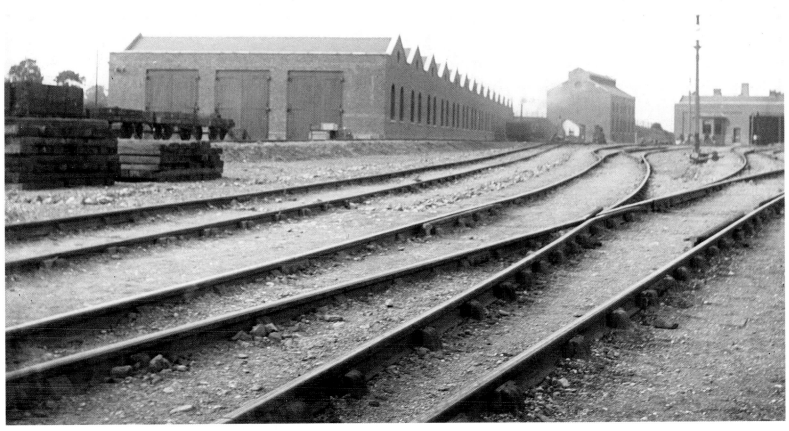

LOCOMOTIVE AND CARRIAGE SHEDS AT WOODFORD HALSE, NORTHAMPTONSHIRE, c 1900

These substantial facilities were provided at the GCR's motive power depot at Woodford Halse. Its central location and convenient links to other railway networks meant that the London Extension transformed this small Northamptonshire village into a thriving railway community. Indeed, the area occupied by the sheds, yards and sidings was probably not that much smaller than the village itself. The large gabled building is the carriage and wagon repair shop, immediately to the left of which ran the main line. Visible on the far right is a section of the engine shed, a still larger structure with room to house 60 locomotives. [L2914]

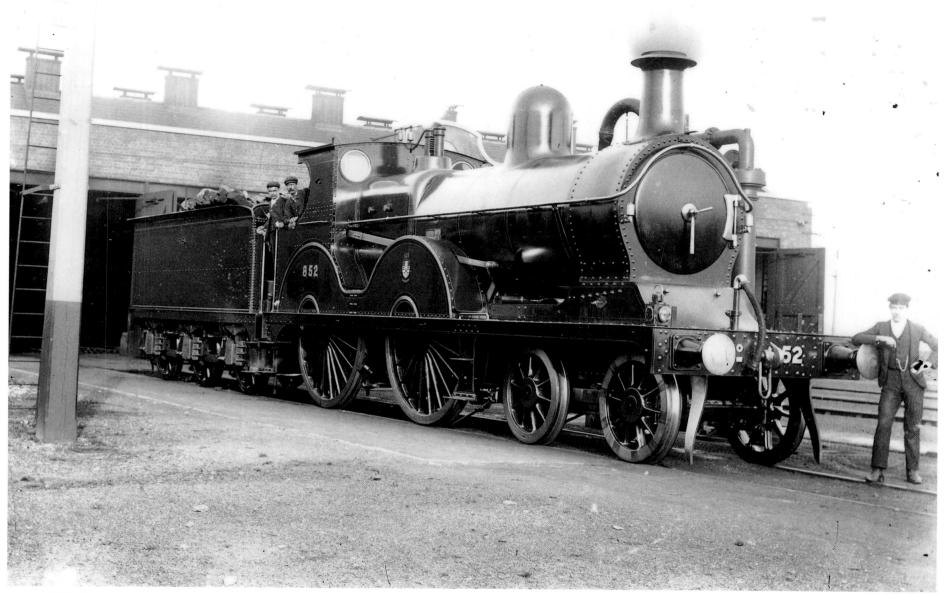

LOCOMITIVE AT WOODFORD HALSE, NORTHAMPTONSHIRE, *c* 1905

When John G Robinson took over as Chief Mechanical Engineer of the GCR in 1901, he soon took the existing locomotive fleet in hand. Most of these were former MSLR types designed by Thomas Parker and Harry Pollitt, which Robinson considered to be underpowered for the London Extension. One of his first actions was to rebuild some of the older locomotives to make them more suitable for the long haul of the new railway. One design to receive this attention was Pollitt's class 11A 4-4-0, which Robinson modified to include such trimmings as new chimneys and crank pin splashers. The example seen here at the Woodford Halse shed is No. 852 and was one of Robinson's rebuilds. [L2438]

KITES HARDWICK, WARWICKSHIRE, JUNE 1901

A woman stands at the gate to an 18th-century brick house in Kites Hardwick. This was Mrs Caroline Lickorish's licensed premises; *Kelly's Directory* lists her as a beer seller and grazier. At the time it was not unusual for a rural publican to augment his or her living with another occupation. [AA97/06100]

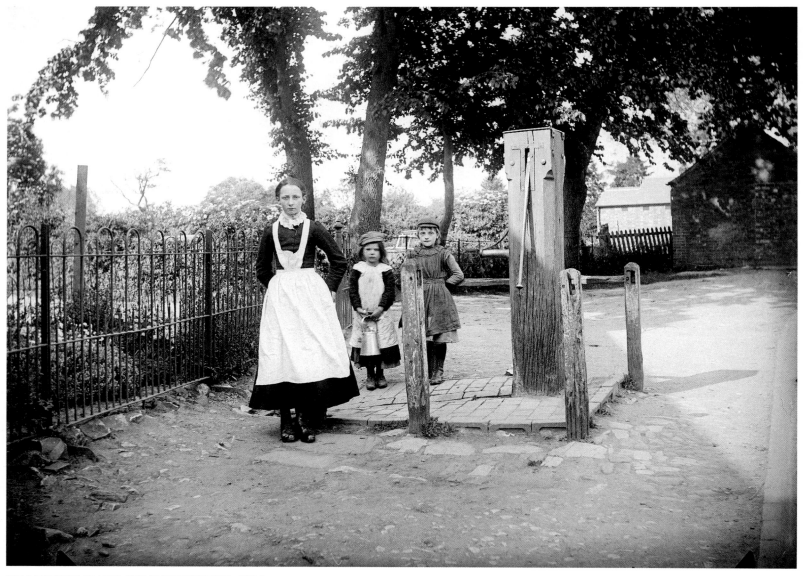

GRANDBOROUGH, WARWICKSHIRE, 1901

Domestic service was a major employment outlet for girls and women from the 17th to the early 20th centuries, employing about 1.7 million women in 1901. In the days before labour-saving devices, the hours were long and the work was heavy. Here a young servant girl in Grandborough has been sent to get water from the village pump. Before houses had a mains supply this was a heavy, daily chore as all the water required for washing and cooking had to be fetched. Two children are on the same errand. Grandborough was served by a branch of the Metropolitan Railway from Quainton Road to Verney Junction. [AA97/05230]

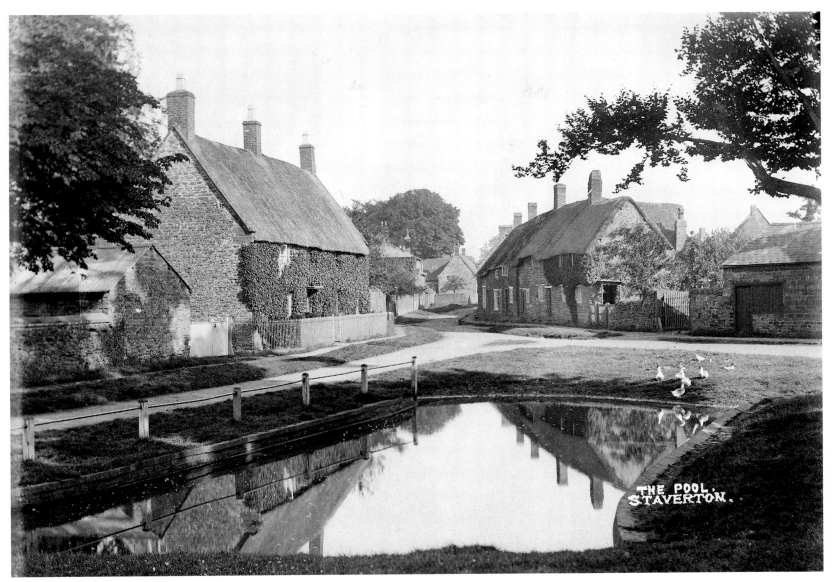

THE POOL, STAVERTON.

THE GREEN, STAVERTON, NORTHAMPTONSHIRE, 1896–1910

Staverton is a typical village of the limestone belt. Marlstone – a form of iron-rich, shelly limestone – was quarried in the village and rubblestone (roughly shaped blocks) was used locally for building. The streets are lined with thatched cottages and ducks waddle beside the pond on the village green (now filled in). A picturesque scene such as this disguises the lack of basic facilities, the hard manual labour and the poverty that were the experience of many country people until well into the 20th century. [BB98/05899]

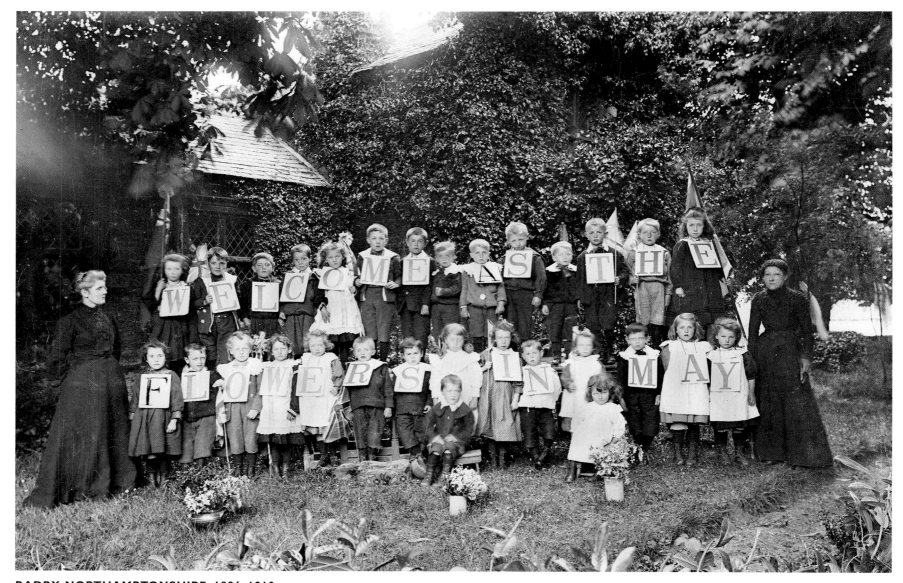

BADBY, NORTHAMPTONSHIRE, 1896–1910

'Welcome as the flowers in May.' Pupils at Badby village school rehearse a 'welcoming' tableau under the watchful eye of their teachers. Unfortunately Newton did not record which distinguished guest they were preparing this tableau for. The village school was built *c* 1812 as the gift of the Dowager Lady Knightley of Fawsley (the Knightleys were a local landowning family). Her architect was James Wyatt. [BB98/01626]

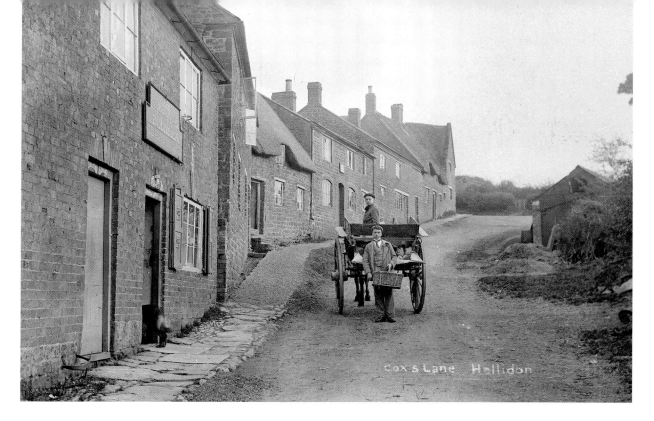

HELLIDON, NORTHAMPTONSHIRE, c 1904

A delivery cart outside the Cash Supply Stores in Cox's Lane, Hellidon, is about to go on its rounds in the photograph above. The shop was a baker, grocer and general store, and the proprietor was R Haycock. Its name suggests that credit was not given. This photograph pre-dates the great fire of August 1904 when the two thatched cottages at the top of the street and a third thatched cottage halfway up the hill were destroyed. Newton returned to photograph the scene after the fire. The damage can clearly be seen in the left-hand photograph, though some houses seem to have been repaired. [BB98/06341; BB98/02452]

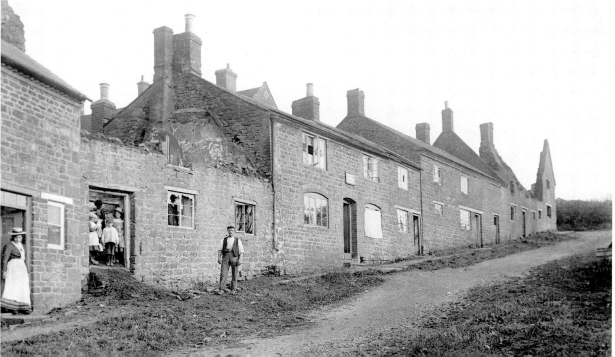

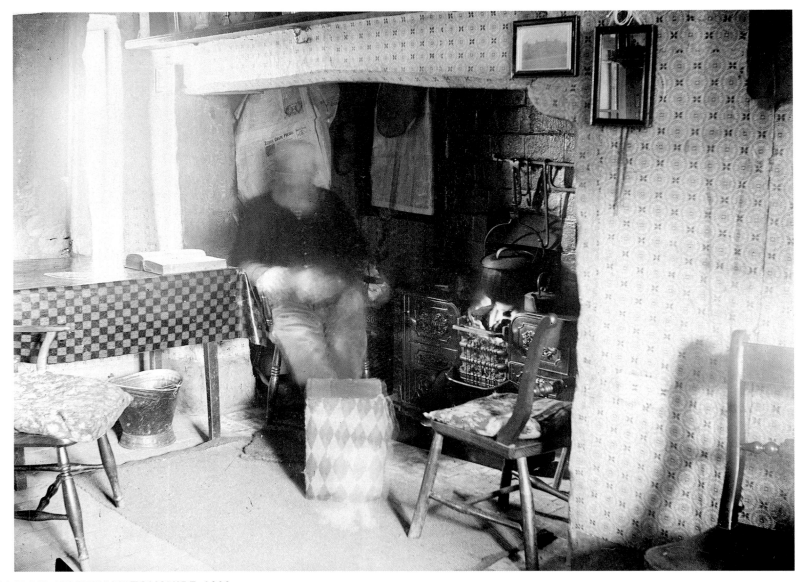

HELLIDON, NORTHAMPTONSHIRE, 1900

Mr Billingham sits next to the stove in a private room in Hellidon post office. Photographs of domestic interiors are rare at this date, due in part to problems of lighting and exposure time, which explains why Mr Billingham is blurred. The picture shows how sparsely furnished the average working person's house must have been. It matches well with Flora Thompson's account of rural life at the end of the 19th century: 'In nearly all the cottages there was but one room downstairs, and many of these were poor and bare, with only a table and a few chairs and stools for furniture and a superannuated potato sack thrown down by way of a hearthrug' (1985, p 19). [AA97/05798]

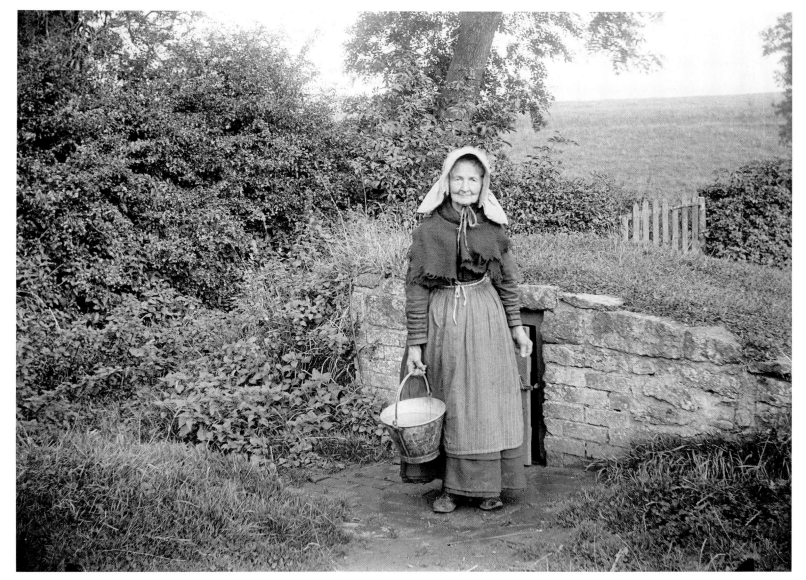

HELLIDON, NORTHAMPTONSHIRE, JULY 1902

An elderly woman in traditional costume and wearing a sun-bonnet collects water from the village pump. This daily domestic chore was regarded as 'women's work'. [AA97/05936]

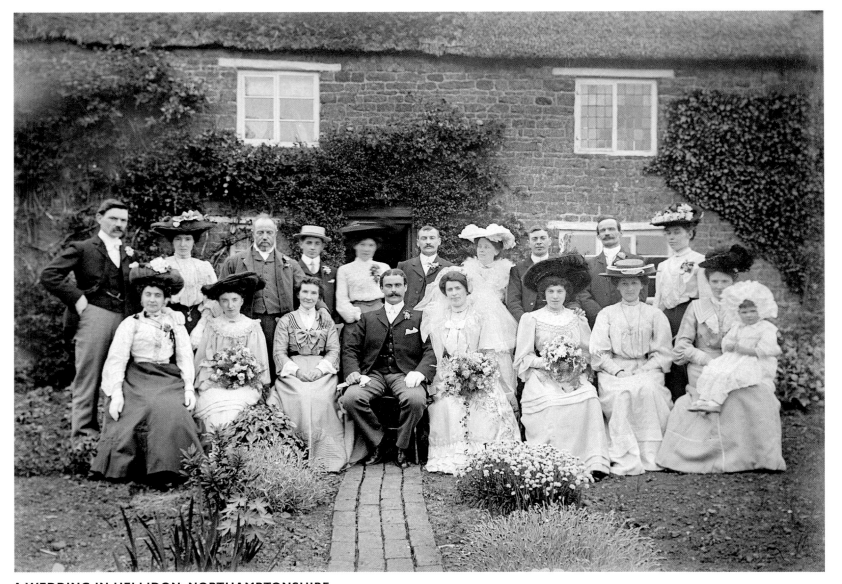

A WEDDING IN HELLIDON, NORTHAMPTONSHIRE

A wedding party poses for a photograph in the front garden of a traditional thatched cottage in Hellidon. Would there have been any wedding photographs if Newton had not been in the area? Occasions such as this were an opportunity for people to show off their best clothes. Wide-brimmed hats were the fashion for ladies. [BB98/02390]

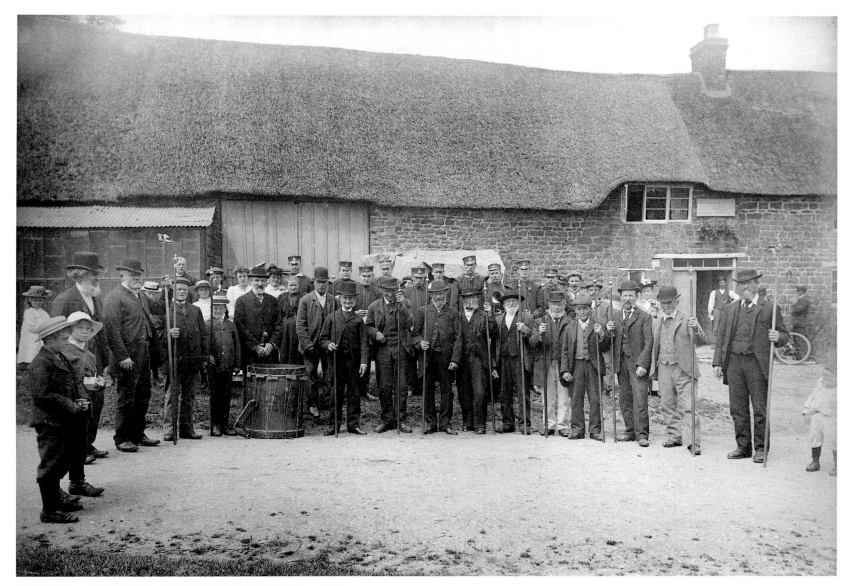

RED LION, HELLIDON, NORTHAMPTONSHIRE, *c* 1905

A procession assembles outside the Red Lion Inn, perhaps on the occasion of the centenary of the Institute (a Friendly Society) in 1905. The men are in their best suits and many are armed with staffs of office (rather like churchwardens' staffs). The parade will presumably be led by the uniformed band in the back row. [BB98/01646]

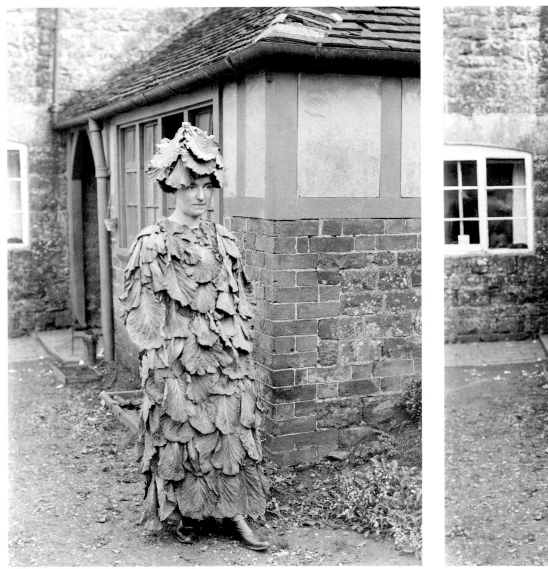
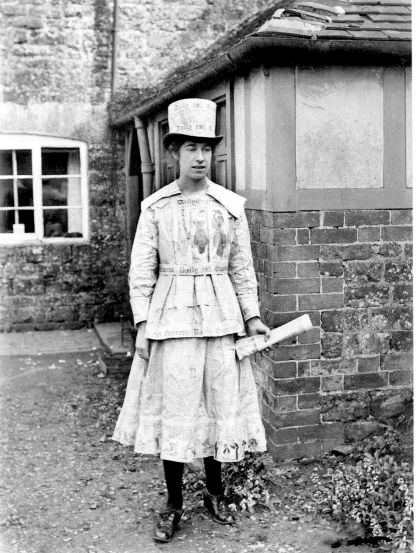

HELLIDON, NORTHAMPTONSHIRE, 1896–1910

Two women are in fancy dress outside the old school house (now the village hall) in Hellidon – one dressed in cabbage leaves, the other as the *Morning Post* newspaper. These are just two of a series of people in fancy dress whom Newton photographed here; unfortunately the occasion is not known. [BB97/08307; BB97/08308]

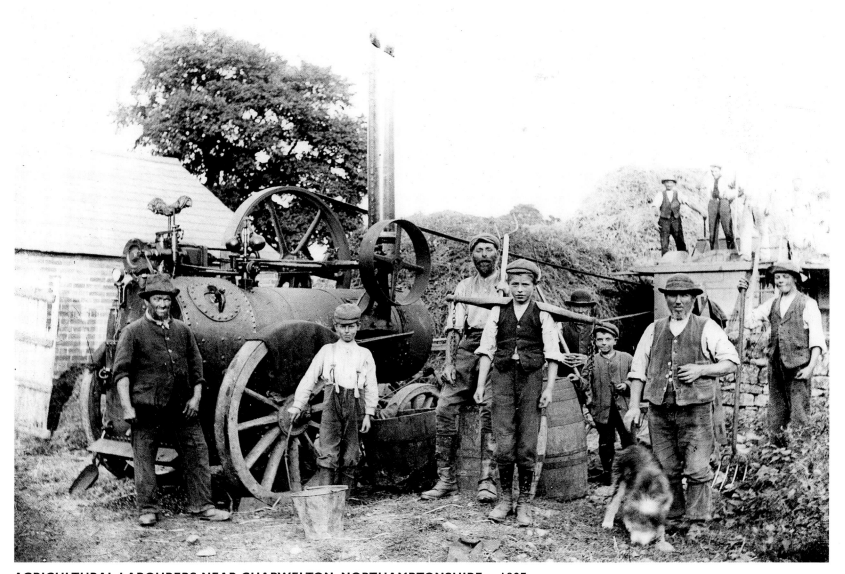

AGRICULTURAL LABOURERS NEAR CHARWELTON, NORTHAMPTONSHIRE, *c* 1897

A group of farm labourers poses with a steam engine and threshing machine. Portable steam engines first appeared on the farm in the 1840s and began the process of mechanisation, which has resulted in the numbers employed on the land falling from 27 per cent of the workforce in 1851 to less than 1 per cent today. [L1178]

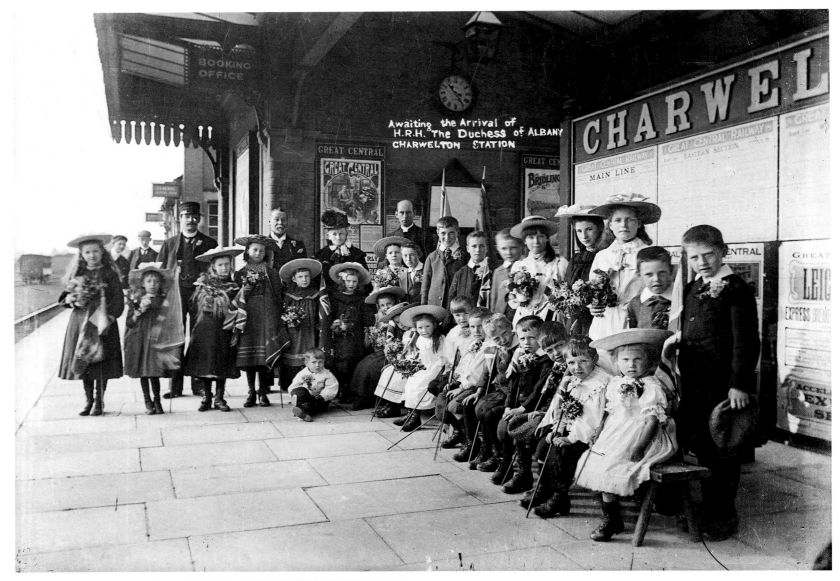

CHARWELTON STATION, NORTHAMPTONSHIRE, 18 MAY 1905

Schoolchildren in patriotic mood and their best clothes form a welcoming party for HRH the Duchess of Albany on Charwelton Station. Born Princess Helena of Waldeck-Pyrmont, she was the widow of Prince Leopold, Queen Victoria's youngest son, who died in 1884 leaving two children. The Duchess was making a social visit to nearby Fawsley Hall, the home of Lady Knightley, her lady-in-waiting. [BB98/05907; BB98/05914]

ARRIVAL OF H.R.H. THE DUCHESS OF ALBANY, CHARWELTON, MAY 18 1905.

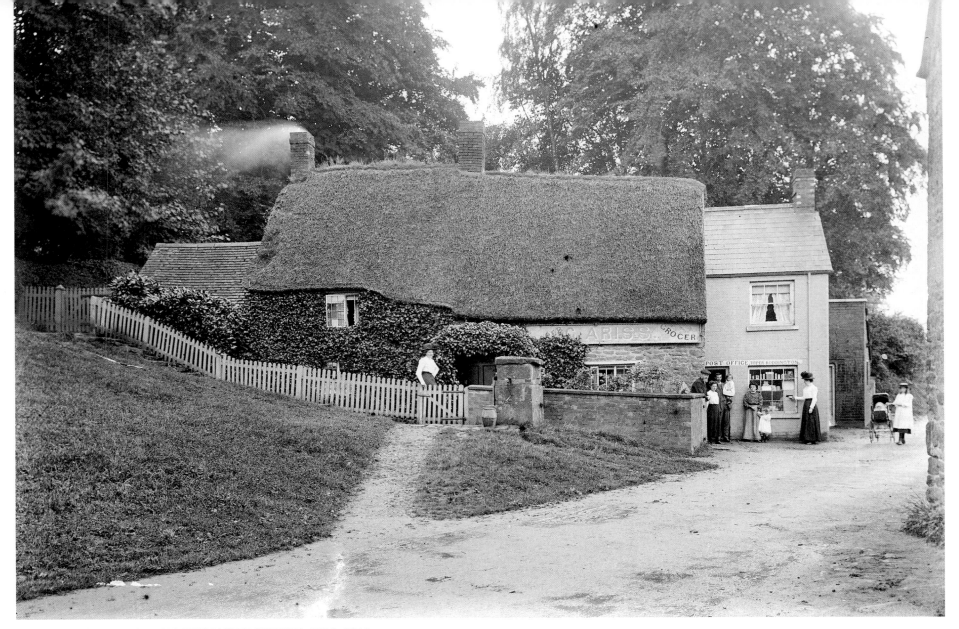

UPPER BODDINGTON, NORTHAMPTONSHIRE, 1896–1910

George Ariss was a boot and shoemaker and grocer, and also managed the post office. Boot and shoe manufacture was widely but unevenly distributed across the country, with a marked concentration in Northamptonshire and Leicestershire. Although the industry was based in the main towns, much of the skilled manual work was undertaken by outworkers in the smaller villages where it could be done more cheaply. Outworking remained an integral part of the factory system for boot and shoe manufacture until the early years of the 20th century. [BB98/05966]

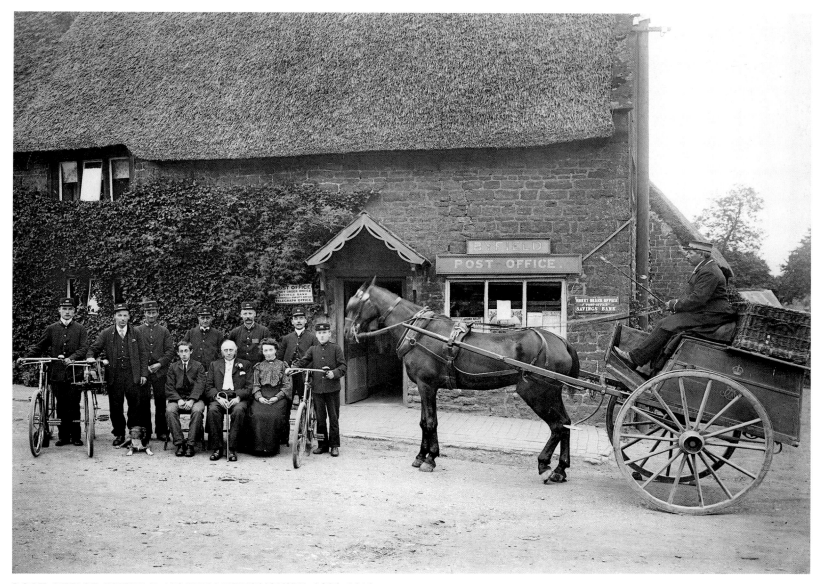

POST OFFICE, BYFIELD, NORTHAMPTONSHIRE, 1896–1910

The postmaster and his staff pose outside the post office in Byfield. Three of the postmen hold their bicycles while a fourth drives the carrier's cart. Social distinctions are finely marked in dress: the postmaster wears a dark suit with a rose in his buttonhole, his wife or female assistant is smartly dressed, his clerk wears a jacket and tie, and the braid on the men's uniforms indicates their gradations of status. [BB98/06055]

Contract No. 5:
Woodford Halse to Brackley

This section of the line ran from Woodford Halse to Brackley, both in Northamptonshire. It was built by Walter Scott & Co of Newcastle-upon-Tyne and involved the construction of two major viaducts. The Helmdon Viaduct carried the GCR across the Northampton & Banbury Railway, while the 22-arch Brackley Viaduct carried it over the Great Ouse. In June 1900 a branch line from Culworth Junction was opened to make a valuable connection with the Great Western Railway at Banbury, Oxfordshire.

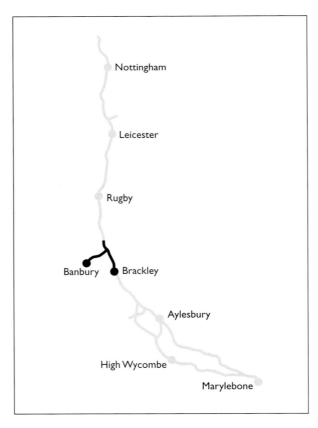

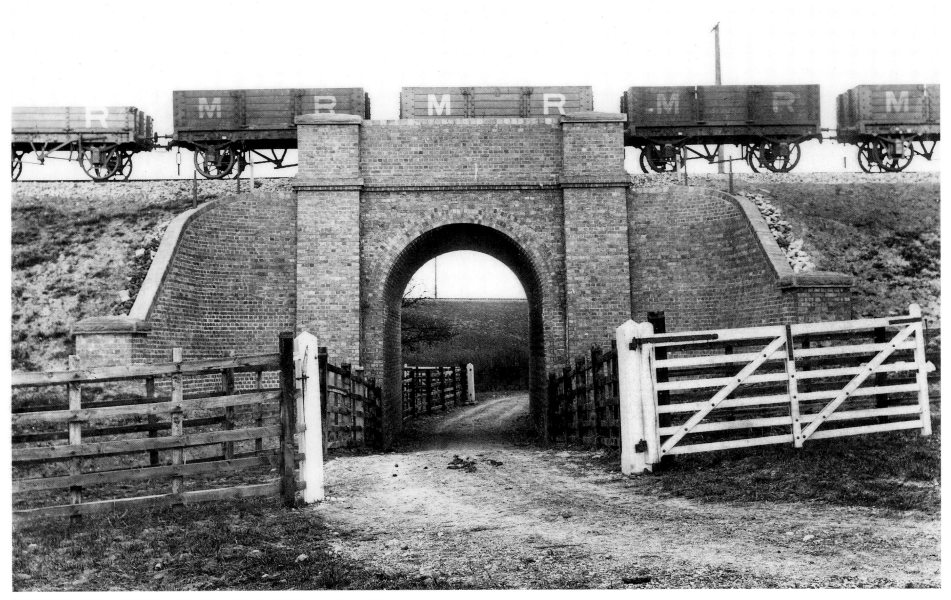

FOXHALL FARM, EYDON, NORTHAMPTONSHIRE, APRIL 1900

This is the Foxhall Farm occupation underbridge near Culworth Junction, the point at which the Banbury Branch met the main line of the London Extension. The branch line was completed less than two months after this picture was taken and included two simple halts – Eydon Road and Chacombe Road – which served the communities of Thorpe Mandeville and Chacombe. The bridge is a typical example of a brick-arch occupation bridge that, like the steel-girder versions, is gated to prevent cattle wandering. The train crossing the bridge is of interest as it is made up of Midland Railway mineral wagons, not GCR or GWR as might be expected. [L1873]

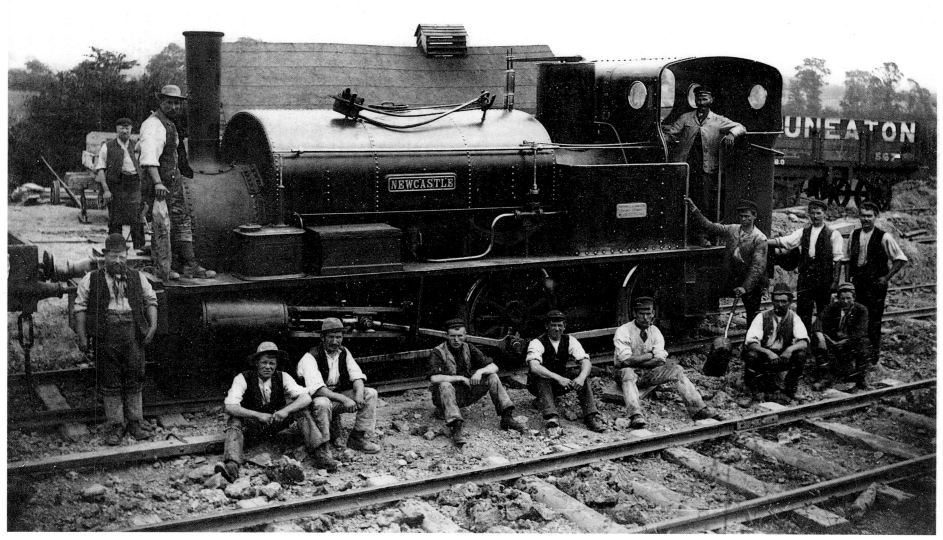

LOCOMOTIVE NEAR CULWORTH, NORTHAMPTONSHIRE, 1896

A Hudswell Clarke & Co 0-6-0 saddle tank locomotive, *Newcastle*, is pictured with her crew and a team of navvies at a contractor's yard near Culworth. Hudswell Clarke, like Manning Wardle and the Hunslet Engine Co, hailed from Leeds and produced a number of tough and powerful locomotives that could be found on the London Extension contracts. This example was No. 237 and was built in 1882. Although not as elegant or graceful as its Manning Wardle counterparts, *Newcastle* probably found favour with locomotive crews because of its wrap-over style cab. Unusual among the 0-6-0 contractors' locomotives working on the London Extension, *Newcastle* has outside cylinders and Stephenson's link valve gear. [L1055]

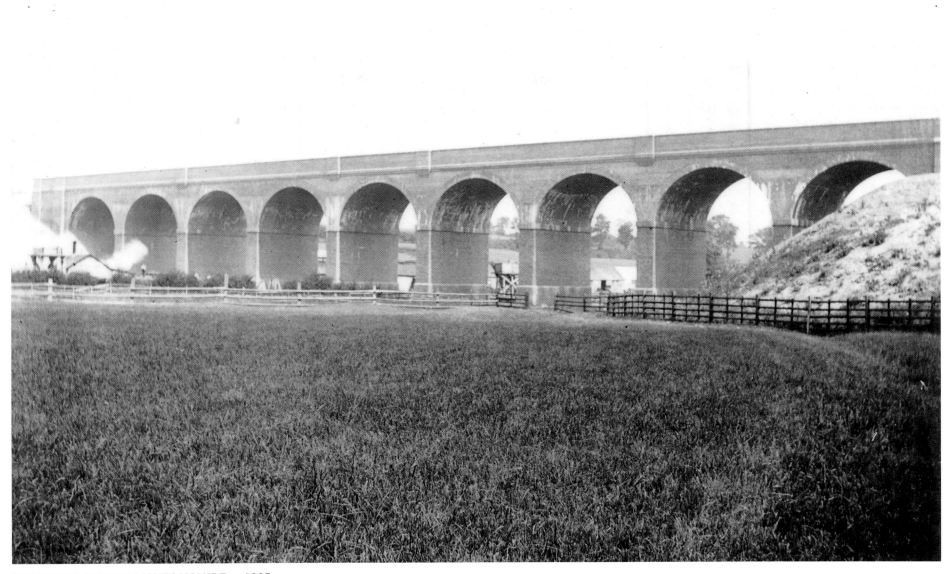

HELMDON, NORTHAMPTONSHIRE, c 1897

The handsome nine-arch Helmdon Viaduct, completed in 1897, lay to the north of Helmdon Station and a short distance to the west of the village itself. It was built of blue engineering brick and carried the London Extension across the Northampton & Banbury Railway (later Stratford & Midland Junction Railway) line from Cockley Brake Junction to Towcester. Helmdon Viaduct still stands today, even though the lines that travelled over and under it have both long since closed. [L2766]

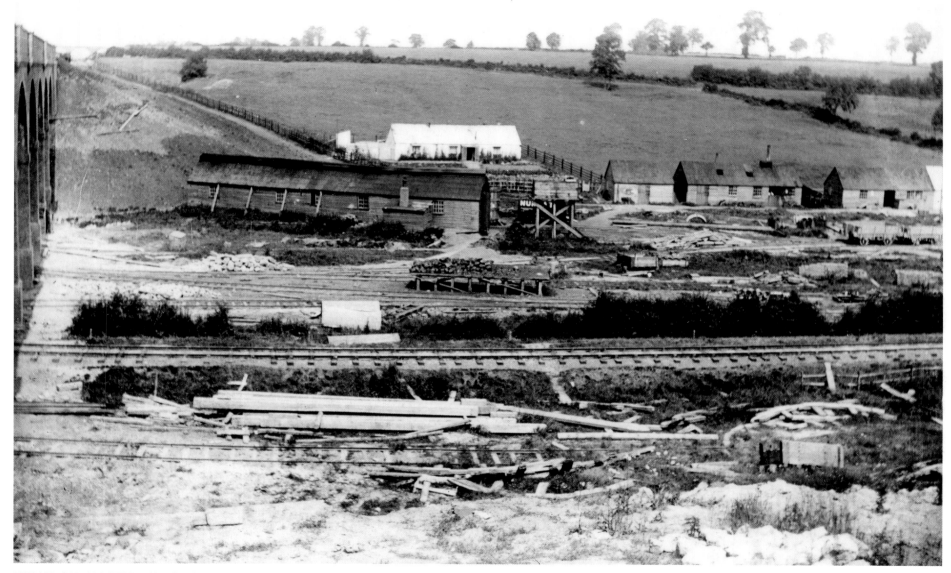

HELMDON, NORTHAMPTONSHIRE, c 1897

This view of Walter Scott & Co's yard provides a wealth of information about railway construction at the turn of the 20th century. The depot was at the foot of Helmdon Viaduct (seen on the left), and contained many huts and sheds for working and accommodation. A network of contractor's railway tracks pass under the arches of the viaduct, some passing the coaling stage in the centre of the picture and others leading to the water tower next to the long shed. The yard was in use for four years between 1894 and 1898, yet today there is no trace that it ever existed. [L1220]

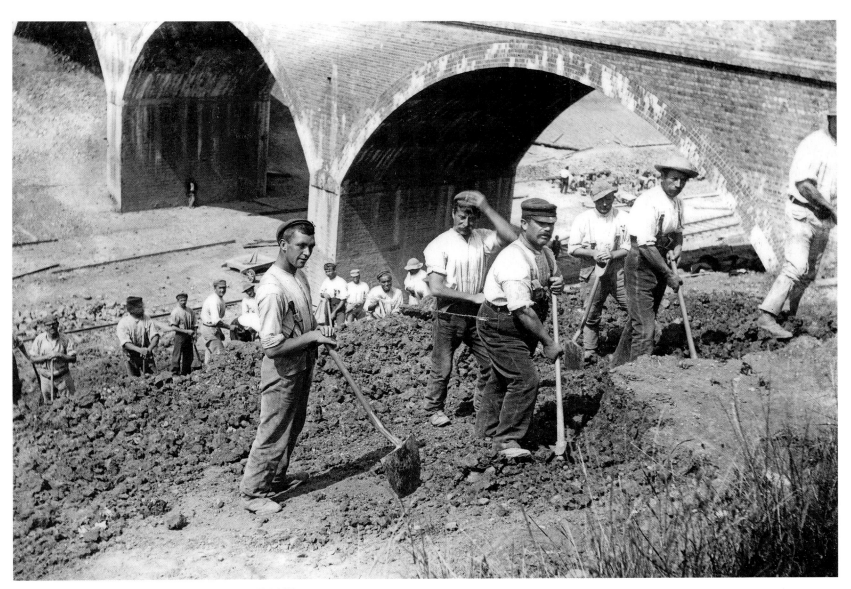

HELMDON, NORTHAMPTONSHIRE, JULY 1897

A bank-trimming gang busy themselves on the cutting close to Helmdon Viaduct. The photograph demonstrates why manpower was still superior to the newfangled steam machines that made such an impact on the construction of the London Extension. Getting the trim of an embankment or cutting correct was simply a matter of doing it by hand. Once the steam excavators had cut out the rough formation, the armies of navvies would move in and create straight and smooth cutting sides using little more than picks, shovels and well-trained eyes. The results were near perfect and always looked as if a machine had done the work! One of the many three-arch bridges can be seen behind the gang. [L1241]

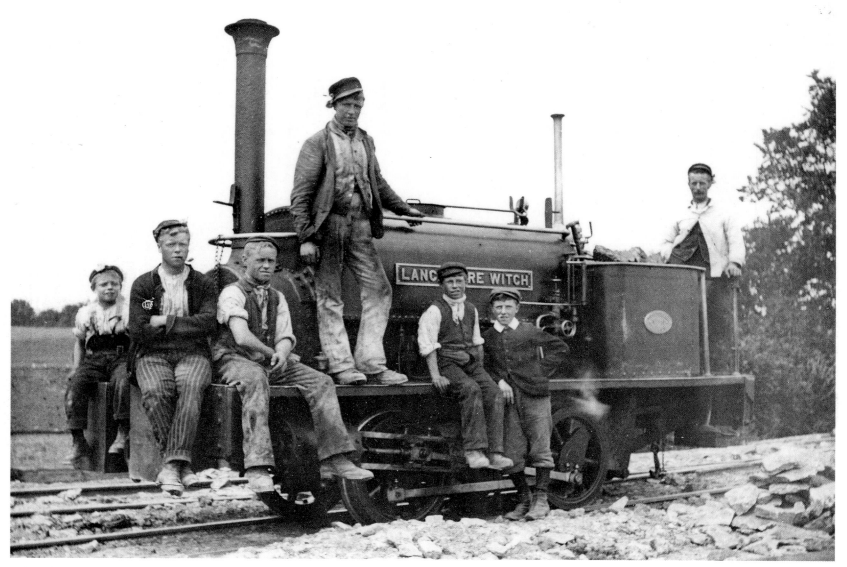

NARROW-GAUGE LOCOMOTIVE NEAR BRACKLEY, NORTHAMPTONSHIRE, JULY 1896

This diminutive locomotive – *Lancashire Witch*, No. 614 – is a Manning Wardle 3ft-gauge 'C' class 0-4-0 saddle tank of 1876. *Lancashire Witch* was the only narrow-gauge locomotive used on the construction of the London Extension. She had previously been owned by Logan & Hemingway before moving to Braddock & Matthews in Southport where she received her name. Narrow-gauge railways were invaluable on contracts such as these where space and weight restrictions were prohibitive. When photographed, the locomotive was being used to construct the station approach at Brackley. Of the seven people posed on the locomotive, five are only boys. [L1099]

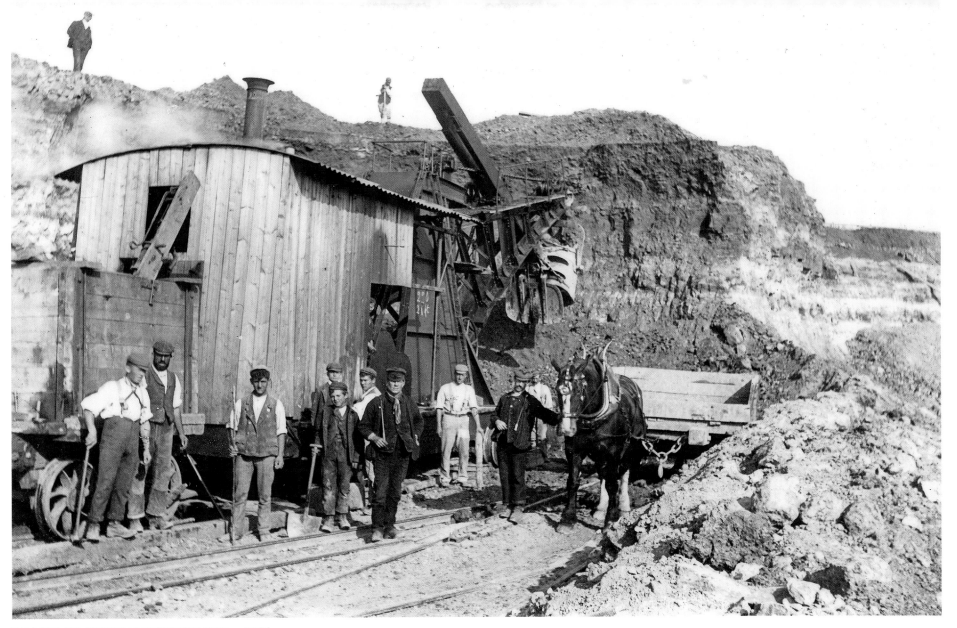

BRACKLEY, NORTHAMPTONSHIRE, *c* 1896

One of the Dunbar-Ruston steam navvies makes headway on the site of Brackley station yard in the southern reaches of Northamptonshire. The photograph illustrates how machinery, men and horses worked side by side on the GCR's construction. The excavator's wooden cab, although a fairly tidy example, is a contractor's modification built to afford the three men operating it a modicum of protection. One can only imagine the noise, heat and dirt that must have bounced off the inside of that timber shelter. What the navvies, many of whom would have never seen a camera before, thought of young Newton as he clambered over mounds of earth to take his pictures is anyone's guess. [L1570]

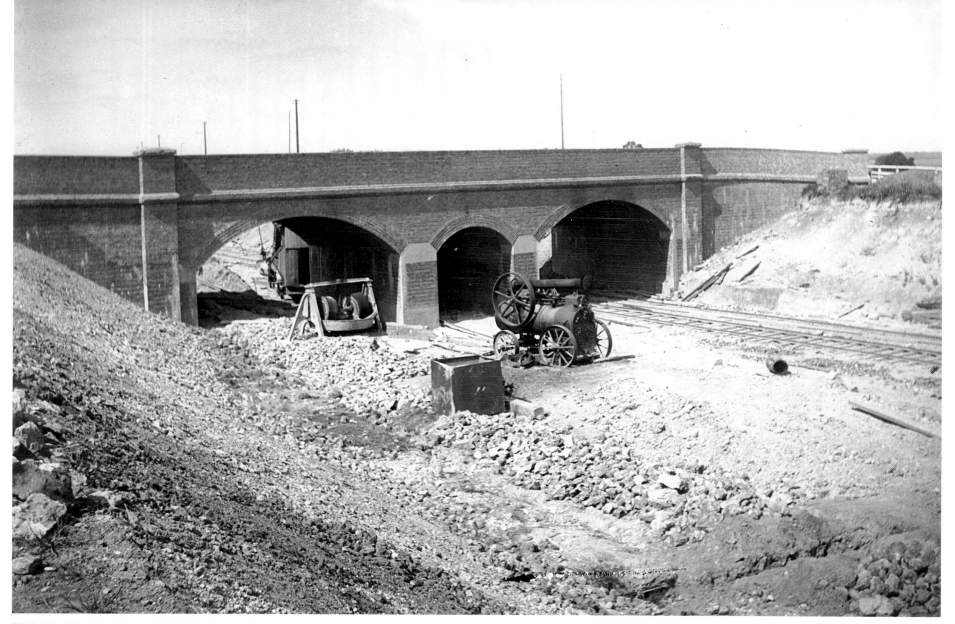

BRACKLEY, NORTHAMPTONSHIRE, 1897

This photograph shows the brick-arch bridge that lay at the northern end of the station at Brackley. In common with the larger stations at Loughborough and Rugby, Brackley was built to the familiar island-platform design. However, it was unique as the platform was not reached by a staircase leading down from the centre of the bridge, but from a footbridge that spanned the Down main line, which would eventually run through the left arch of the bridge. Moreover, the booking hall was built on an embankment overlooking the line, rather than on the bridge as at Loughborough and Rugby. Note the portable steam engine at the centre of the picture, used to drive the mechanical stone crusher that is in front of the left-hand arch. [L2894]

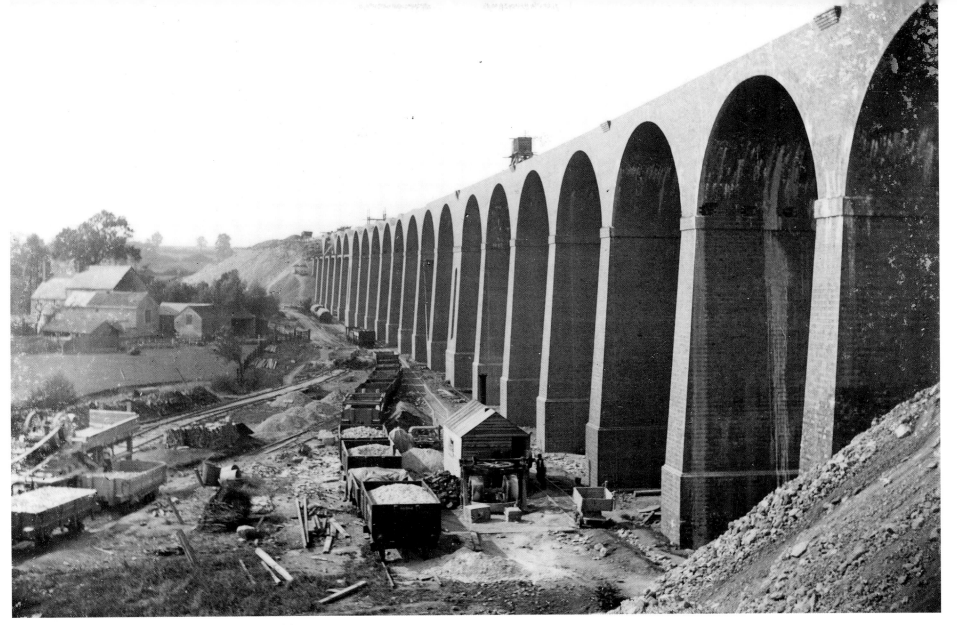

BRACKLEY, NORTHAMPTONSHIRE, JULY 1896

This is the west side of the impressive viaduct at Brackley, seen here nearing completion. Built to carry the railway across the Great Ouse and its flood plain, the 22-arch viaduct measured 258 yards in length and was perhaps the most striking piece of architecture on the whole of the London Extension (although some might argue that this honour lies with Nottingham Victoria Station). Several lines of the contractor's temporary railway carry laden mineral wagons along the valley floor. Regrettably, the viaduct was demolished in 1978. The building on the left of the picture is St Peter's Mill. [L2431]

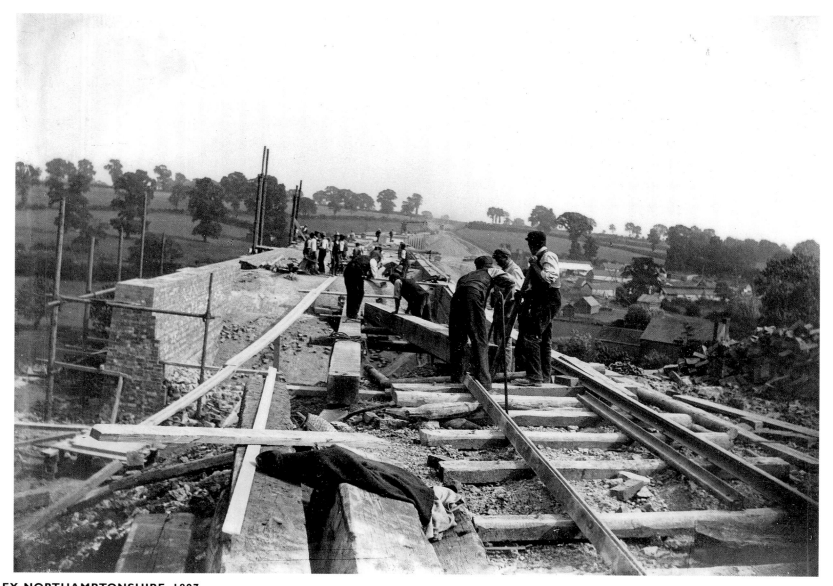

BRACKLEY, NORTHAMPTONSHIRE, 1897

On top of Brackley Viaduct one got an entirely different perspective from the one seen from the valley floor. This view looks south at the cluster of navvies constructing the viaduct. They appear to be filling in the space between the vaults of the arches, positioning huge timber beams that may have been used to support the contractor's railway. To the left is a narrow planked walkway used for wheeling barrows on and off the viaduct. Looking closer at the contractor's railway, the photograph shows how these lines were laid with great speed, little accuracy and dubious timber for sleepers. When the viaduct was demolished in 1978, the quality of its build meant that it took over a year to remove it completely. [L1243]

ST PETER AND ST PAUL, MAIDFORD, NORTHAMPTONSHIRE, SEPTEMBER 1903

This is the interior of the church of St Peter and St Paul, looking east. Lighting was difficult in these large buildings, which often had small windows and stained glass. A row of oil lamps hang down the centre of the nave while the pulpit is lit by two candles. The evening service was frequently held in the mid-afternoon to get the benefit of the daylight. The metal grating in the nave floor shows that this church had heating. [AA97/05624]

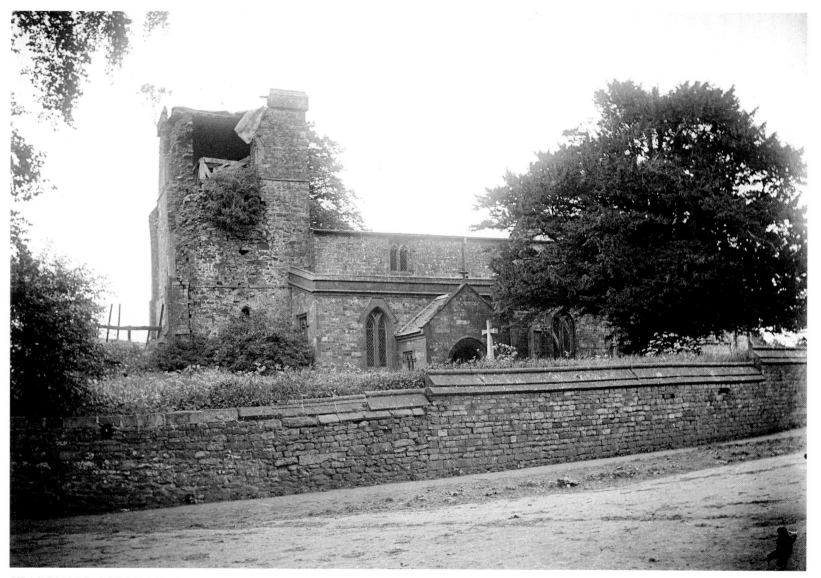

ST LEONARD, ASTON LE WALLS, NORTHAMPTONSHIRE, SEPTEMBER 1903

The care and maintenance of historic buildings is an ongoing responsibility, but the 13th-century church of St Leonard may have been more demanding than most. Restored in the 1870s and again in 1881–2, it clearly suffered a subsequent disaster which the parish seems to have lacked the resources or enthusiasm to address. Part of the tower wall and roof have fallen away to reveal the bell frame and a bush has grown in the opening. The bare rafters of the west porch are also visible to the left. With wonderful understatement, the Methuen *Little Guide* for Northamptonshire (1906) states, 'The west tower has fallen into decay.' [AA97/05643]

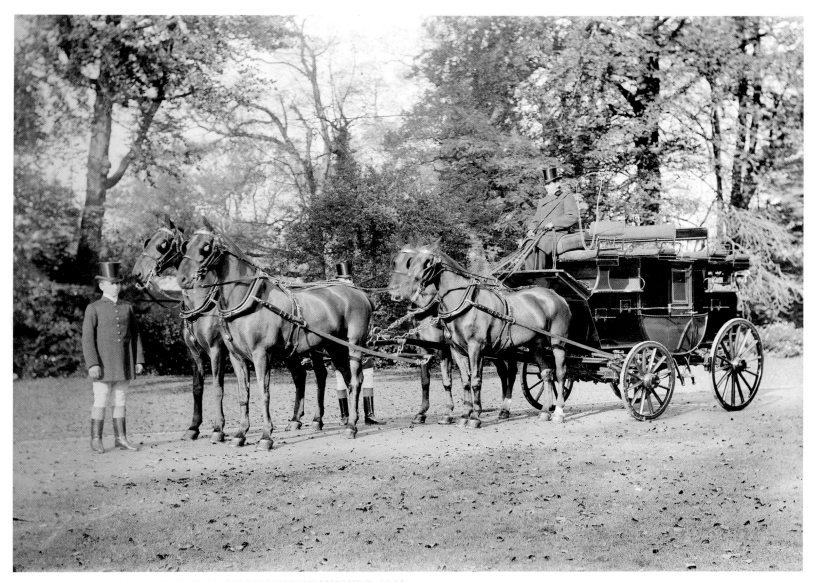

FARNBOROUGH HALL, FARNBOROUGH, WARWICKSHIRE, 1902

This state coach with a team of four, a driver and two footmen was photographed at Farnborough Hall, a mid-18th-century house in Warwickshire. The home of the Holbech family, Farnborough Hall is an example of the elegant classical taste of the Georgian period. Such great houses required a small army of servants to manage them and, like this extravagant style of transport, were soon to be a thing of the past. [BB97/08158]

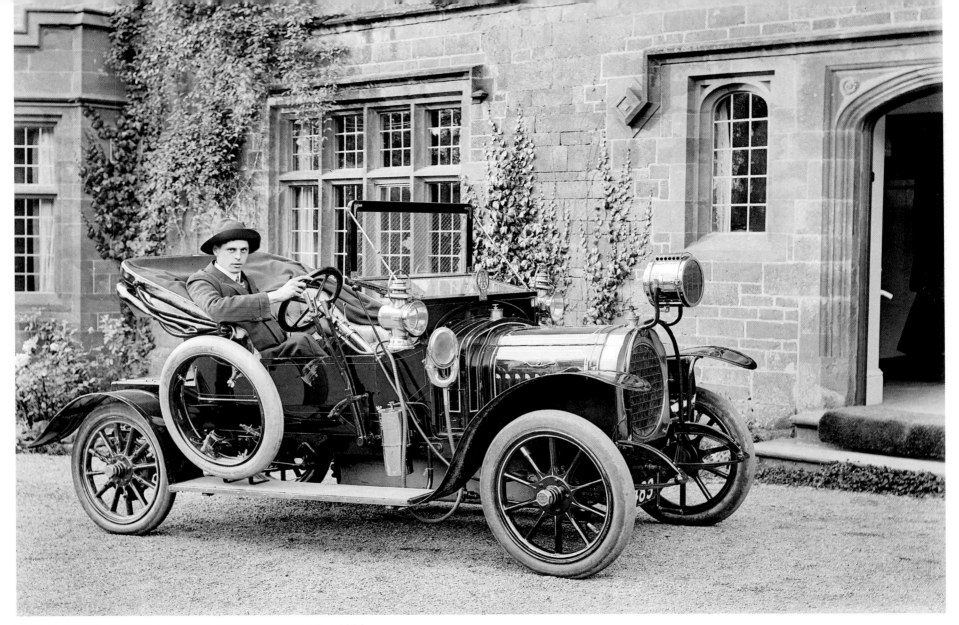

THE GRANGE, FARNBOROUGH, WARWICKSHIRE, c 1906

A young gentleman shows off his new car – a French-made Chenard-Walcker – outside The Grange in Farnborough. Private cars were very unusual at this date and were mostly built to order. This example displays the familiar 'AA' badge. The Grange is a substantial house built in the local ironstone. It has a surviving 16th- and 17th-century core, but was considerably altered in the 18th and 19th centuries. *Kelly's Directory* for 1904 records the Misses Prater as householders. [BB97/08148]

The BANBURY CROSS BANBURY,

BANBURY, OXFORDSHIRE, 1896–1910

Banbury Cross stands in the Horsefair with the distinctive tower of St Mary's Church behind. It has become well known as a result of the nursery rhyme, 'Ride a cock horse to Banbury Cross'. Although it is in the style of a 13th-century Eleanor Cross, it was erected in 1859 to designs by John Gibbs of Oxford to celebrate the marriage of Victoria, Princess Royal, to Frederick, Crown Prince of Prussia. Statues of Queen Victoria, Edward VII and George V were added in 1914 on the occasion of George V's coronation. [BB98/05476]

MORETON PINKNEY, NORTHAMPTONSHIRE, SEPTEMBER 1904

A boy stands in the gateway to Moreton Pinkney Manor. Gatehouses were the first thing a visitor to a great house saw, so they were often designed to impress. This turreted lodge and gateway, with the arms of the Barons Sempill above, were built in 1859 by E F Law and the house itself was built between 1859 and 1870. The Misses Grey of Moreton Pinkney Manor were among several local landowners who contributed to the welfare of the navvy community on their doorstep, in their case by placing a coffee room in the village at the disposal of the London Railway Extension Mission. It was later used as a reading room. [BB98/06350]

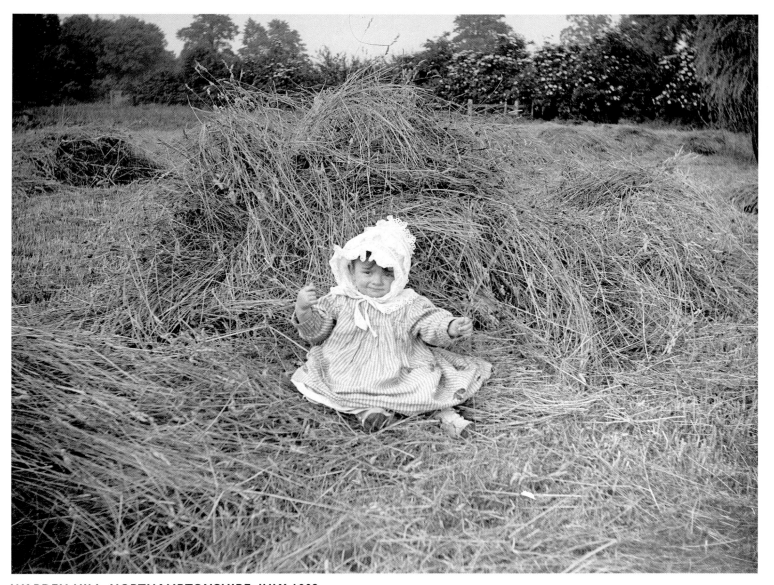

WARDEN HILL, NORTHAMPTONSHIRE, JULY 1902

A toddler is propped up against a haycock at Warden Hill, near Chipping Warden, while its parents work. The casual work available for women and older children at harvest time was an important source of income for many rural families. [AA97/05963]

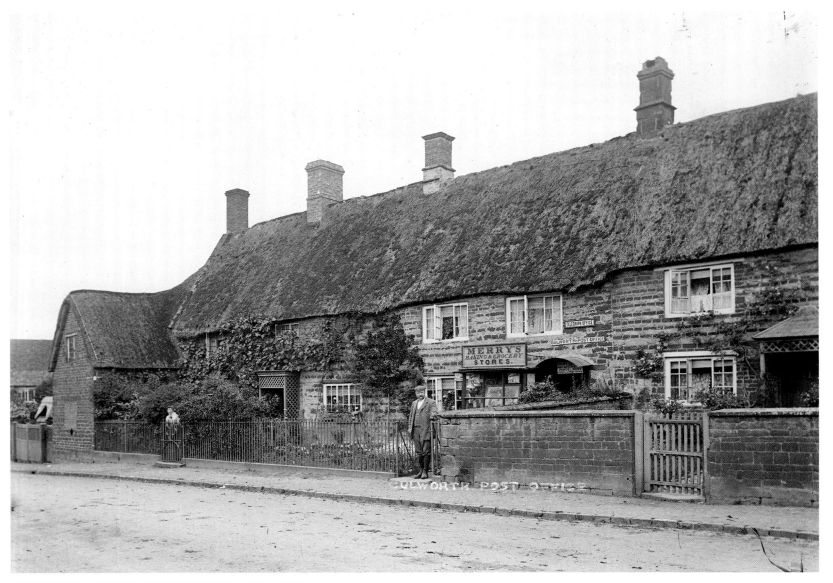

CULWORTH, NORTHAMPTONSHIRE, 1896–1910

The proprietor stands at the gate outside Merry's Baking and Grocery Stores in Culworth. Before travel became commonplace, the village shop had to supply all those everyday items that were not produced locally. The shop, one in a terrace of comfortable-looking cottages, also served as the post office and telegraph office. [BB98/05937]

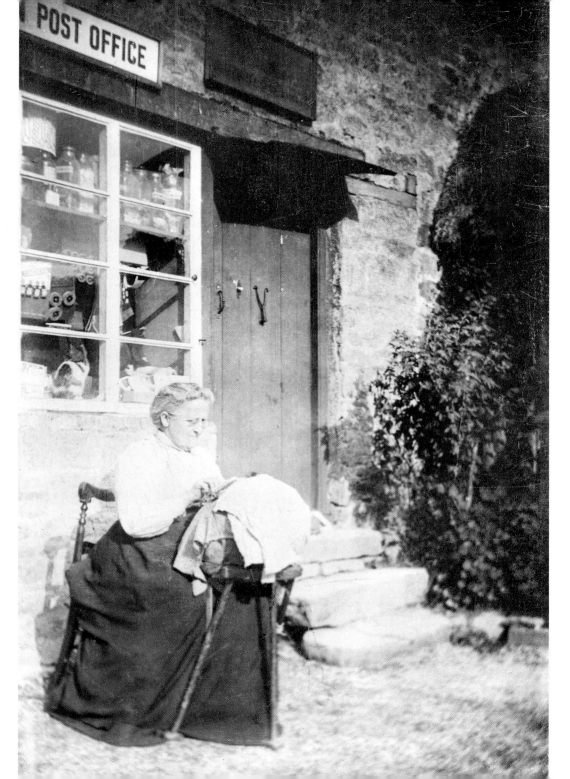

WESTON, NORTHAMPTONSHIRE, MAY 1907
Lace making was a traditional skill for women and could be sold to augment the household income. Mrs Lucy Ann Owen, the sub-postmistress at Weston, takes advantage of a slack time to sit outside the post office in the High Street on a warm early summer's day and do some craftwork. [BB97/08193]

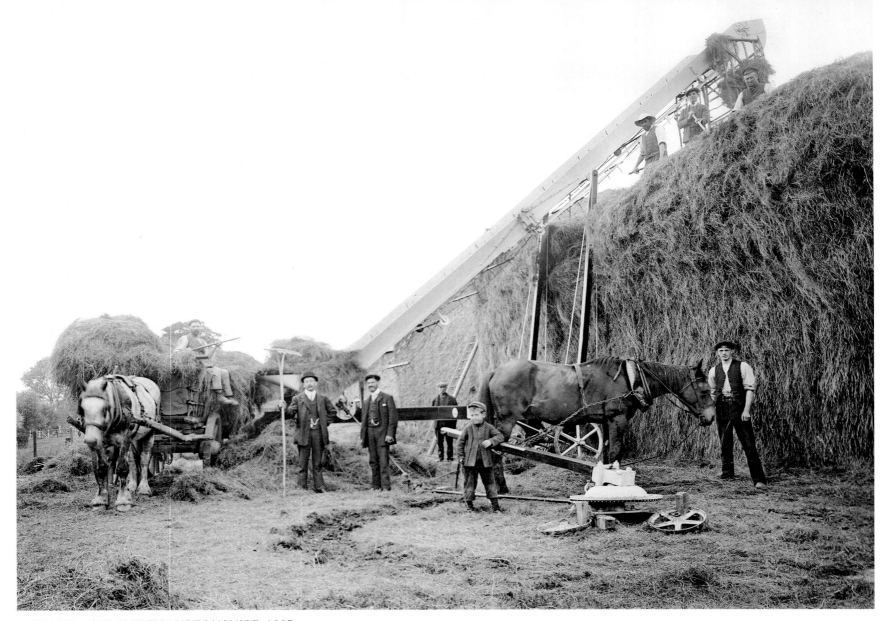

WEEDON LOIS, NORTHAMPTONSHIRE, 1907

The horse engine (also known as a horse gin or whim) was used to power machinery on the farm from at least the early 19th century. It was mechanically simple: one or more horses turned a beam connected via a gear to a drive shaft that powered the machinery. Here the portable horse engine in the foreground powers an elevator, which is being used to build a huge haystack near Weedon Lois. Despite this help, the work is labour intensive. [BB97/08196]

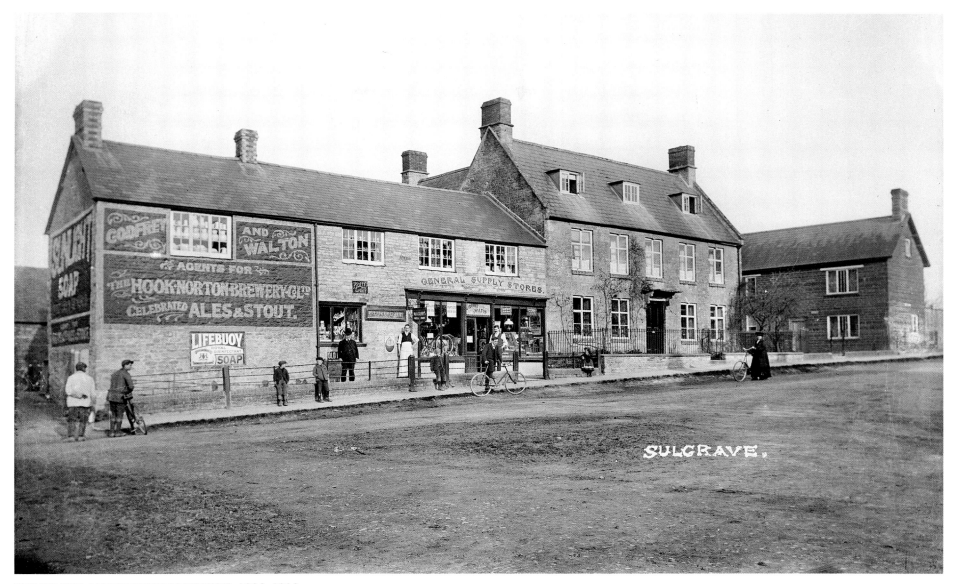

SULGRAVE, NORTHAMPTONSHIRE, 1896–1910

Godfrey and Walton General Supply Stores is another example of a village shop stocking a wide range of goods which the local community could not produce for itself. Adverts for soap and beer are painted on the wall. This shop abuts an elegant 18th-century town house. [BB98/05928]

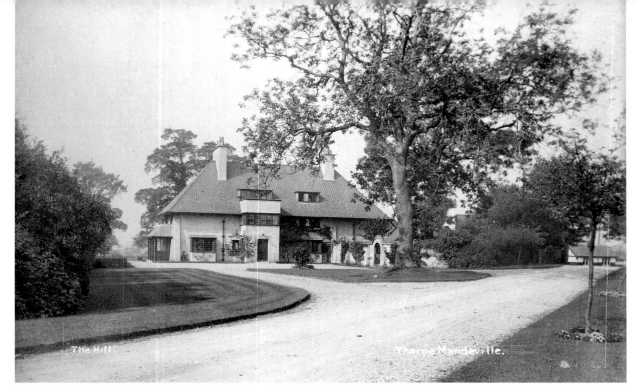

'THE HILL', THORPE MANDEVILLE, NORTHAMPTONSHIRE, MAY 1907

'The Hill' was built in 1897–8 for Mr Hope Brook by the architect Charles Voysey, who was linked to the Arts and Crafts Movement. Compared with the other houses recorded by Newton, it looks surprisingly 'modern'. The gardener has just finished digging over the vegetable garden, which would have formed an important part of the household economy. In the background is a wind pump, which was used to raise water. [BB98/06074; BB98/06306]

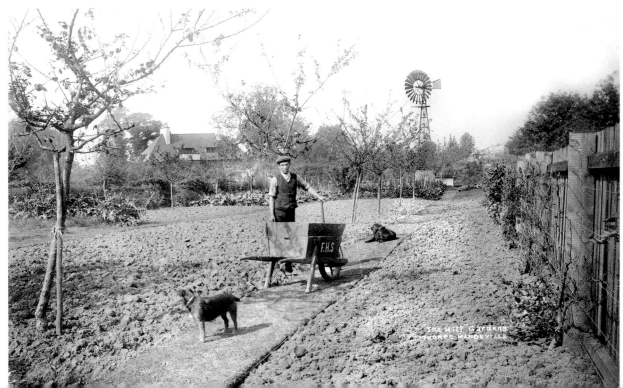

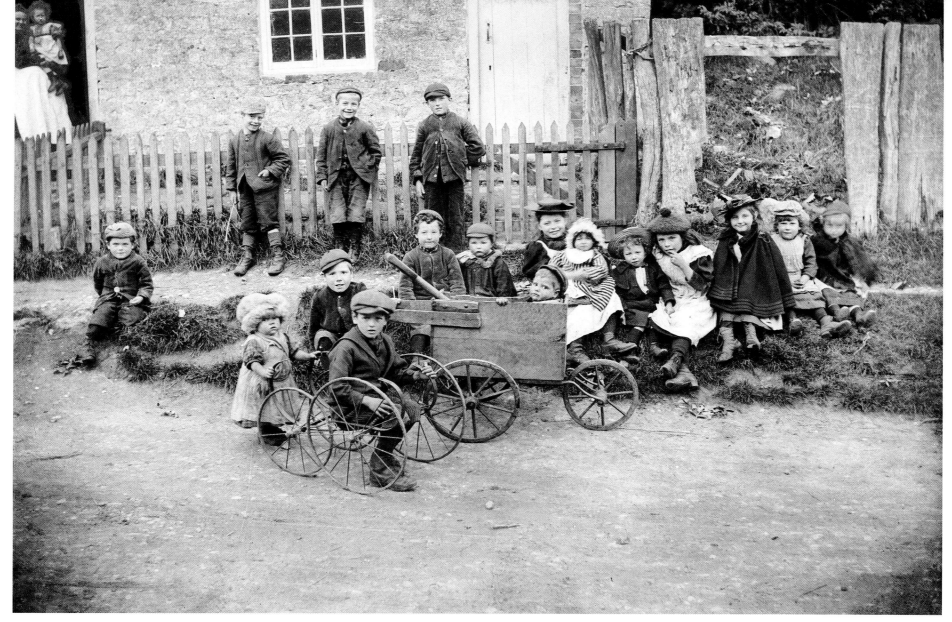

GREATWORTH, NORTHAMPTONSHIRE, OCTOBER 1901

A photographer was an unusual sight in these rural settlements, drawing a group of curious children who pose on the verge and footpath. Older girls look after their younger siblings. Two of the older boys have go-carts; one reuses the base of a pram, while the other appears to be made out of a wheelbarrow. [AA97/05215]

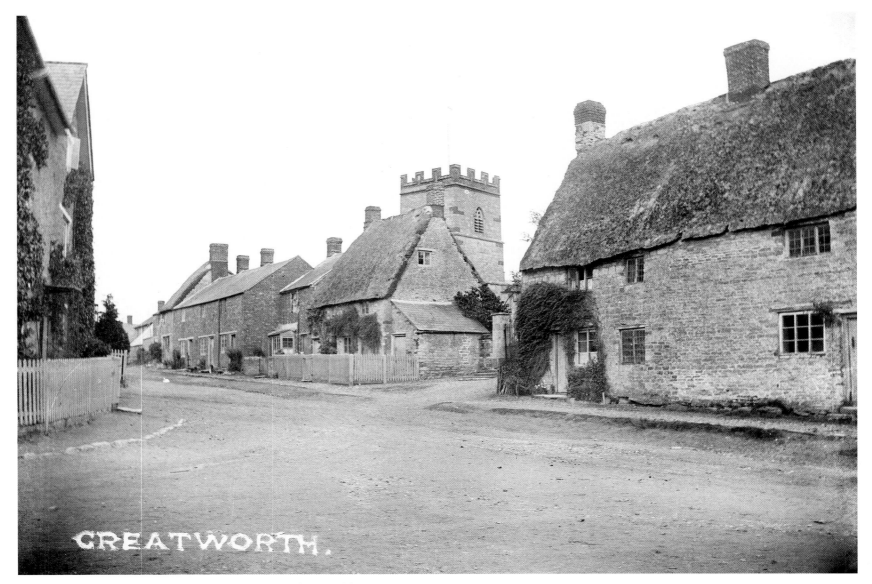

GREATWORTH.

GREATWORTH, NORTHAMPTONSHIRE, OCTOBER 1901

This view is of Church Road, Greatworth, with the tower of St Peter's Church just visible over the rooftops. The cottages bordering the churchyard have since been demolished. [AA97/05982]

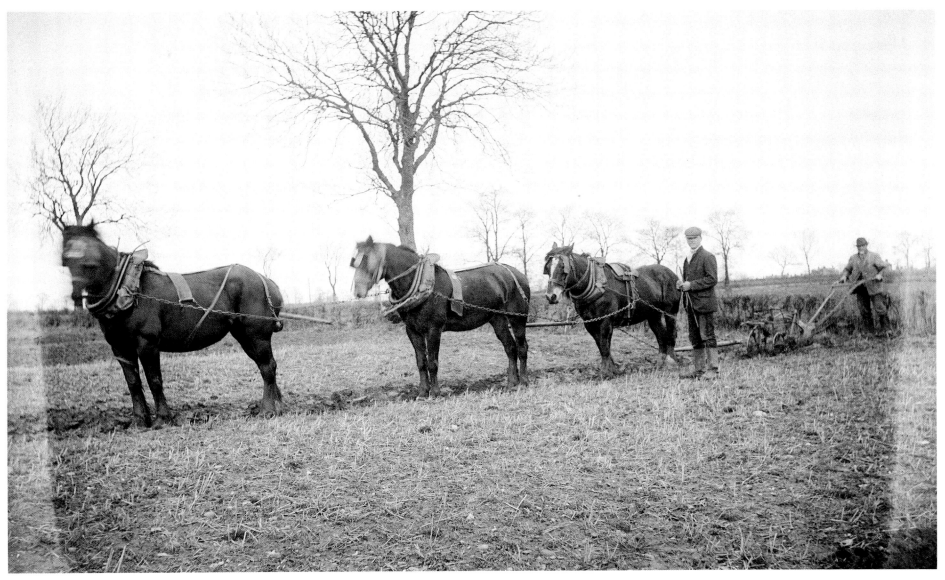

PLOUGHING NEAR SYRESHAM, NORTHAMPTONSHIRE, 1901

This plough team is at work near Syresham. Mr Thomas Horn is at the plough – the 1901 census records him as a general labourer aged 62 years. A younger man guides the horses.

[AA97/05473]

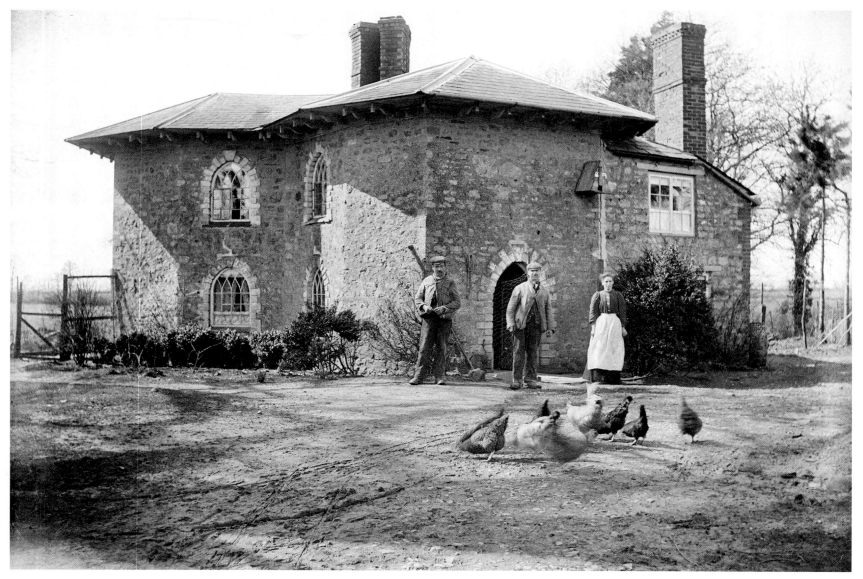

LODGE, BIDDLESDEN, BUCKINGHAMSHIRE, 1901

Biddlesden Park House dates from the early 18th century. The gate lodge was built *c* 1820, with window and door openings in the fashionable Gothic style. The lodge provided accommodation for estate workers, three of whom stand outside. The chickens were kept by the lodge keeper's family to supplement their income. [AA97/05324]

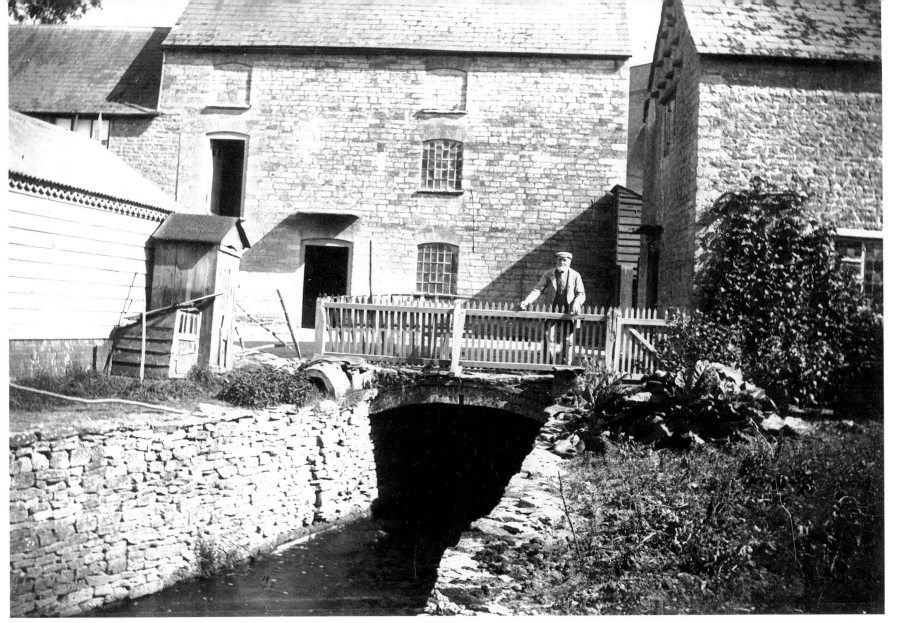

ST PETER'S MILL, BRACKLEY, NORTHAMPTONSHIRE, c 1897

This water mill in Mill Lane, Brackley, which may date from the late 18th century, was powered by the Great Ouse. The elderly man leaning on the railings over the mill race may be Thomas Course, miller, corn dealer and baker. The viaduct of the GCR is just visible between the mill buildings (*see* p 105). [L2899]

Contract No. 6:
Brackley to Quainton Road

Contract No. 6 was the second of two contracts on the London Extension built by Walter Scott & Co. It ran from Brackley, Northamptonshire, to Quainton Road, Buckinghamshire, a few miles to the north of Aylesbury, where the GCR London Extension joined the Metropolitan Railway to run on to London.

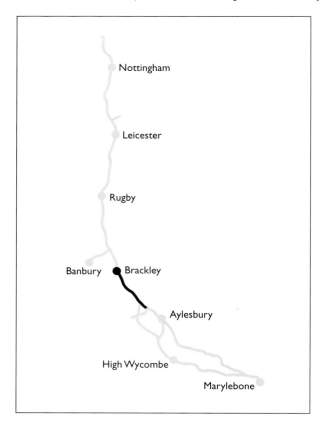

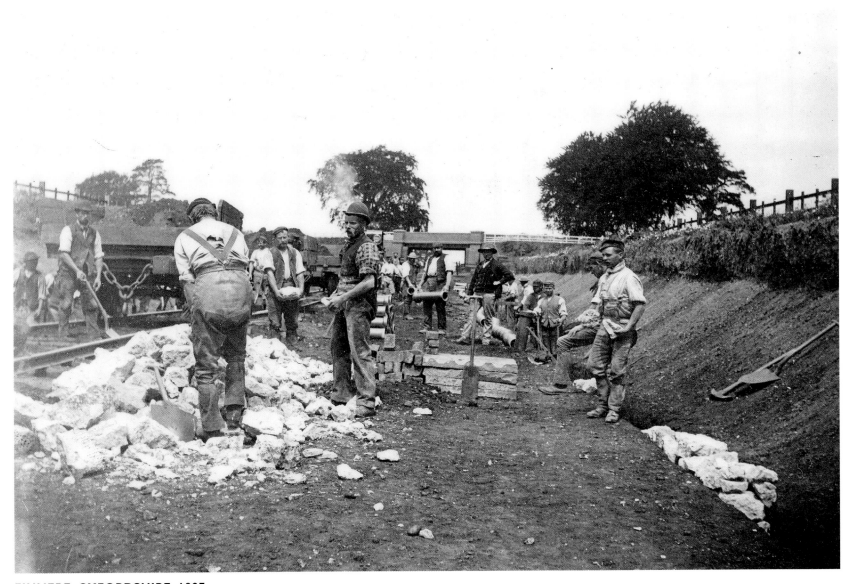

FINMERE, OXFORDSHIRE, 1897

A well-laid permanent way and long stretches with minimal gradients might appear to make a desirable railway, but without adequate drainage cuttings would quickly flood, causing the line to subside and undermining bridges and structures. The London Extension had a massive network of drains and soakaways, as Newton witnessed when he took this photograph near Finmere. Creating good drainage was a laborious task, needing men to carry pipes, break rocks and shovel dirt to get the job finished. These men could only dream of the long reels of plastic drainpipes used today. [L1585]

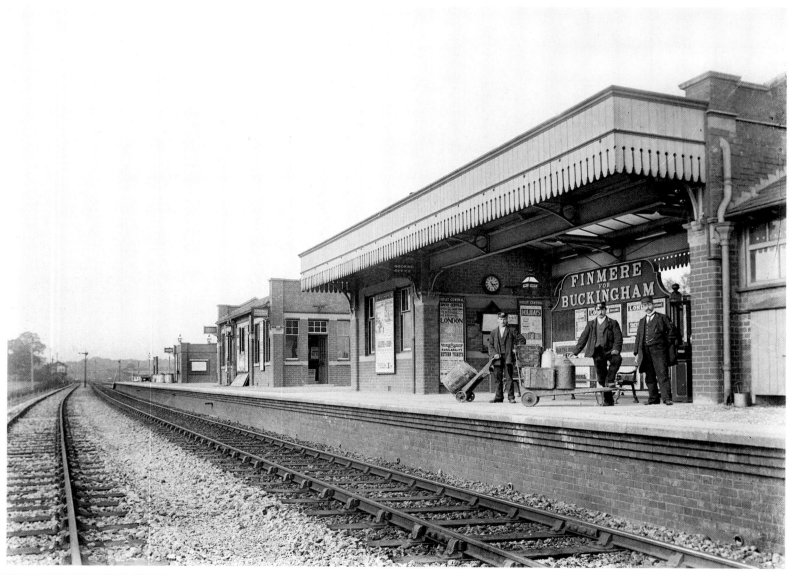

FINMERE, OXFORDSHIRE, JUNE 1904

Three railwaymen pose for Newton's camera on the Down platform of Finmere Station. Built on an embankment to a design typical of the London Extension, the station was situated next to Bridge 541, which carried the railway across the main Buckingham to Bicester Road (now the A4421). Lying more than a mile to the south-west of Finmere village, the station was actually closer to Newton Purcell. Interestingly, the station sign reads 'Finmere for Buckingham', yet the station received the majority of its traffic from the boys at the famous Stowe School nearby. Clearly something attracted Newton to Finmere, as he later named one of his houses after the village. [BB98/05550]

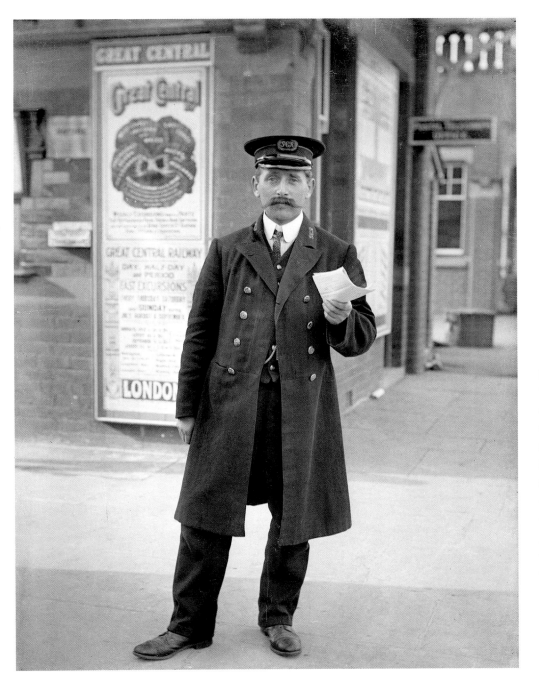

FINMERE, OXFORDSHIRE, JUNE 1904
The GCR quickly earned itself a reputation for the high quality of its trains and the cleanliness of its stations. Company pride was never more evident than in the appearance of the station and train staff, who were always immaculately groomed. This gentleman is one of the stationmasters at Finmere and is wearing the smart uniform entrusted to him. The frock coat, polished buttons, pressed collar, handlebar moustache and peaked cap all add to the general feeling of efficiency, which is exactly what the GCR was trying to achieve. Note the full-height poster boards on the booking office walls. [BB98/05551]

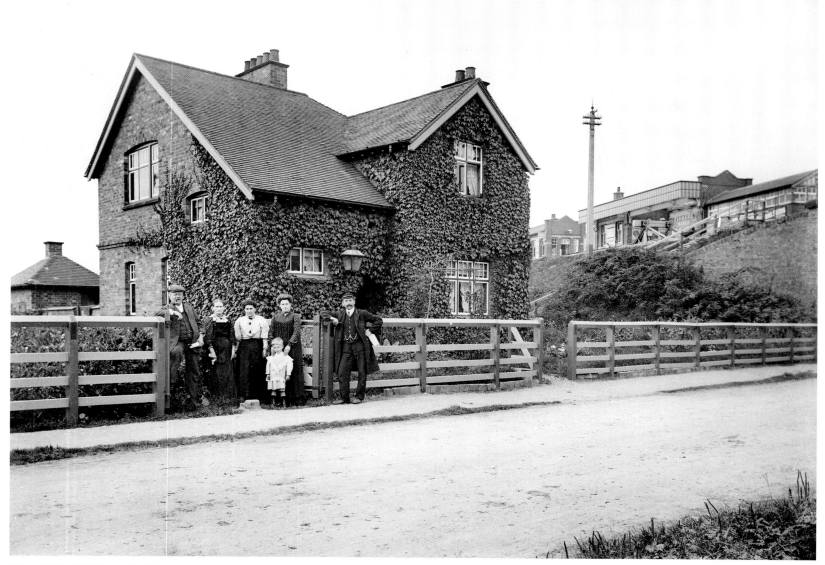

FINMERE, OXFORDSHIRE, *c* 1904

This is a fine study of the stationmaster and his family as they pose in front of their home adjacent to Finmere Station. The station buildings themselves – including the modest platform canopy around the ticket office – are up on the embankment on the right of the picture. In common with much of the London Extension's architecture, speed and economy dictated that the stationmasters' houses should all be built to a single standard design, with some variation in layout. Their size and quality mean that most are still lived in today. The extensive growth of the ivy on the front of the house suggests that this photograph was taken a few years after the line opened. [BB97/08286]

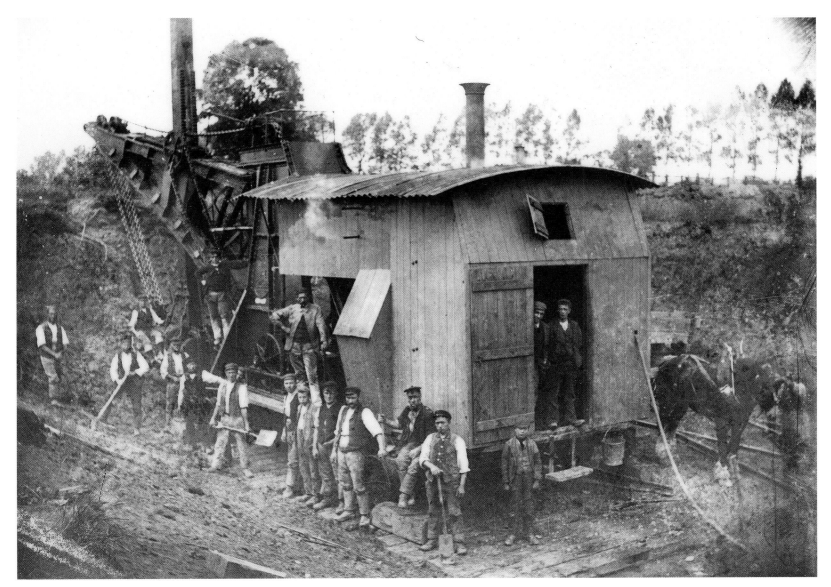

CHETWODE, BUCKINGHAMSHIRE, 1897

Operating steam excavators required three men – a driver, a stoker and a wheelman. Once the machine was in position, the driver would release the winding drum so that the bucket arm swung vertically. The wheelman would adjust the length of the arm until the blade of the bucket was touching the soil. When ready, the driver would throw the main chain drum into reverse and the bucket would be dragged upward, describing an 80-degree arc. By the time the chain was completely wound, the bucket would be fully loaded. The main jib was then swung around and the bucket positioned over a waiting wagon. The wheelman would then release a catch that would open a door on the back edge of the bucket, allowing the contents to spill into the wagon. [L1374]

CALVERT, BUCKINGHAMSHIRE, 21 JUNE 1896

Walter Scott & Co's yard at Calvert was a sprawling site, with everything at hand for the construction of the station alongside. The timber shed to the right housed a steam engine that was used to drive the grinding mill on this side of it. Sand and mortar from the mill lie in heaps, with planks laid across the site in places to allow the navvies to load their wheelbarrows. On the far right of the picture is the new island platform belonging to Calvert Station, although it is still devoid of buildings. The wagons alongside the mill are bolster wagons, used to carry such things as long lengths of timber and steel rails. [L1293]

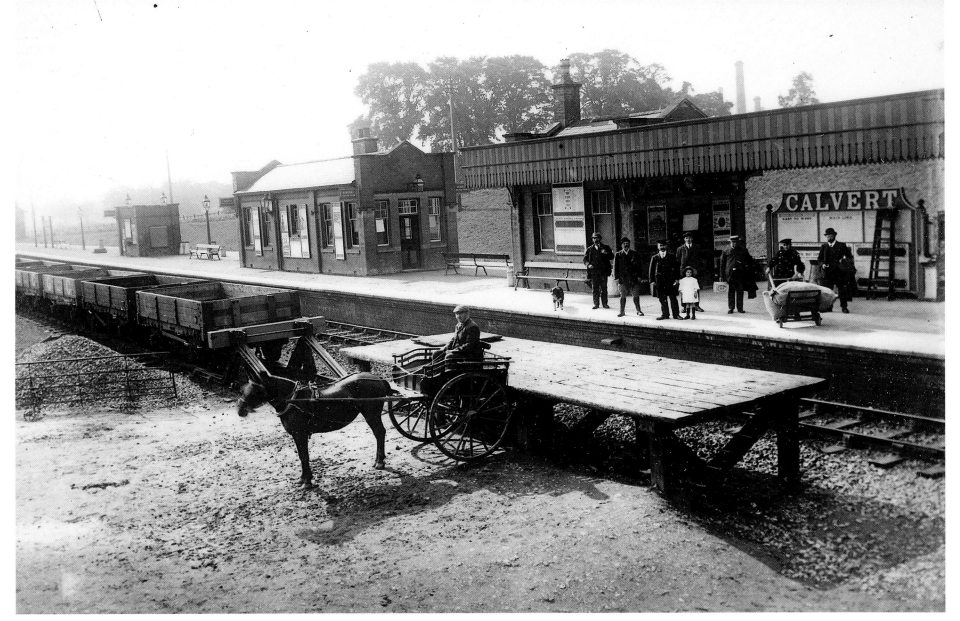

CALVERT STATION, BUCKINGHAMSHIRE, 1900

This photograph – taken only a year after the line opened – highlights one of the disadvantages of the island-platform design: freight deliveries could not easily gain access to the platform without crossing the main line. This resulted in makeshift loading docks being built, but these required the driver of the locomotive to take extra care when stopping so that the correct carriage, wagon or van pulled up alongside the dock. Calvert was the last of the island-platform stations on the London Extension before the line connected with the Metropolitan Railway at Quainton Road. [L1387]

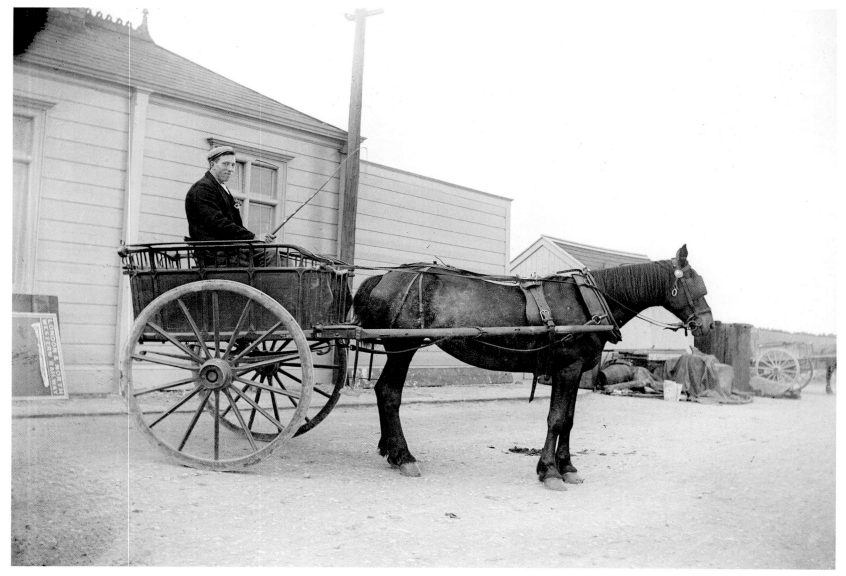

LNWR STATION, MARSH GIBBON, BUCKINGHAMSHIRE, 1904

A carrier's cart waits in the yard at Marsh Gibbon Station. This was not part of the GCR; rather it was the LNWR branch line to Oxford and the station was not built to the same high standards as those found on the GCR. The board propped against the wooden station building reads London & North Western Railway. [AA97/07437]

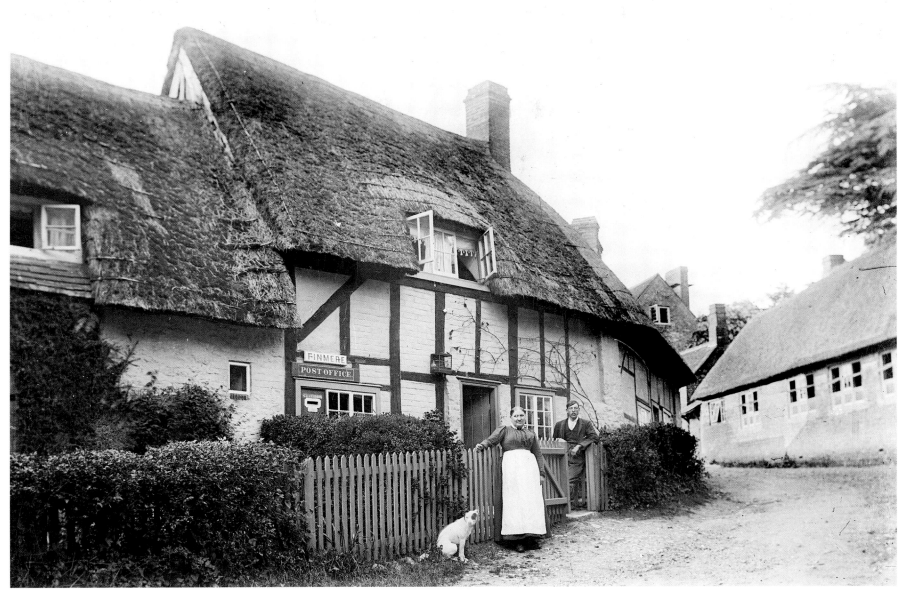

POST OFFICE, FINMERE, OXFORDSHIRE, JUNE 1904

Mrs Rachel Paxton, sub-postmistress, poses for the camera outside her post office near the Cross Tree in Finmere. This 17th-century timber-framed building with a thatched roof has since been demolished. The old school stands to the right of the post office. Built in 1824 for the benefit of poor children, it finally closed in 1948. [BB98/05546]

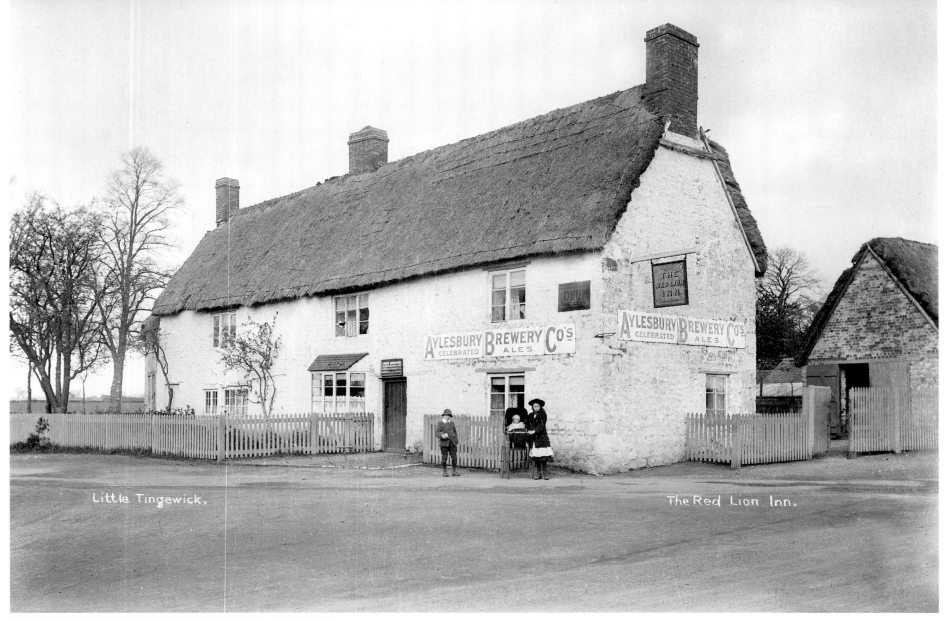

Little Tingewick.

The Red Lion Inn.

RED LION INN, FINMERE, OXFORDSHIRE, JUNE 1904

Edmund Grantham was publican of the Red Lion Inn, Finmere. (This end of the village originated as a separate hamlet called Little Tingewick and is over the county boundary in Buckinghamshire.) The two children and the baby in a pram outside the gate may be members of his family. This thatched house, built in the local style using local stone, may date from the 17th or 18th century. [BB98/05545]

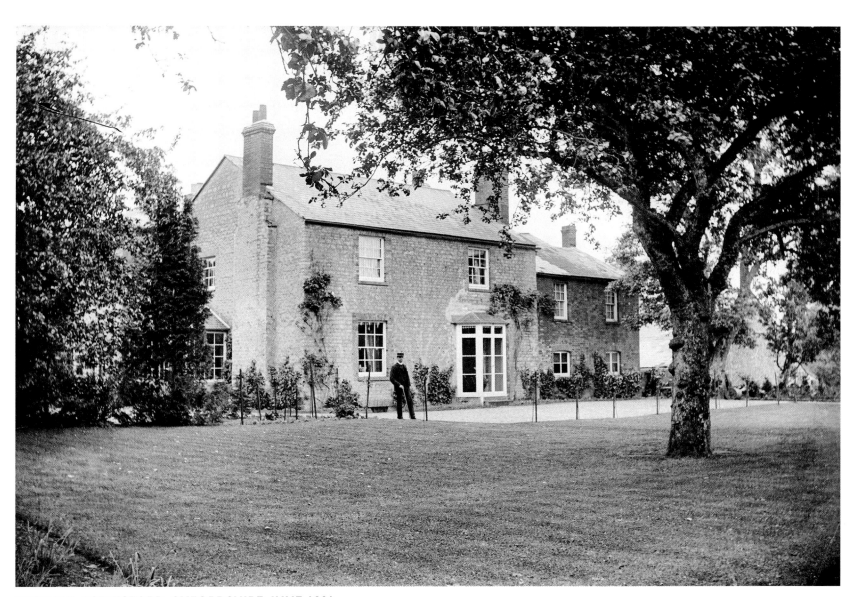

RECTORY, COTTISFORD, OXFORDSHIRE, JUNE 1901

The Revd Henry Edwin Barnacle FGS (Edinburgh) stands in the garden of his rectory in Cottisford. The clergyman was often the best educated person in a rural community and must have felt the lack of intellectual stimulus. [AA97/05656]

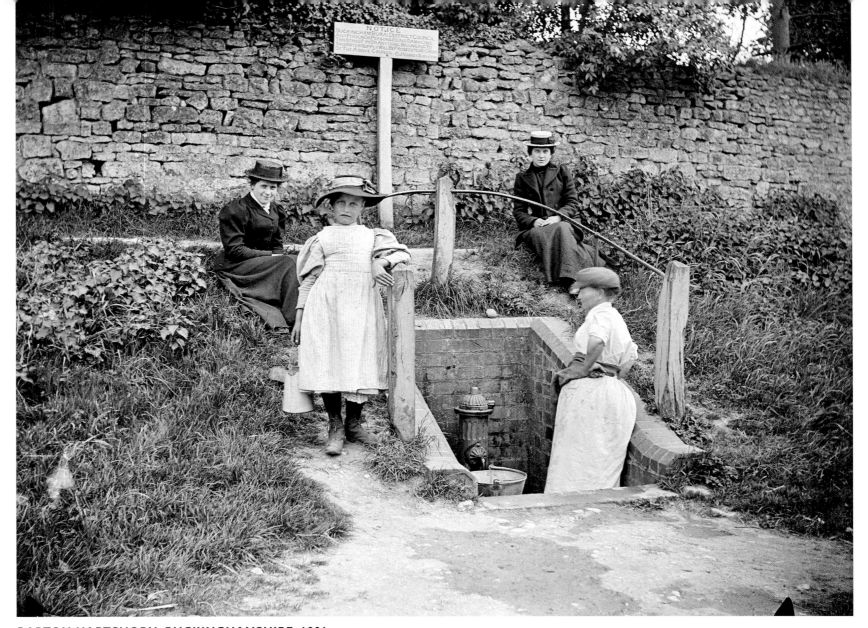

BARTON HARTSHORN, BUCKINGHAMSHIRE, 1901

A woman and child collect water from the public standpipe at Barton Hartshorn, while two better dressed ladies look on. The notice above the standpipe warns people not to damage the water supply on pain of prosecution. [AA97/05320]

HETHE, OXFORDSHIRE, JUNE 1901

The small stream which divides the settlement in two is a tributary of the Great Ouse. In this view five children stand beside the bridge in the centre of the village. Main Street climbs the valley side behind them. [AA97/05652]

PRESTON BISSETT, BUCKINGHAMSHIRE, 1904

Three boys play on a kissing gate at Preston Bissett, while a younger boy watches the photographer. The village school is in the background. It is salutary to remember that in 10 years time these boys would fight in the First World War. [AA97/05319]

NUTLEY HOUSE, HILLESDEN, BUCKINGHAMSHIRE, 1896–1910

The gardens of Nutley House combine the formality of a Victorian public park with the greater informality of the Edwardian garden. Beds cut in the lawn are in the tradition of carpet bedding and the bed in the foreground is packed with geraniums. A tall border runs in the shelter of the garden wall, while a swing and canvas chairs hint at the casual use of the garden by family and friends. [BB98/01714]

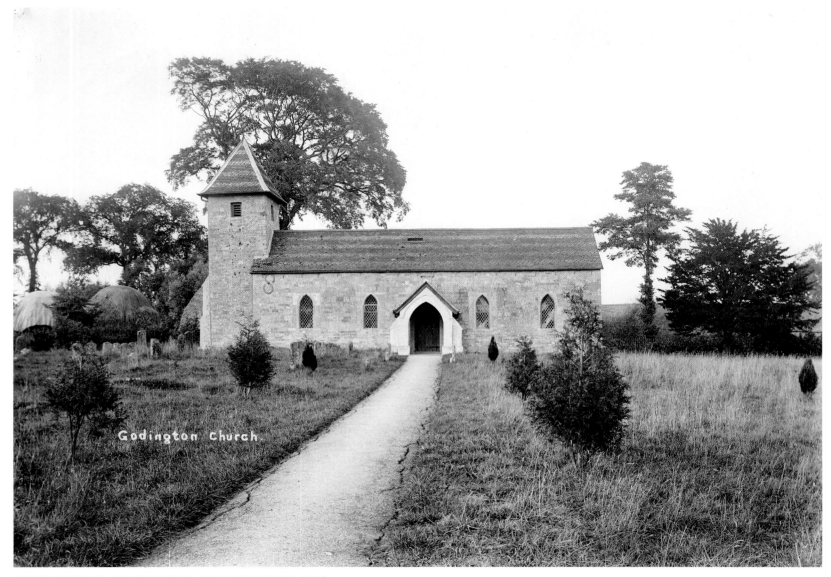

Godington Church

HOLY TRINITY, GODINGTON, OXFORDSHIRE, 1913

The small rural church of the Holy Trinity, Godington, was rebuilt in 1792; it was restored in 1852 and again in 1905. Some medieval work survives in the west tower. There are remarkably few headstones in the churchyard, a reminder that few people could afford such an enduring memorial at this time. [BB98/05488]

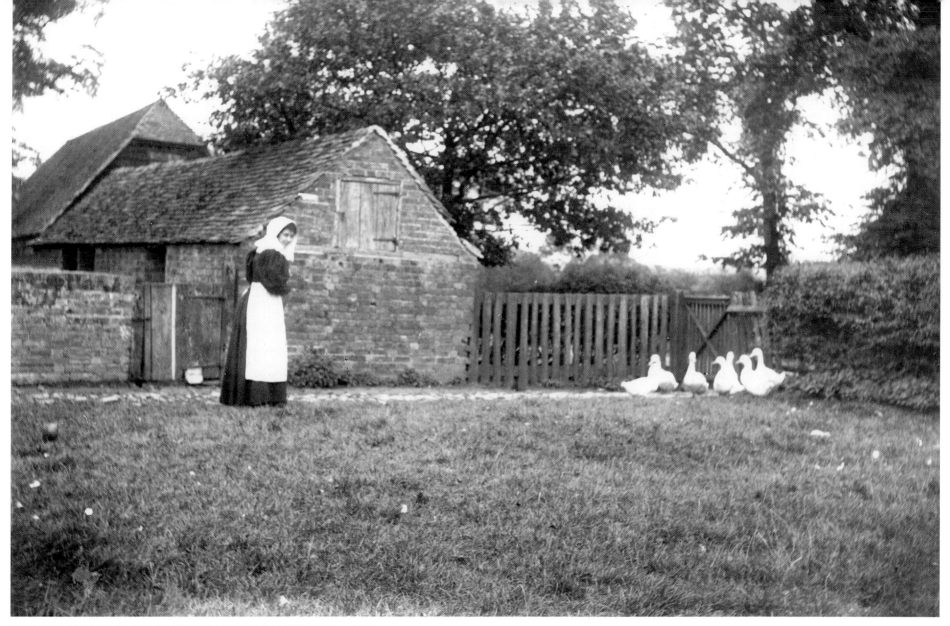

GREAT POND FARM, CALVERT, BUCKINGHAMSHIRE, *c* 1897

Mrs Burberry is seen here with a flock of Aylesbury ducks beside the outbuildings at Great Pond Farm, a short distance to the east of the London Extension. She is wearing traditional costume, including an apron and bonnet. [L2858]

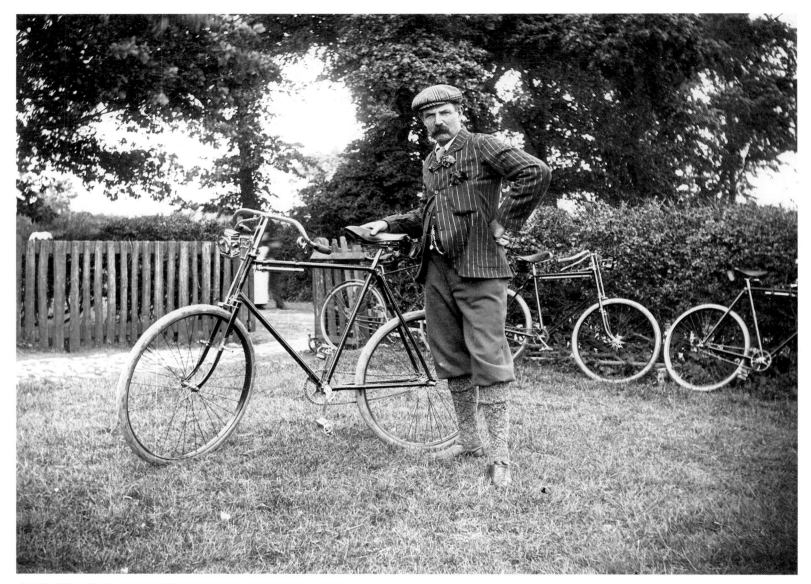

CYCLIST NEAR CALVERT, BUCKINGHAMSHIRE, 1897

Mr Overman is photographed here with his bicycle at Great Pond Farm, near Calvert, the day before Queen Victoria's Diamond Jubilee in June 1897. The bicycle had become fashionable at this date and this is an interesting study of late Victorian dress and transportation. [L2830]

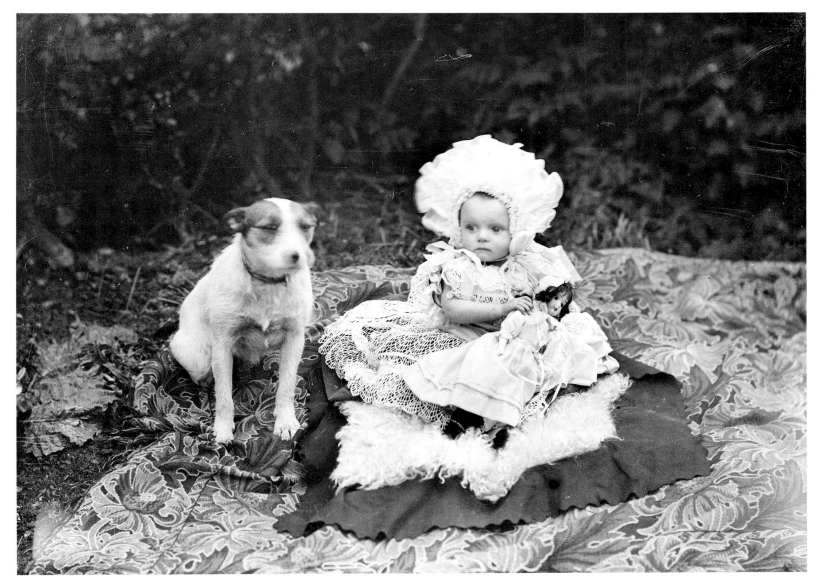

CHARNDON, BUCKINGHAMSHIRE, MAY 1904

A toddler is posed for the camera. The child wears her best clothes and clutches her doll, while the family terrier sits beside her. Newton was presumably commissioned to take portraits such as this. [BB98/02206]

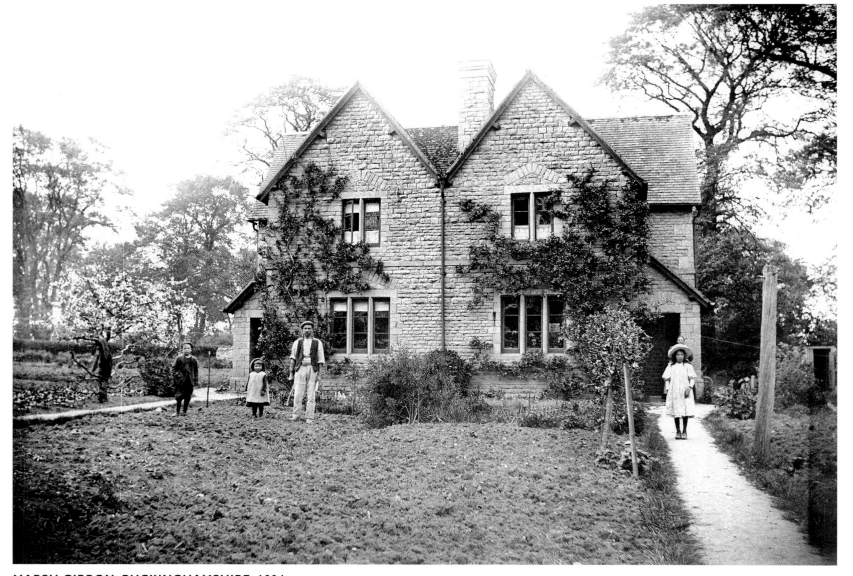

MARSH GIBBON, BUCKINGHAMSHIRE, 1904

Two families stand outside one of several pairs of semi-detached estate cottages, which appear to be quite recently built. Their large gardens are given over to vegetables, which provided an important supplement to their incomes. [AA97/05501]

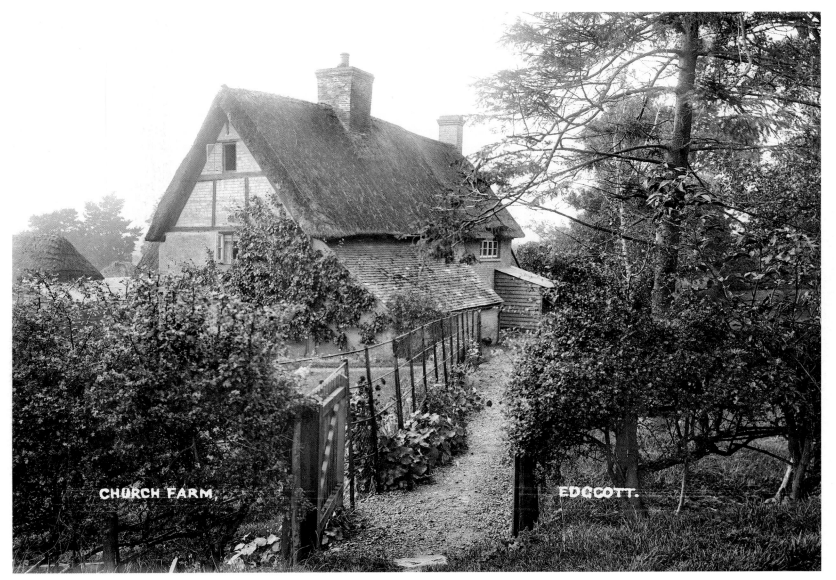

CHURCH FARM, EDGCOTT, BUCKINGHAMSHIRE, 1896–1910

Church Farm is a 17th-century building, which is mostly faced in brick. Exposed timber framing with brick infill can be seen in the gable and the roof is thatched. Although it is a two-storey house with further accommodation in the roof, it seems to nestle comfortably in the landscape. The farm is named from St Michael's Church which is just out of shot to the right. [BB98/06295]

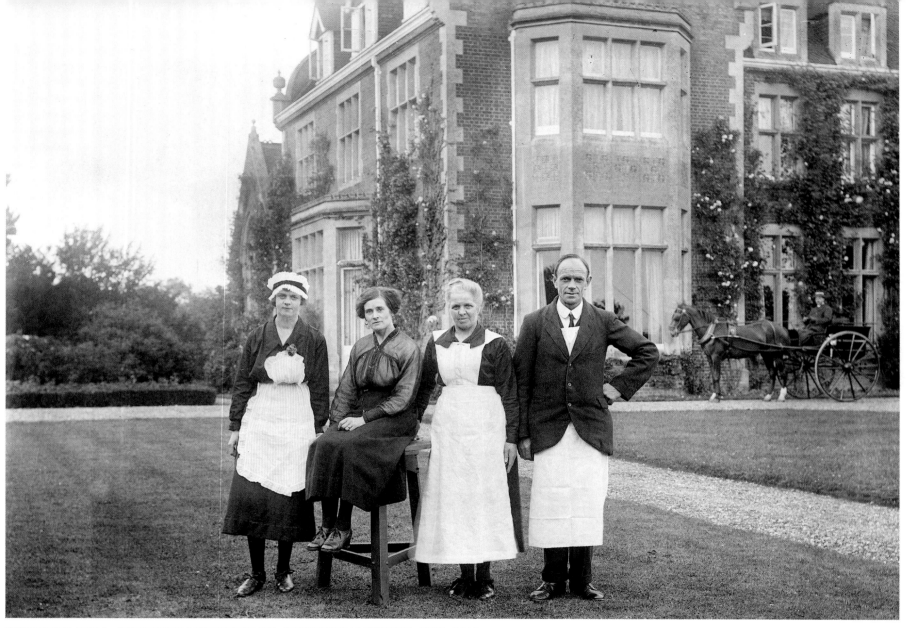

GRENDON HALL, GRENDON UNDERWOOD, BUCKINGHAMSHIRE, 1896–1910

Grendon Hall was built in the Jacobean style in about 1882 to designs by the Revd Randolphe Piggott for his brother Sir Digby Piggott. By the time of this photograph it was the home of Alfred Skinner Esq, a local Justice of the Peace. Large houses such as this required an army of servants and a strict hierarchy was maintained. Here four of the senior staff pose for the photographer. Teams of stable hands and gardeners would also have been needed. The photograph opposite shows a corner of the dining room with the table laid for a formal meal. [BB98/10670; BB98/01929]

Metropolitan Railway joint working

Part of the vision of the London Extension was to provide a link between two railway systems that fell under Sir Edward Watkin's control – the Manchester, Sheffield & Lincolnshire Railway and the Metropolitan Railway. Therefore, when the new line reached Quainton Road, just to the north of Aylesbury, Buckinghamshire, it joined the Metropolitan, leaving it again at Harrow South Junction to run on new tracks to its London terminus at Marylebone.

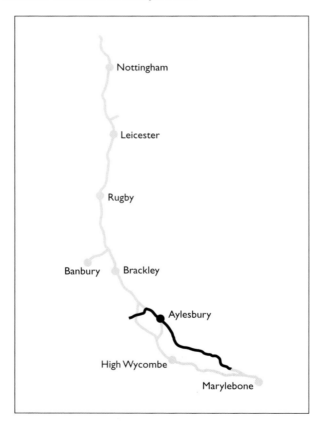

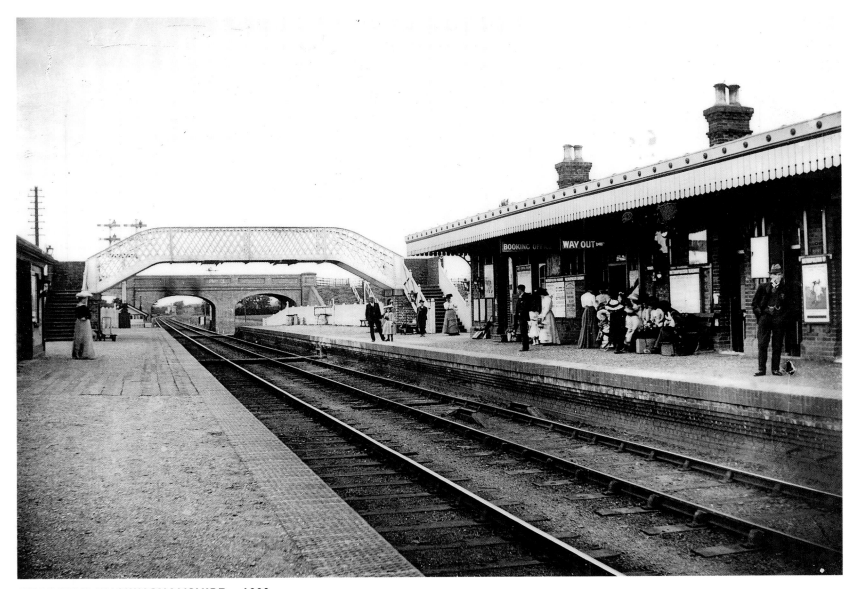

QUAINTON, BUCKINGHAMSHIRE, *c* 1900

The northernmost point of the Metropolitan Railway was at Verney Junction on the old Aylesbury & Buckingham Railway. However, the GCR joined the Metropolitan at Quainton Road Station, only a short distance from Aylesbury. The station opened in 1868 and soon became an important junction. The Verney Junction line left from here, as did the Brill Branch (or Wotton Tramway). The arrival of the London Extension saw a certain amount of remodelling at the station, including a new brick-arch bridge that was constructed to replace a level crossing in order to avoid delaying the extra traffic that accompanied the Metropolitan's new relationship with the GCR. [L1581]

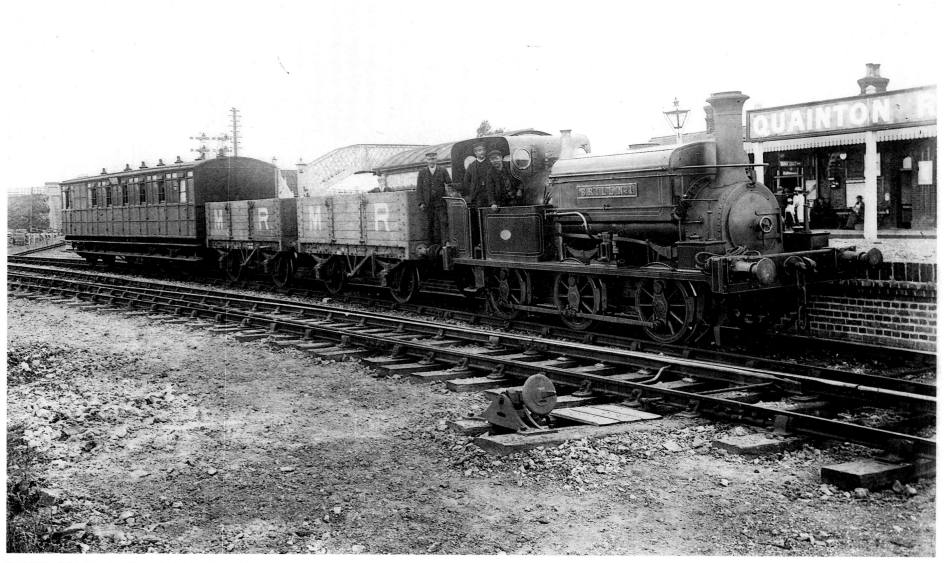

QUAINTON, BUCKINGHAMSHIRE, *c* 1900

The 6¼-mile Brill Branch was built in 1871 to serve the Duke of Buckingham's estate. Originally worked by horses, these were superseded by a pair of chain-driven Aveling & Porter locomotives, which were little more than traction engines on railway wheels. In 1876, two Bagnall saddle tank locomotives were supplied to replace the Aveling & Porter engines, but these were replaced after operations were handed over to the Oxford & Aylesbury Tramroad Company in 1894. One of the replacement locomotives – *Brill*, No. 1 – was a Manning Wardle 'K' class 0-6-0 saddle tank of 1894, seen here at Quainton Road Station at the Brill Branch platform hauling two Midland Railway wagons and a rather antiquated carriage. [L1062]

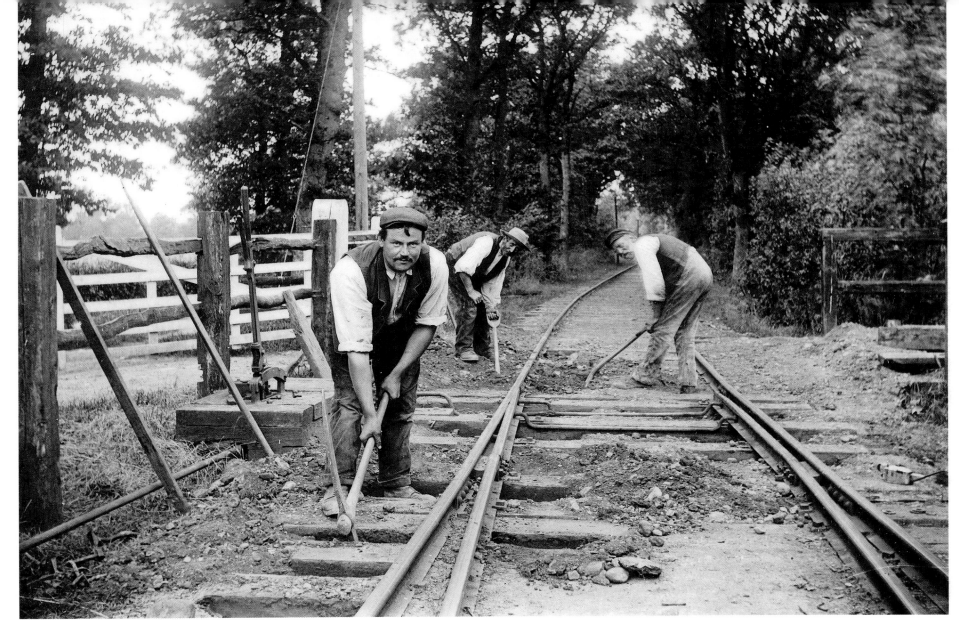

BRILL BRANCH, BUCKINGHAMSHIRE

The Brill Branch was strictly part of the Metropolitan Railway, not the GCR system. These platelayers, at work near Wotton Station, appear to be in the process of digging out rotten sleepers or repacking some that have worked loose. Clearly the rails have been down for some time and all appear to be tightly packed by the ballast. Unlike the nearby London Extension that used real stone ballast, the Brill Branch probably made use of a finer grade material such as ash and coal waste. When the Metropolitan started using its own locomotives on the branch, the permanent way was quickly upgraded to have heavier section chaired rails. [L1357]

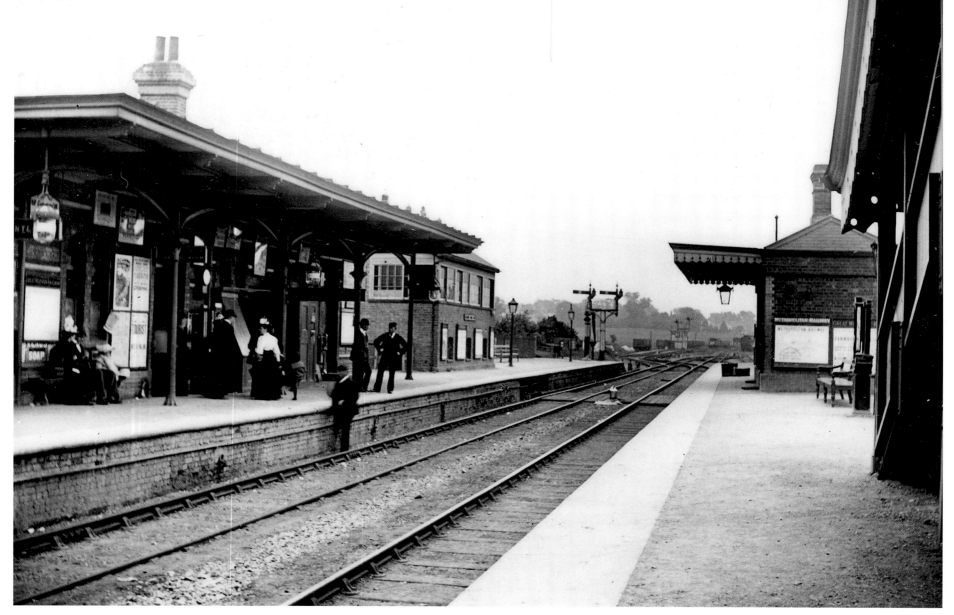

AYLESBURY, BUCKINGHAMSHIRE, JUNE 1897

This view along the platform at Aylesbury Station was taken when the London Extension was still in the midst of construction. The station was on the Metropolitan Railway's main route to Baker Street, but also served the GWR's branch line to Princes Risborough. The photograph gives a glimpse of the fashions of the period, along with the attitude to health and safety 100 years ago – the gentleman standing on the tracks would never be allowed to do that today. The sharp curvature of the track seen in the distance was a contributing factor in a terrible accident that occurred at the station on 23 December 1904, which led to the negotiation of a new management agreement between the Metropolitan and the GCR. [L2476]

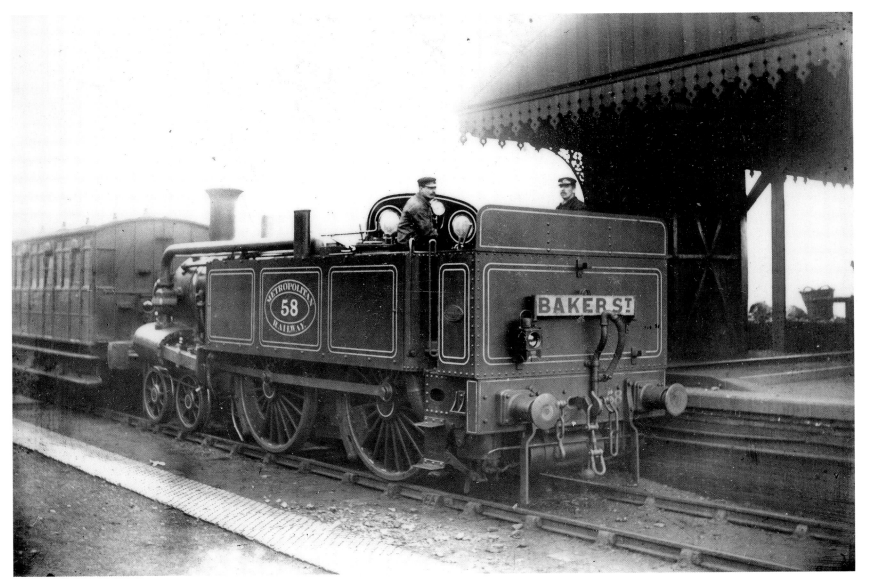

LOCOMOTIVE AT WEST HAMPSTEAD, GREATER LONDON, MARCH 1897

With the opening of the Metropolitan Railway's extensions to Willesden Green and Harrow in 1879 and 1880, a new batch of 4-4-0 locomotives was ordered. These new locomotives differed slightly from the Metropolitan's existing 'A' class examples, having larger coal bunkers along with other minor changes, and were designated the 'B' class. This example, No. 58, was built by Beyer Peacock & Co and originally worked on the South Eastern Railway before being sold to the Metropolitan in 1883. Note the destination board on the rear of the bunker and the locomotive's condensing apparatus, fitted to help reduce steam emissions when working in suburban tunnels. [L1322]

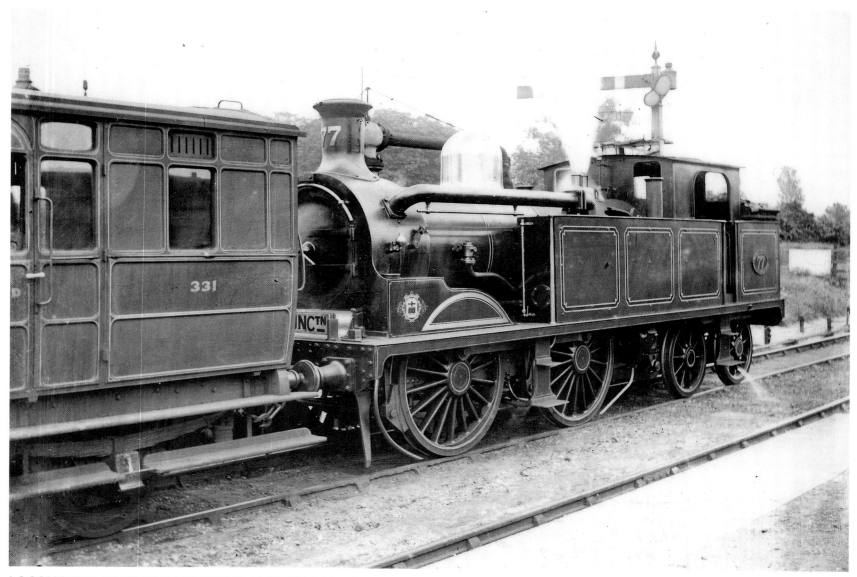

LOCOMOTIVE AT WEST HAMPSTEAD, GREATER LONDON, *c* 1897

The first true Metropolitan Railway locomotive design appeared in 1896 with the emergence of the 'E' class 0-4-4 tank locomotives. They were the work of T F Clark and were an enlargement of the unsuccessful 'C' class. With a tractive effort of 15,000lbs and driving wheels of 5ft 6in diameter, the handsome 'E' class was well suited to the hard main line work to Aylesbury and Verney Junction. Pictured to the right is No. 77, a pioneer 'E' class 0-4-4. Like many of the Metropolitan locomotives, this example is fitted with condensing apparatus. One of the 'E' class locomotives – No. 1 of 1898 – is today preserved at the Buckinghamshire Railway Centre at Quainton Road. [L1323]

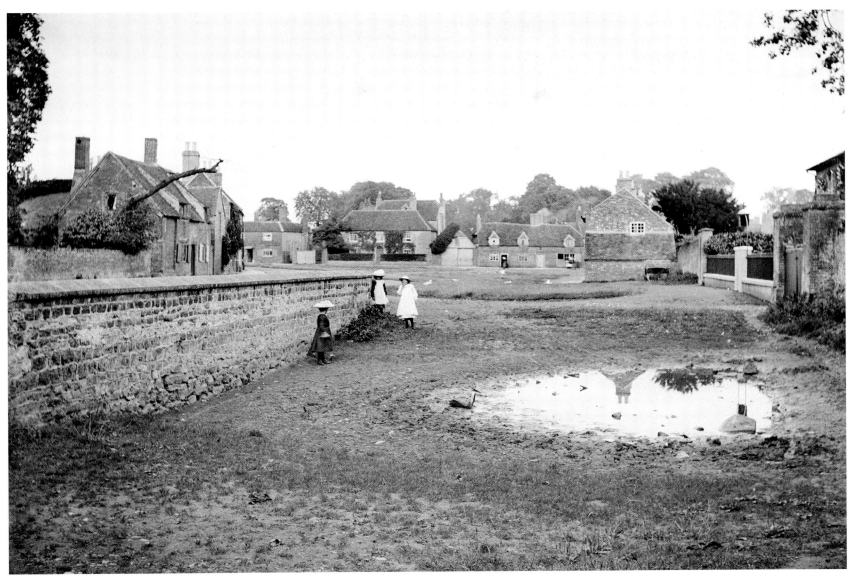

BRILL, BUCKINGHAMSHIRE, AUGUST 1904

Three young girls in wide-brimmed hats stand beside a pond in Brill, which has dried out in the summer weather. Behind them, the village is ranged around The Square. Waterloo House is to the right and the old vicarage faces the photographer across the green. Brill was served by a tramway from the Metropolitan Railway station at Quainton Road; the tramway was opened in 1871 and closed (pre-Beeching) in 1935. [AA97/06072]

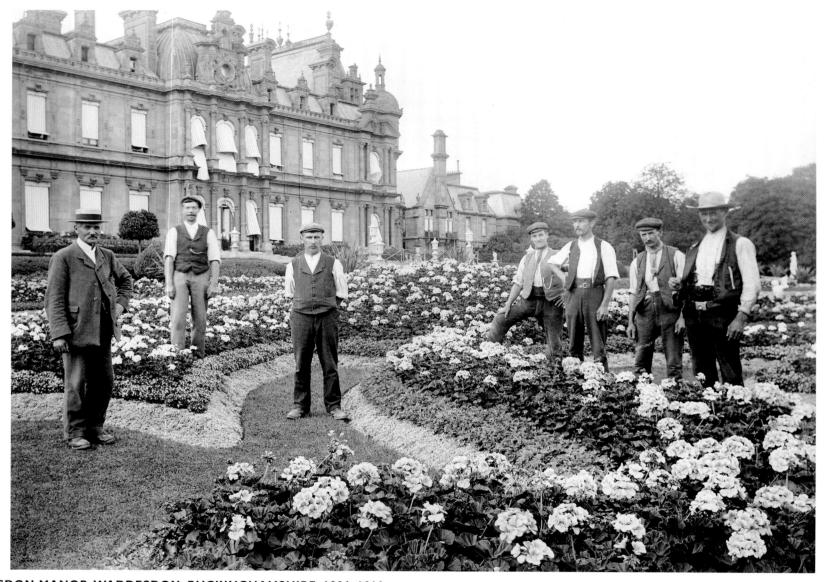

WADDESDON MANOR, WADDESDON, BUCKINGHAMSHIRE, 1896–1910

Baron Ferdinand de Rothschild, a member of the famous banking family, commissioned a country house at Waddesdon. The French architect Gabriel-Hippolyte Destailleur was engaged to build it in the style of a French Renaissance château and Waddesdon Manor was completed in 1880. A team of gardeners stands among the luxurious bedding plants on the parterre to the south of the house. (In one year alone 53 gardeners were employed, 14 of them in the glasshouses.) At the time of this photograph, Waddesdon had been inherited by Ferdinand's sister, Alice. In 1897 the Metropolitan added a station at Waddesdon Manor, only a mile from Quainton Road, to serve the estate. [BB98/01813]

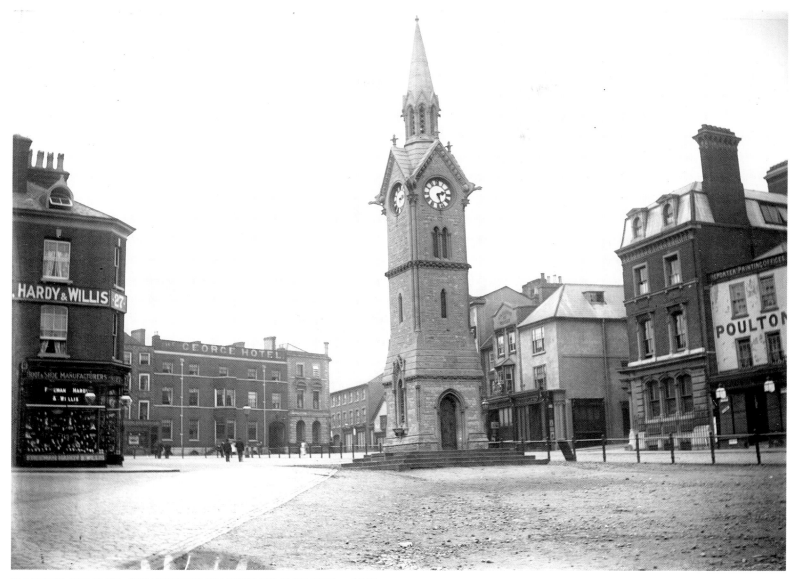

MARKET SQUARE, AYLESBURY, BUCKINGHAMSHIRE, *c* 1900

The clock tower in Aylesbury was built in 1876 by David Brandon. Assuming the clock is correct, the market square is remarkably quiet for half-past two in the afternoon. The Metropolitan Railway reached the town in 1892 and, once the London Extension began using the Metropolitan network for its route into the capital from 1899, Aylesbury also became a stop on the GCR's new main line. [L2860]

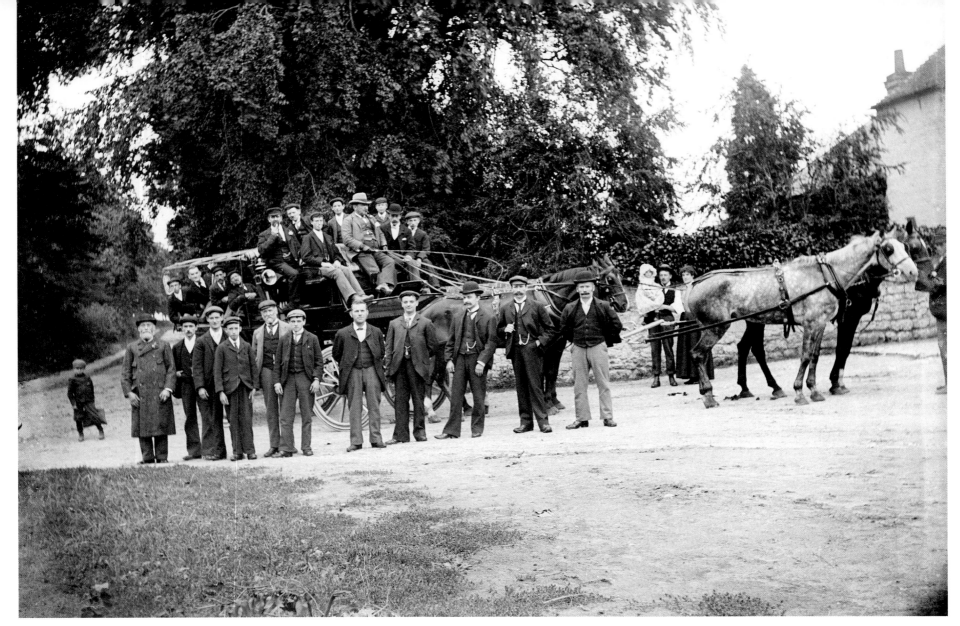

AYLESBURY, BUCKINGHAMSHIRE, JULY 1900

A coach party assembles outside the Bugle Horn Hotel, Aylesbury, to go on an outing. Perhaps in another year they might take the new railway. [AA97/05229]

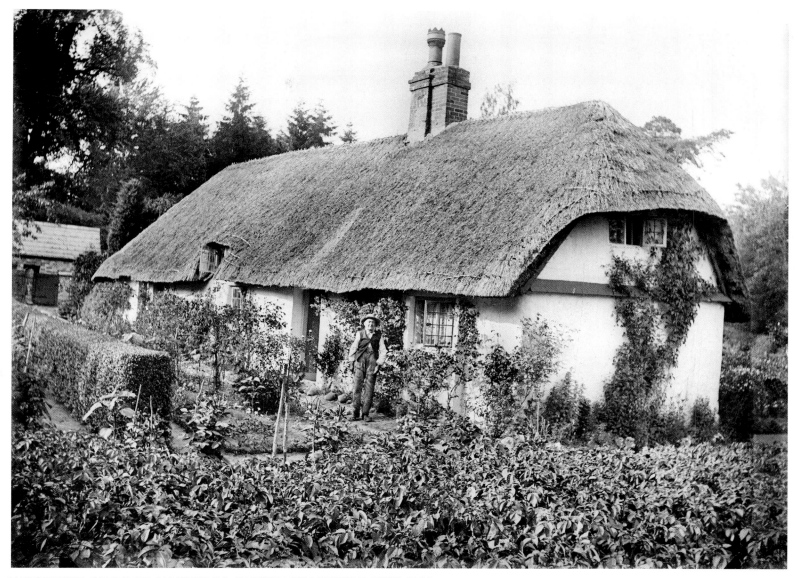

WOODBINE COTTAGE, HARTWELL, BUCKINGHAMSHIRE, JULY 1900

This picturesque thatched and whitewashed cottage dates from the 17th or 18th century. An elderly man stands in the garden, which has been put to vegetables. Speaking about the hamlet of Lark Rise at the close of the 19th century, Flora Thompson recalled the importance of home-grown food in the diet of country people. She noted that 'every house had a good vegetable garden and there were allotments for all' and 'the energy they brought to their gardening after a hard day's work in the fields was marvellous' (1985, pp 22 and 62). [AA97/06093]

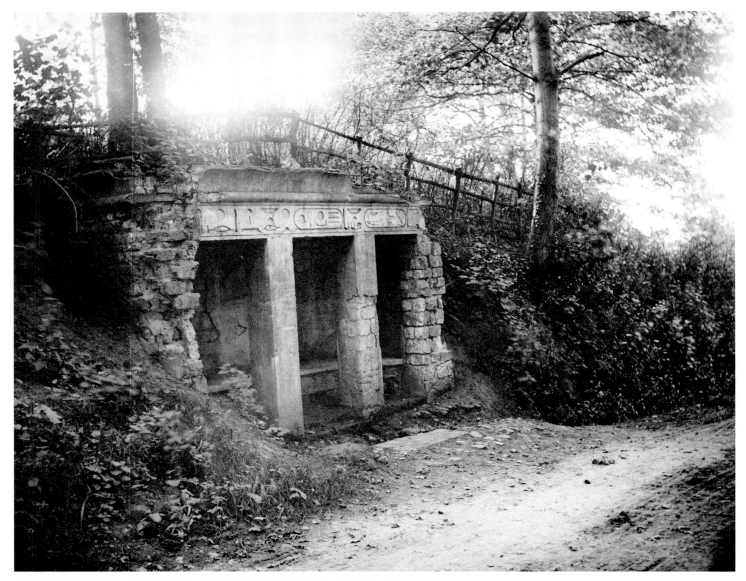

EGYPTIAN SEAT, HARTWELL, BUCKINGHAMSHIRE, JULY 1900

The Egyptian Seat was built in 1850–1 by Joseph Bonomi II for Dr John Lee of Hartwell House, a director of the Metropolitan Railway. The shelter is sited opposite a spring. Bonomi was an Egyptologist and the hieroglyphic inscription records the building of the shelter. [AA97/06094]

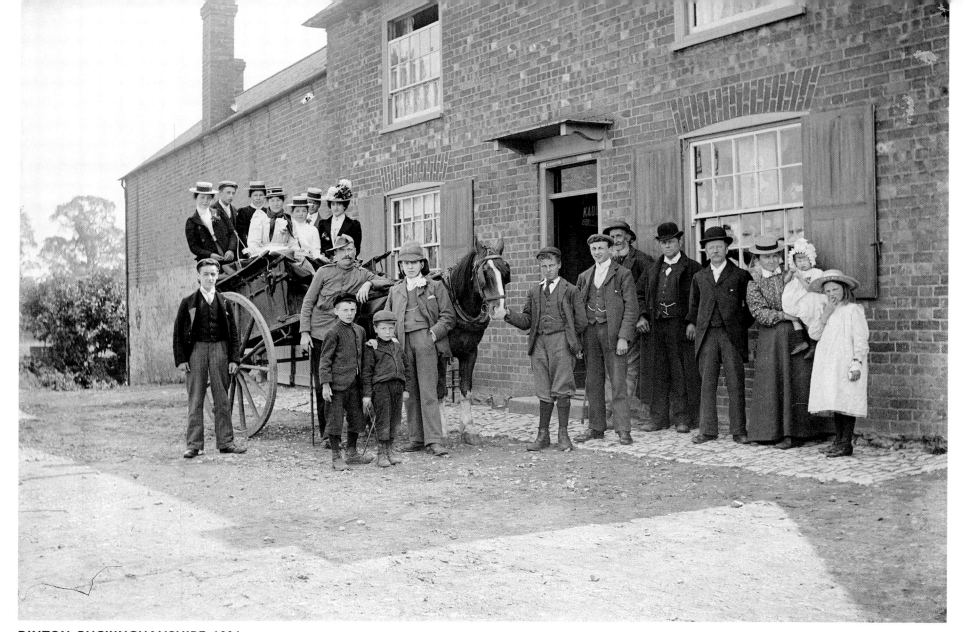

DINTON, BUCKINGHAMSHIRE, 1904

In this photograph a party outside Wootton's Store is ready to go on an outing. As the cart is already full, they may be waiting for a second to carry the rest of the group. *Kelly's Directory* for 1907 records four shopkeepers (one of whom was also sub-postmaster) in the village as well as a fishmonger, baker, two pubs and a beer retailer. The total population of Dinton, together with the neighbouring settlements of Ford and Upton, each of which also supported a shop, was only 663. [AA97/05329]

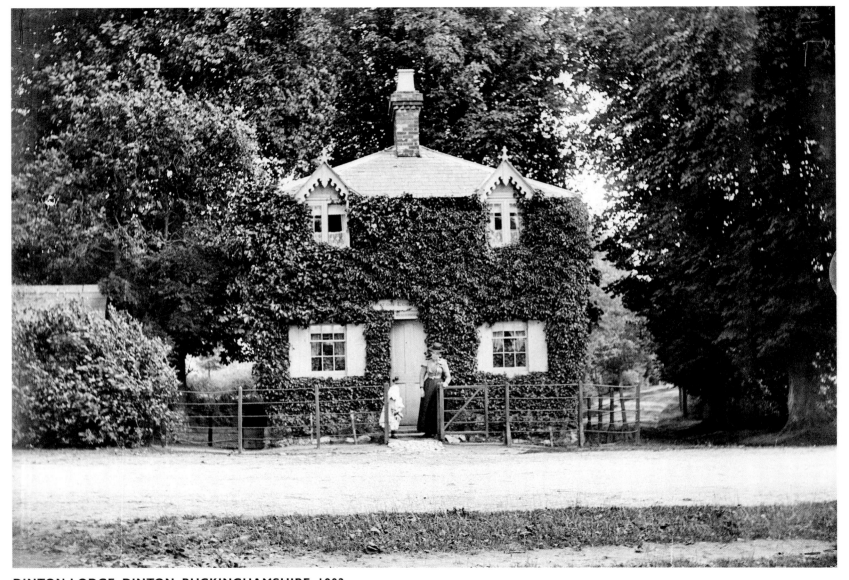

DINTON LODGE, DINTON, BUCKINGHAMSHIRE, 1902

A mother and daughter pose in the small front garden of Dinton Lodge. Following the passing of the County and Borough Police Act of 1856, the Buckinghamshire Constabulary was established in 1857. The nature of communications and transport during this period meant that policemen were stationed in villages and local centres in order to be able to respond to incidents in a timely manner. At the time of Newton's visit, Dinton Lodge was the village police house. Over the door is the metal plate marked 'County Police', which every constable was required to display outside his lodgings. [AA97/05346]

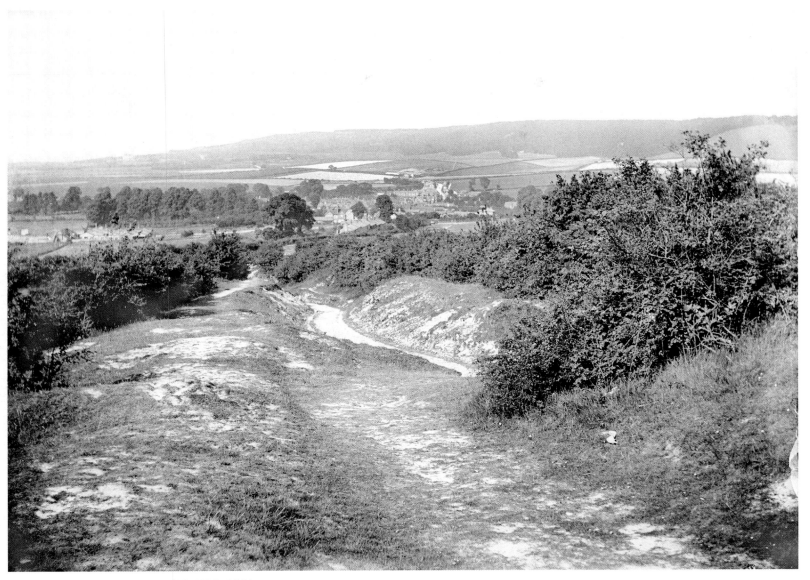

WENDOVER, BUCKINGHAMSHIRE, 1901

This is a view over Wendover and the surrounding countryside from Bacombe Hill on the edge of the Chilterns. At this time the town had a population of just over 2,000 inhabitants. Today the population is around 8,000. [AA97/07515]

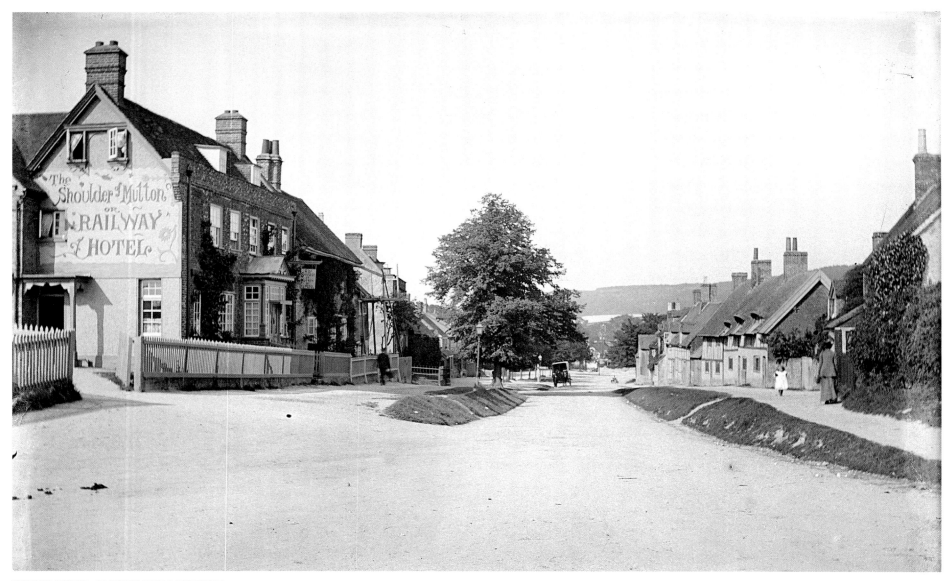

WENDOVER, BUCKINGHAMSHIRE

The Shoulder of Mutton or Railway Hotel in Pound Street, which stands near the railway station, is a venerable building dating from the 17th and 18th centuries. The Shoulder of Mutton is the older name, but the landlord, Frederick John Pedel, appears to have had an eye to commercial opportunity, renaming it 'The Railway' and upgrading it to a hotel. [AA97/05330]

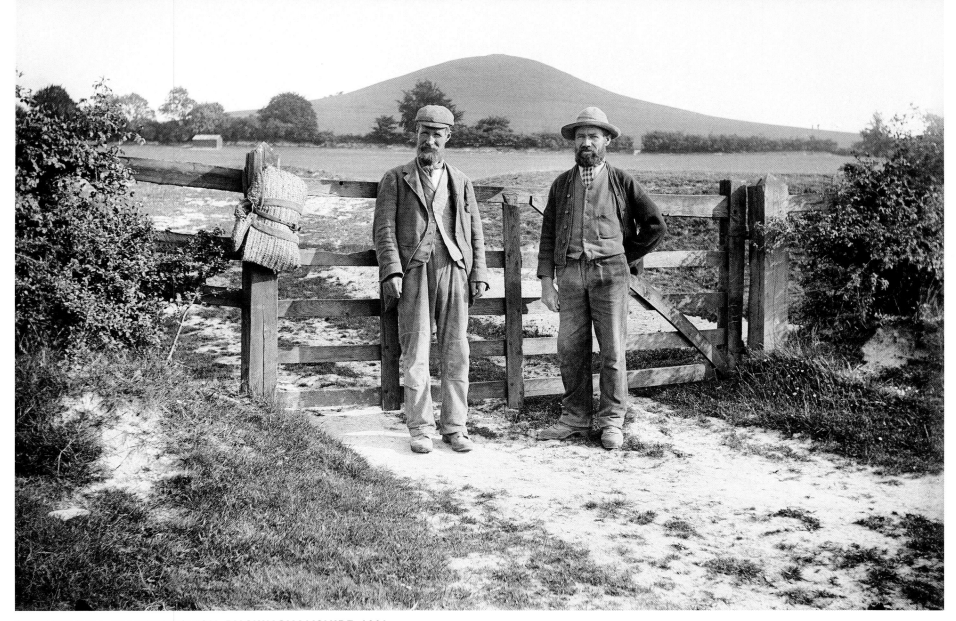

COOMBE HILL, ELLESBOROUGH, BUCKINGHAMSHIRE, 1901
Two agricultural labourers (or possibly navvies on the GCR) pose beside a field gate near Ellesborough with the distinctive shape of Coombe Hill in the background. Their straw pantrys, traditional soft bags for food and other provisions, hang on the gatepost. [AA97/07513]

Great Western Railway joint working

Soon after the opening of the London Extension it was realised that the twisting nature of the Metropolitan Railway section, combined with congestion caused by sharing the lines with Metropolitan trains, was restricting GCR services. To reduce journey times, an Alternative Route was built in conjunction with the Great Western Railway (GWR) in contracts between 1901 and 1905. This route took the GCR out of London on a sweeping curve, passing through High Wycombe and Princes Risborough before leaving the GWR at Ashendon to rejoin the London Extension at Grendon Underwood, to the north of the Metropolitan line.

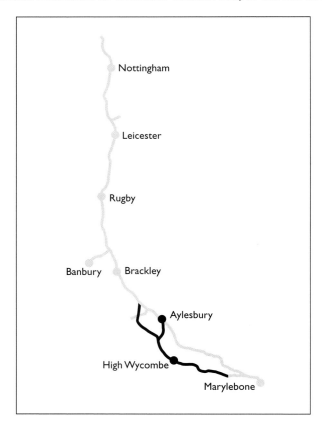

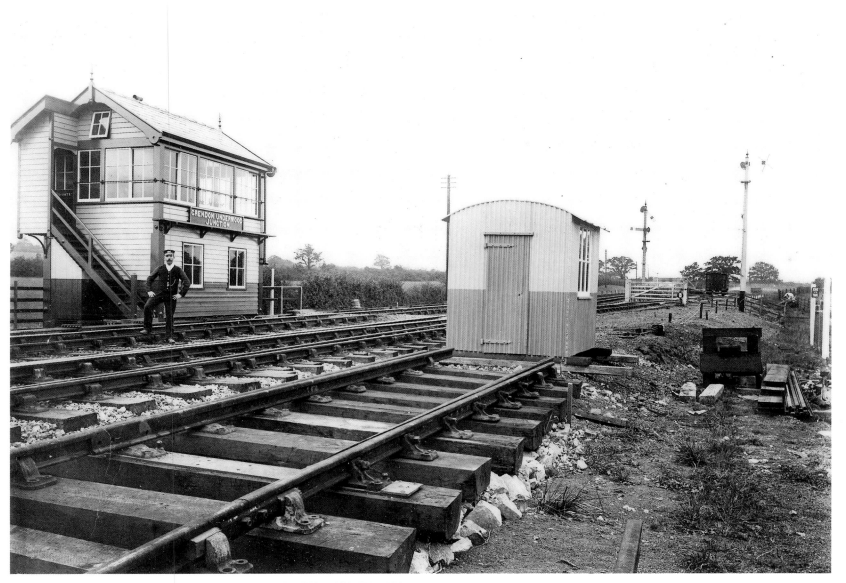

GRENDON UNDERWOOD JUNCTION, BUCKINGHAMSHIRE, 1905

The GCR joined with the GWR to rebuild part of the latter's London to Birmingham line, creating the faster Alternative Route to and from London. A spur, seen here shortly before it opened in 1905, left the GWR line at Ashendon to connect with the GCR's own London Extension at Grendon Underwood Junction and a signal box was built to control the junction. The small corrugated structure on the track was a contractor's store, which would be moved once work was completed. [L1647]

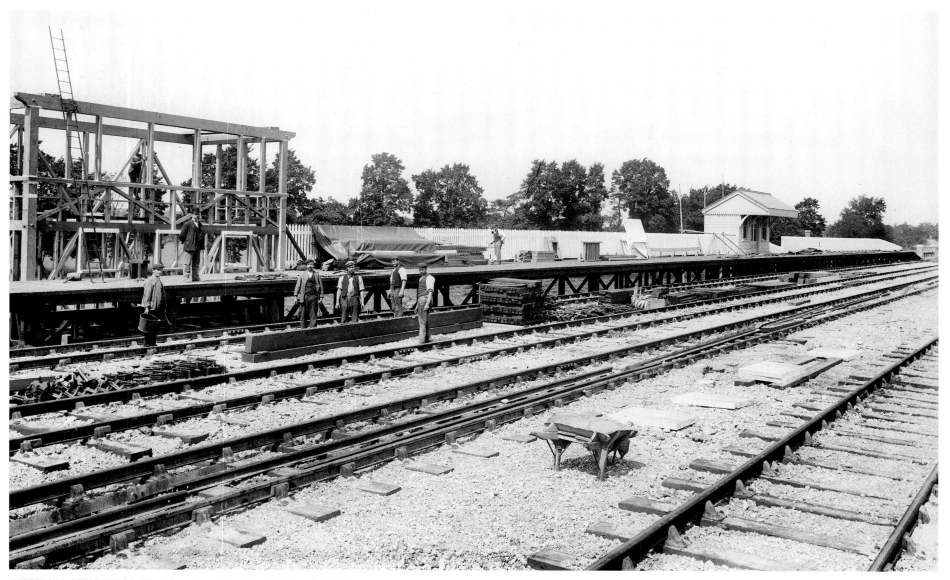

AKEMAN STREET STATION, BUCKINGHAMSHIRE, 1905

Akeman Street, seen here under construction, was one of two small stations on the link between the GCR at Grendon Underwood and the GWR joint line. This station is not a typical GCR design – it does not make use of an island platform and the buildings are of timber rather than brick, perhaps suggesting a need for economy. [BB98/02306]

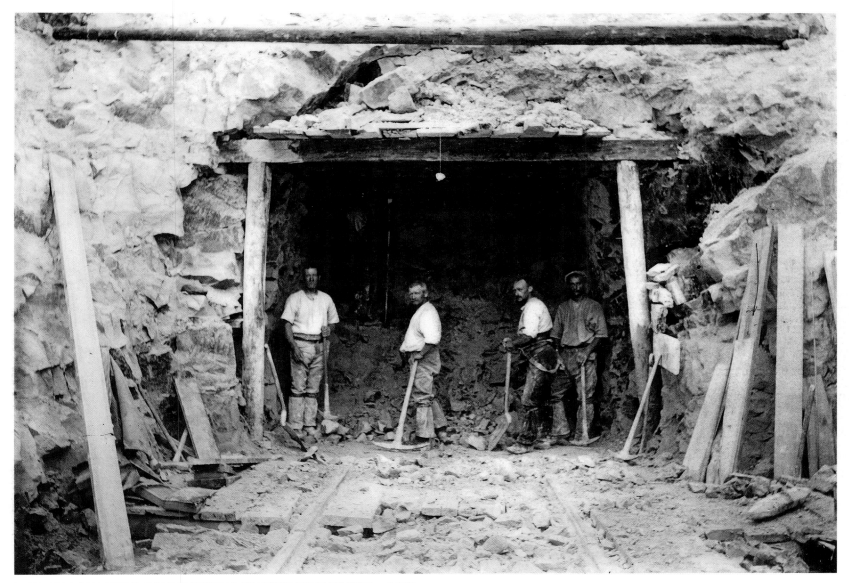

TUNNELLING NEAR SAUNDERTON, BUCKINGHAMSHIRE, c 1903

This photograph illustrates the very physical and dangerous nature of tunnel construction at the time. The tunnel heading is only supported by wooden props and the rock around it seems unstable. This short tunnel just south of Princes Risborough was 88 yards long. [L1238]

GCR AND GWR JOINT OFFICES, HIGH WYCOMBE, BUCKINGHAMSHIRE, 1902

With the two railway companies sharing the new railway, it seemed logical that they should share other facilities, such as this office in High Wycombe. [AA97/05314]

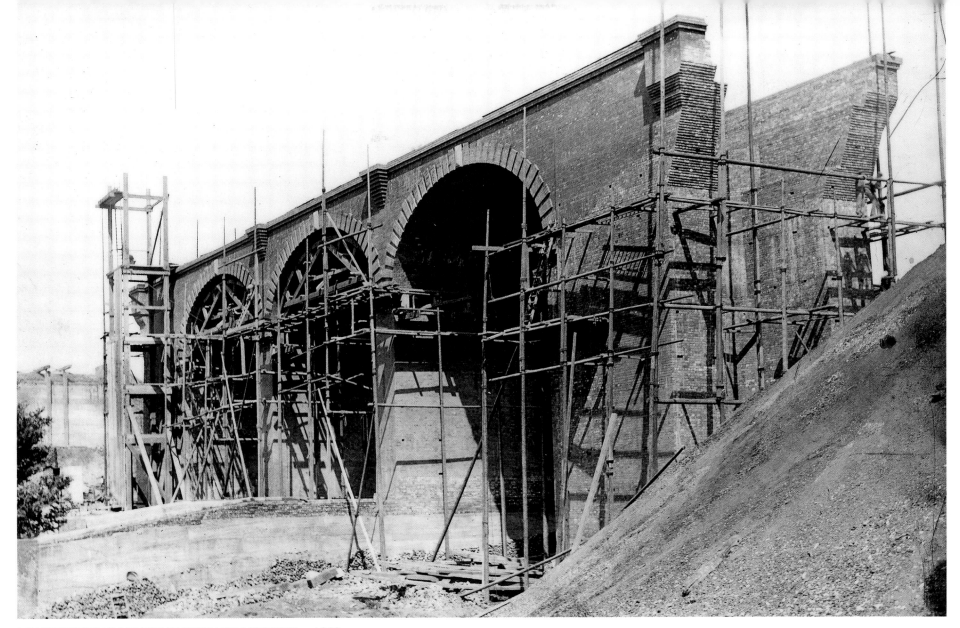

LOUDWATER VIADUCT, BUCKINGHAMSHIRE, *c* 1903

The Loudwater Viaduct near Beaconsfield was built as part of the Northolt Junction to High Wycombe contract, constructed between 1901 and 1905 by Pauling & Co of Westminster. This photograph shows that the viaduct was designed as two outer 'skins' that still have to be filled in. Scaffolding surrounds the partially completed structure, the parapet walls have still to be added and the embankment cannot be built up until the viaduct is finished. [L1170]

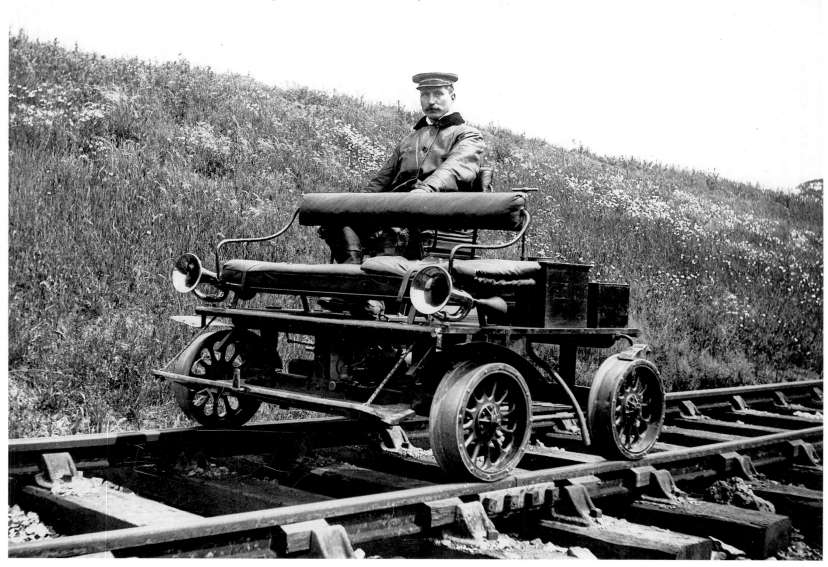

INSPECTION TROLLEY NEAR DENHAM, BUCKINGHAMSHIRE, c 1903

This unusual four-wheeled engineers' inspection trolley, powered by an internal combustion engine, may have been made by the Drewry Car Co Ltd of Teddington. It probably had a BSA single-cylinder, four-stroke, air-cooled engine with a two-speed gearbox and chain drive to the rear axle. Note the highly specified padded bench seat and the brass horns on either side. The driver is dressed in a typical chauffeur's uniform with button-over front and fur collar. [L1100]

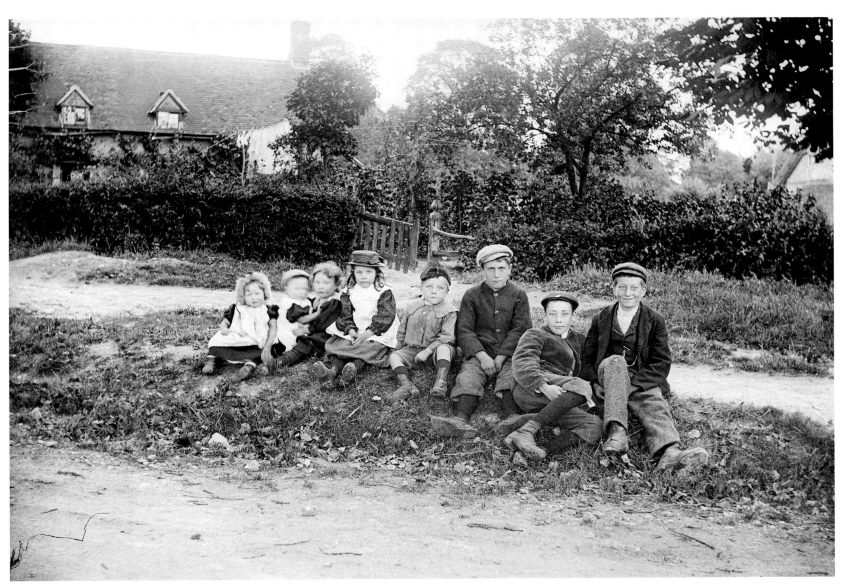

LOWER WINCHENDON, BUCKINGHAMSHIRE, 1902

Spurred on by curiosity, a group of children of different ages have gathered together for the photographer. As they pose on a bank, the younger children seem uncertain about what is happening. [AA97/05309]

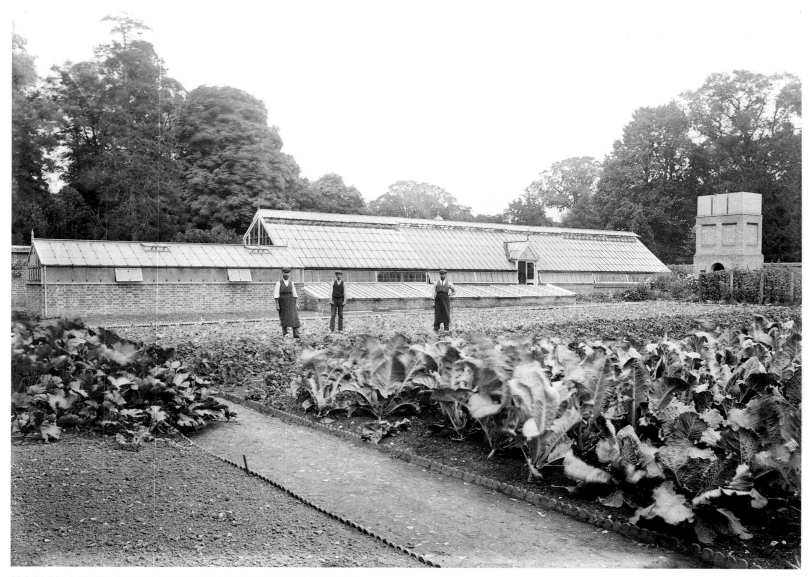

NOTLEY ABBEY, LONG CRENDON, BUCKINGHAMSHIRE

Many large houses maintained kitchen gardens to produce fresh fruit, vegetables and cut flowers throughout the season and Notley Abbey was no exception. The walled kitchen garden is seen here, complete with gardeners, greenhouses, cold frames and a water tower. A combination of the railway, which transported fresh produce around the country, and wage inflation gradually saw the decline of household economies such as this. [BB97/08204]

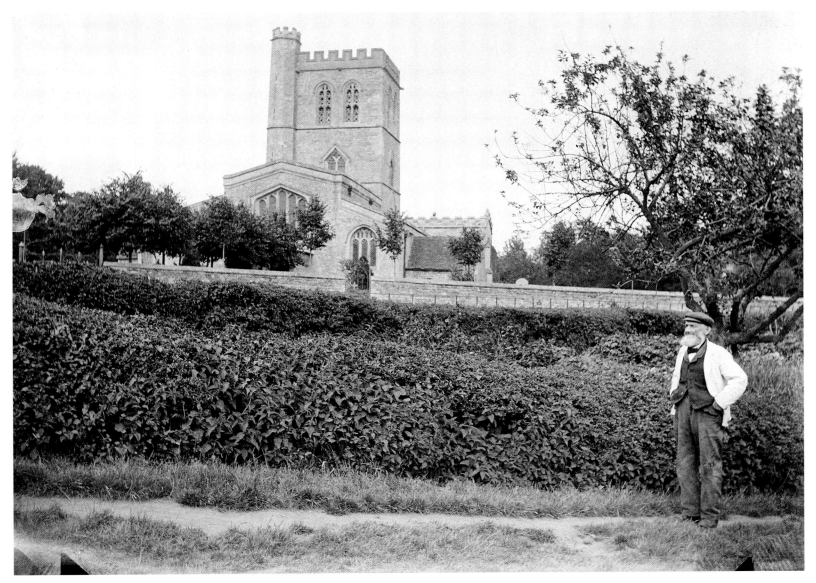

LONG CRENDON, BUCKINGHAMSHIRE, AUGUST 1904

A bearded elder of Long Crendon walks past the church. St Mary's is a large building with a central crossing tower. The tower is late Perpendicular (late 15th–early 16th century in date), though the remainder of the church is Early English (early 13th century). [AA97/05649]

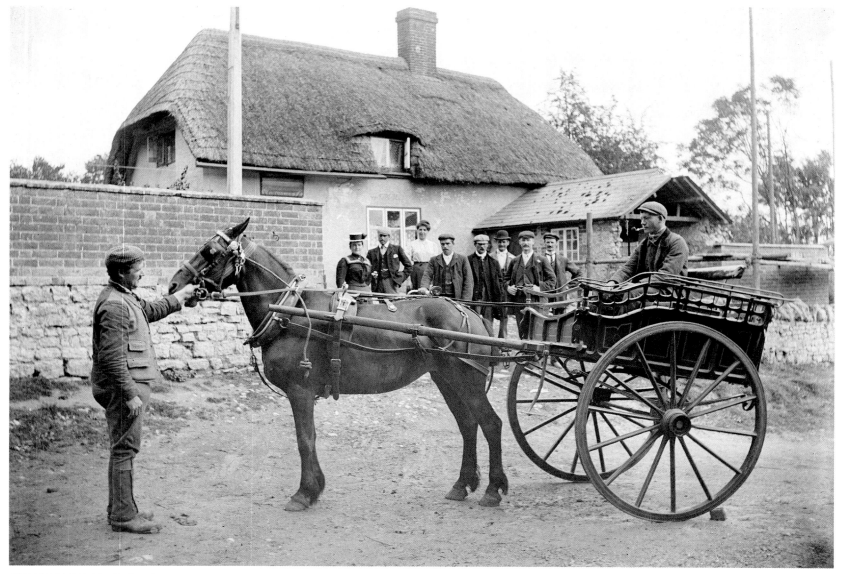

CHEARSLEY, BUCKINGHAMSHIRE, 1900

A small crowd has gathered to watch Newton photograph a horse and trap outside the White Horse Inn in Church Lane (licensee Samuel King). Jesse Coggins holds the horse's head and Harry Turner rides in the trap. The stone extension at the front of the inn served as a bakery. The inn burned down soon after this picture was taken, but it was rebuilt after the fire. [AA97/05480]

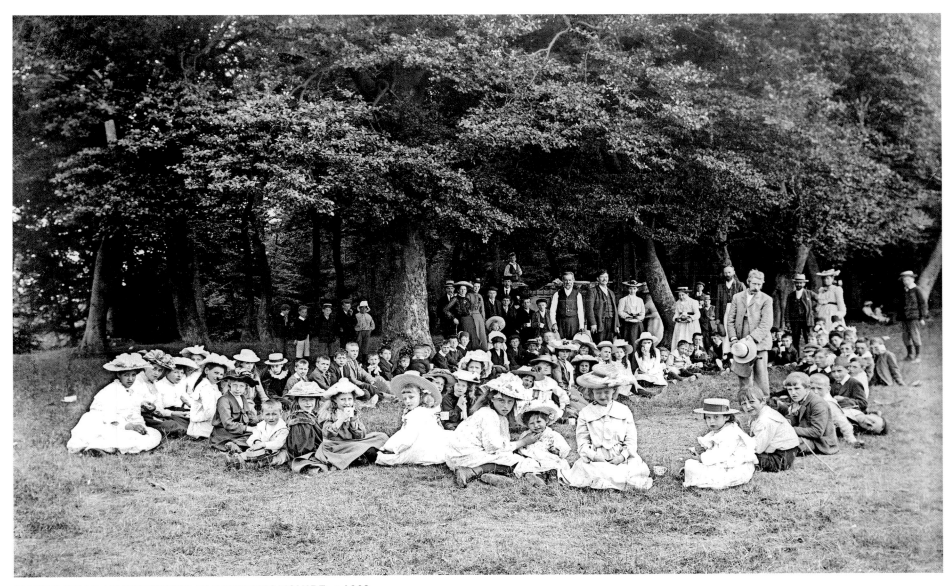

PICNIC NEAR HADDENHAM, BUCKINGHAMSHIRE, *c* 1903

These children have dressed up to enjoy a picnic near Haddenham. Their adult hosts stand in the shade of the wood. The occasion for this treat is unknown. [BB97/08231]

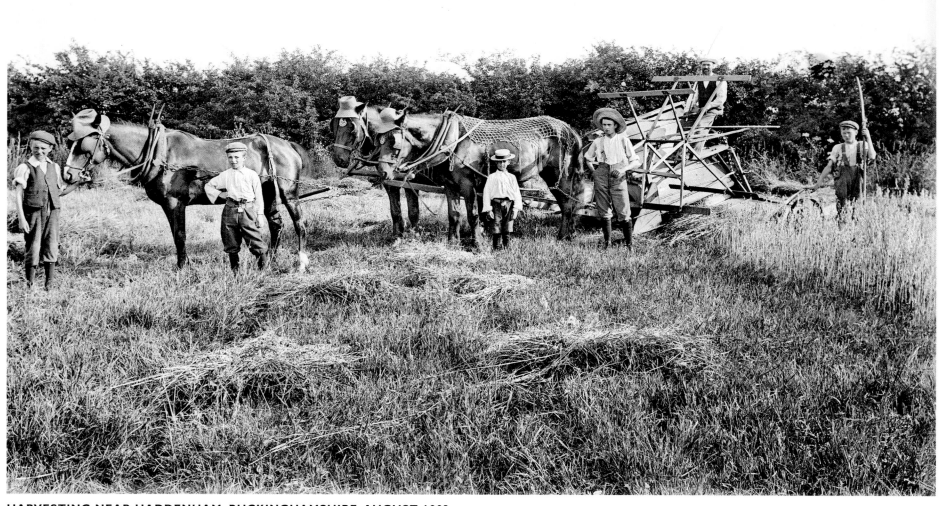

HARVESTING NEAR HADDENHAM, BUCKINGHAMSHIRE, AUGUST 1903

Increasing mechanisation led to a reduction in the amount of manual labour required by agriculture. Reaping and binding machines were designed both to reduce costs and to speed up the harvest in the uncertain British weather. Here a reaper-binder drawn by three horses is in use. It cut the cereal and bound it into sheaves that were then thrown out to the side. The process may not have required help from all five boys, but one would certainly be needed to lead the team and others to gather the sheaves into stooks. [BB97/08222]

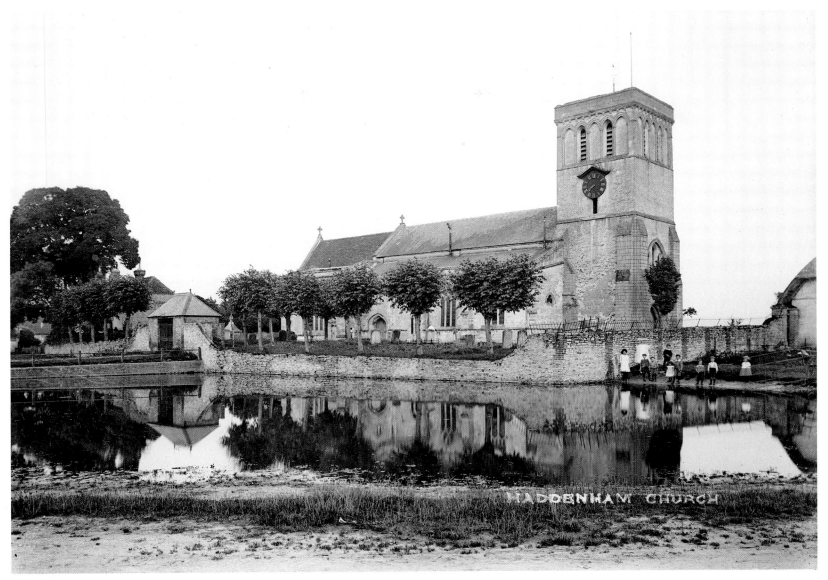

ST MARY, HADDENHAM, BUCKINGHAMSHIRE, AUGUST 1903

This view is of St Mary's Church, Haddenham, from the north-west across the village pond. The imposing west tower dates from the 13th century. A group of children have gathered against the churchyard wall on the far side of the pond to watch Newton at work. [BB97/08208]

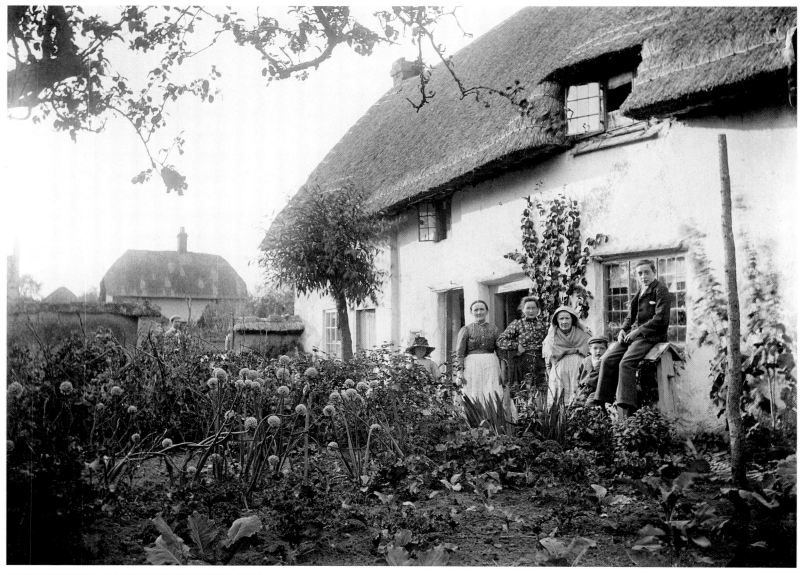

HADDENHAM, BUCKINGHAMSHIRE, 1900

Three generations of a family pose for the photographer in the garden outside their thatched cottage in Haddenham. Most of the garden is given over to vegetables to supplement their diet. [AA97/05311]

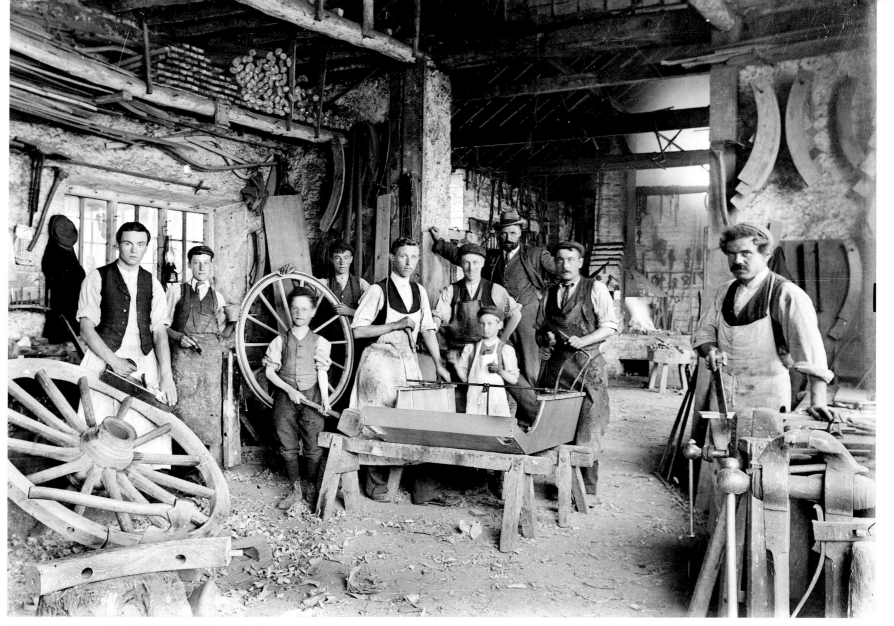

HADDENHAM, BUCKINGHAMSHIRE, 1903

The staff at J Plater's Cart, Van and Carriage Works pose for a group photograph. The gentleman in the suit may be the proprietor. Several traditional crafts are seen here: carpenter, wheelwright and smith. Two of the apprentices look particularly young, a reminder that the school leaving age at this time was 12 years and was not raised to 14 years until 1918. [BB97/08210]

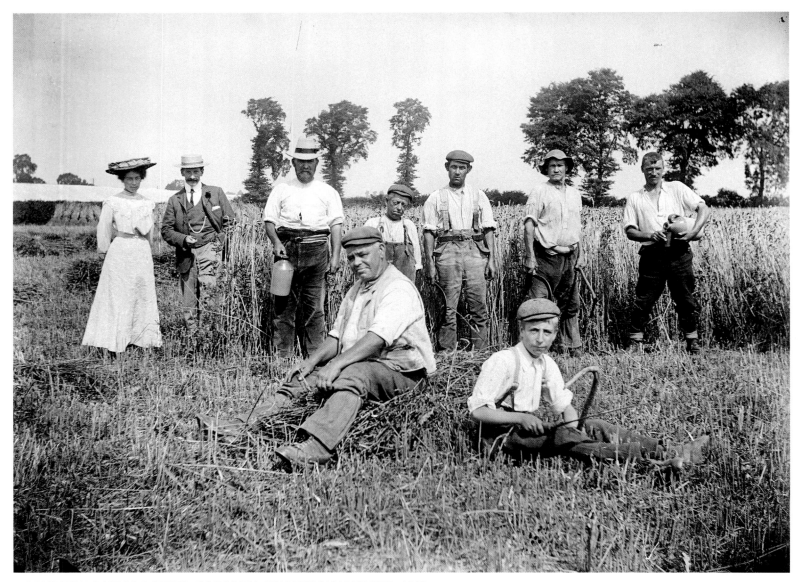

HARVESTING NEAR LOWER CADSDEN, BUCKINGHAMSHIRE, 1903

A group of farm labourers pause to be photographed during the harvest and take the opportunity for refreshment at the same time. Note the curved stick held by the seated boy in the foreground – this is a simple safety device used in one hand to hook a stook of corn, which is then cut with a sickle in the other. The well-dressed lady and gentleman on the left may be the farmer and his wife who have come to join the photograph. [AA97/05316]

RECTORY, MONKS RISBOROUGH, BUCKINGHAMSHIRE

The Rectory in Mill Lane is glimpsed here from the garden. Dating from 1670, it was much enlarged in 1863. The rector at the time of Newton's visit was the Revd George Blamire Brown MA. [BB98/02204]

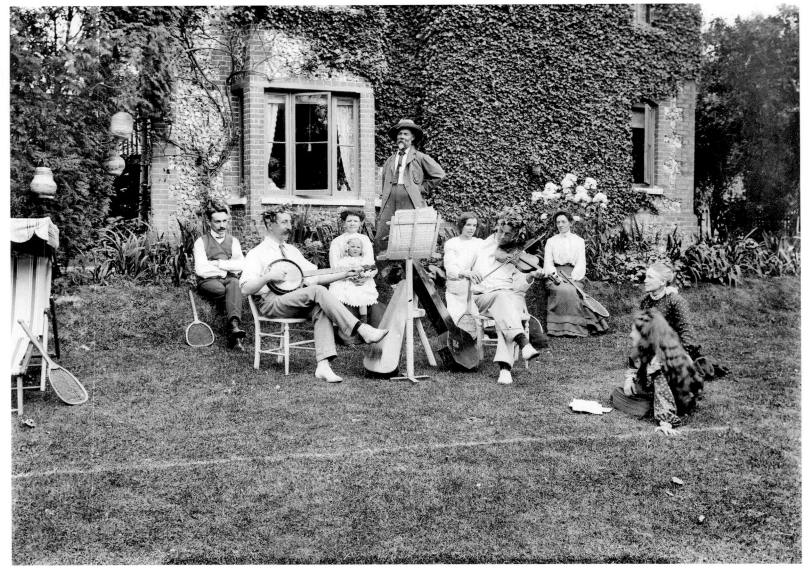

GARDEN PARTY, PRINCES RISBOROUGH, BUCKINGHAMSHIRE

The Edwardian years at the start of the 20th century were a time of increasing leisure and informality for the rising middle classes. Here a house party relaxes in a suburban-looking garden. Two men play a duet on a violin and a ukulele, while tennis rackets hint at a more strenuous pastime. Chinese lanterns suggest that the gathering may continue into the evening. A household such as this would have employed at least one servant, who may have lived out. [BB98/05519]

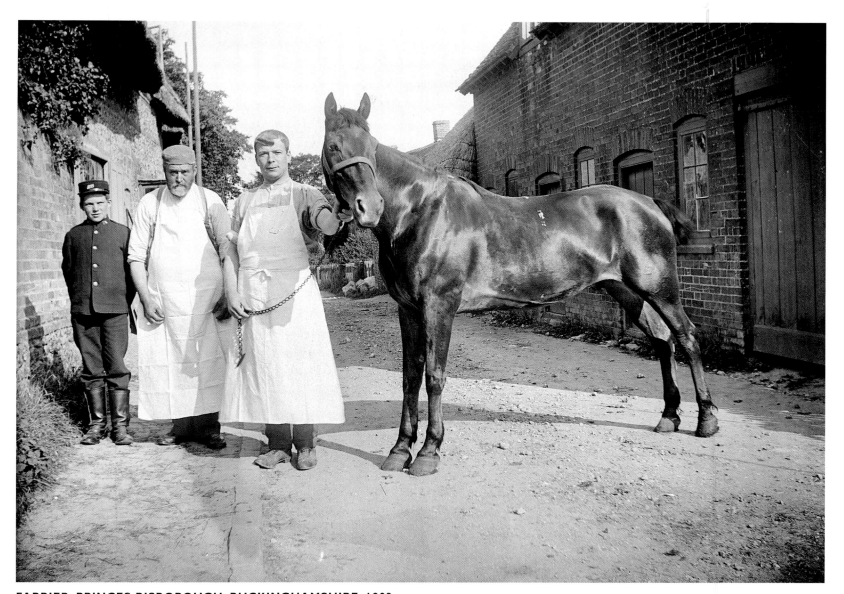

FARRIER, PRINCES RISBOROUGH, BUCKINGHAMSHIRE, 1903

Mr Smith, a farrier, and his assistant pose with a horse. A telegram delivery boy has joined them for the photograph. Farriers were assured of steady work at this time because horses were the main means of transport and a critical tool for agriculture, and horses typically needed to be shod every month to six weeks depending upon what they were used for. [AA97/05386]

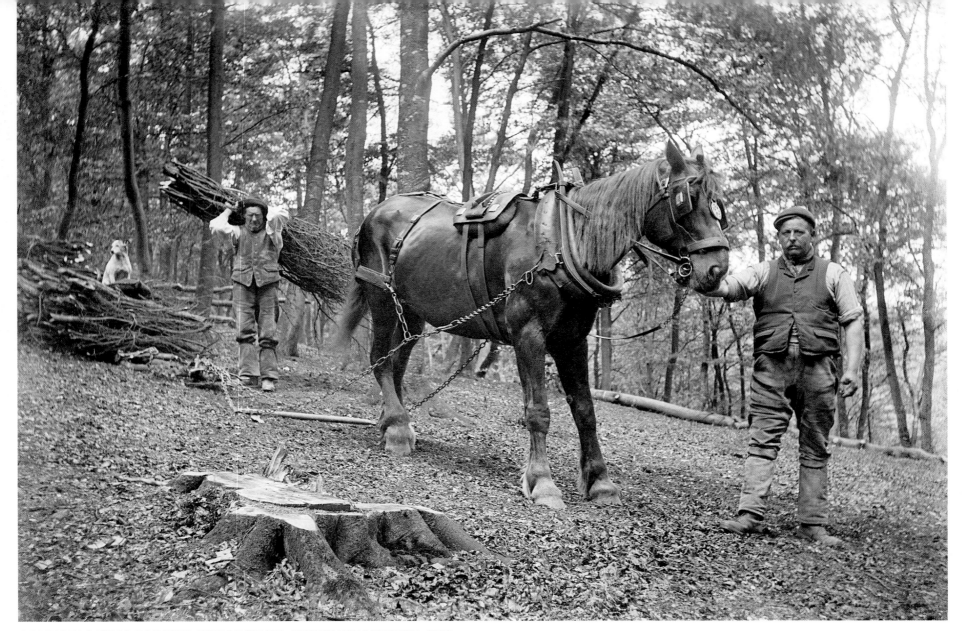

COPPICING NEAR PRINCES RISBOROUGH, BUCKINGHAMSHIRE, 1903

Woodland was an important economic resource. One method was to coppice or manage the trees to create a supply of straight, uniform poles for a variety of uses. Here two men gather young timber produced by coppicing, which is then dragged out of the wood by the horse. [AA97/05315]

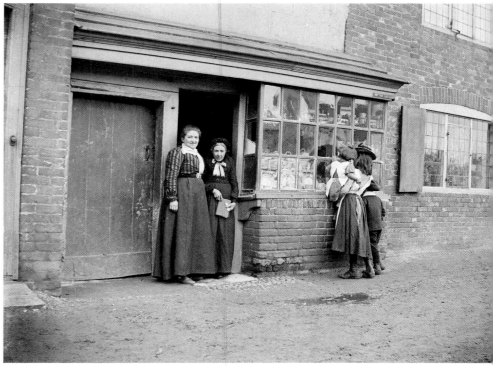

BEACONSFIELD, BUCKINGHAMSHIRE, 1902

Miss Emma Clark and Mrs Clark pose in the doorway of their fancy goods shop in the High Street, Beaconsfield, while two young women with a toddler indulge in a little window shopping. [AA97/05326]

MEETING HOUSE, JORDANS, BUCKINGHAMSHIRE, 1903

The Friends' Meeting House at Jordans, Chalfont St Giles, is one of the oldest in the country. It was opened in 1688, though meetings were taking place in a neighbouring building by 1669. (William Penn, founder of the colony of Pennsylvania, was a member here from 1672–7.) Friends' meeting houses are traditionally very simple, as is their worship. This interior view shows the plain panelling around the walls, which dates from 1773, and open wooden benches. [AA97/05345]

Contract No. 7:
Canfield Place to Marylebone

The final contract took the GCR from Canfield Place to its new London terminus at Marylebone. Built by J T Firbank of London Bridge, much of this section was, of necessity, tunnelled under London's inner suburbs; the tunnels, which passed beneath Lord's Cricket Ground, took four years to complete (1894–8). A few years later, a new line was laid from Neasden to Northolt to connect with the Alternative Route shared with the GWR.

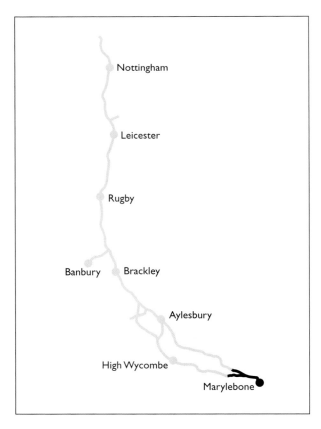

WEST HAMPSTEAD, GREATER LONDON, *c* 1897

After leaving the Metropolitan Railway's metals close to Canfield Place, the last leg of the London Extension into Marylebone ran mostly underground through a series of tunnels. Here work on the tunnels between Canfield Place and Broadhurst Gardens appears almost complete. The level of disruption caused by the construction of these tunnels must have been considerable, especially considering the amount of compulsory purchase and demolition of property that was required. The white walls of the building on the right of the tunnel entrance show the fireplaces where a house has been demolished. [L1509]

WEST HAMPSTEAD, GREATER LONDON, c 1897

This steam crane is in use on the Fairfax Road, with a large house in the background. Nine navvies stand around the crane, three of whom are almost hidden in the ramshackle shelter that surrounds the crane's boiler and winch drum. These shelters or cabins were often built by the navvies themselves out of anything they could get their hands on – in this case wood, but sometimes corrugated iron. The crane's hook can be seen in blurred motion, swinging on the right. The piles of logs and wood that litter the ground would have been used to shore up tunnel walls before the brickwork was completed. [L1204]

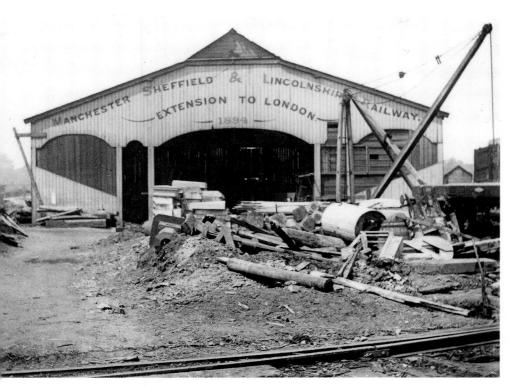

ST JOHN'S WOOD, GREATER LONDON, *c* 1897

There's nothing like a bit of free advertising and the same was true in the late 19th century. The building featured here is the carpenters' shed in Alpha Road that belonged to J T Firbank. Painted in bold letters on the shed's awning are the words 'Manchester, Sheffield & Lincolnshire Railway Extension to London 1894', making it quite clear who the work was being carried out for. Plenty of building materials and timber litter the foreground and a scotch derrick can be seen to the right. [L1515]

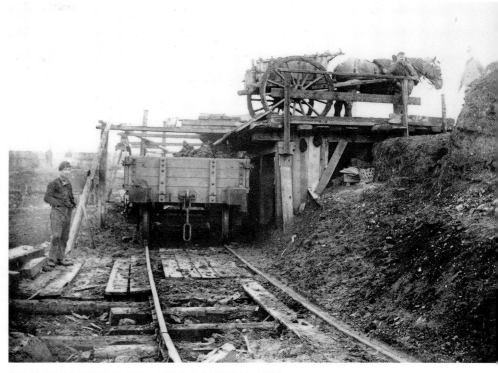

ST JOHN'S WOOD, GREATER LONDON, 1897

It is strange to think that a new high-speed railway with its gleaming locomotives and luxurious carriages required a horse and cart to help build it. This pony is pictured depositing its cart's load into a wagon near Carlisle Street. The construction and condition of the contractor's temporary rails and loading dock is poor, but not untypical. Looking at the muddy state of the earth, the photograph was probably taken after a period of heavy rain. The navvy on the left looks slightly wary of Newton's camera. [L1260]

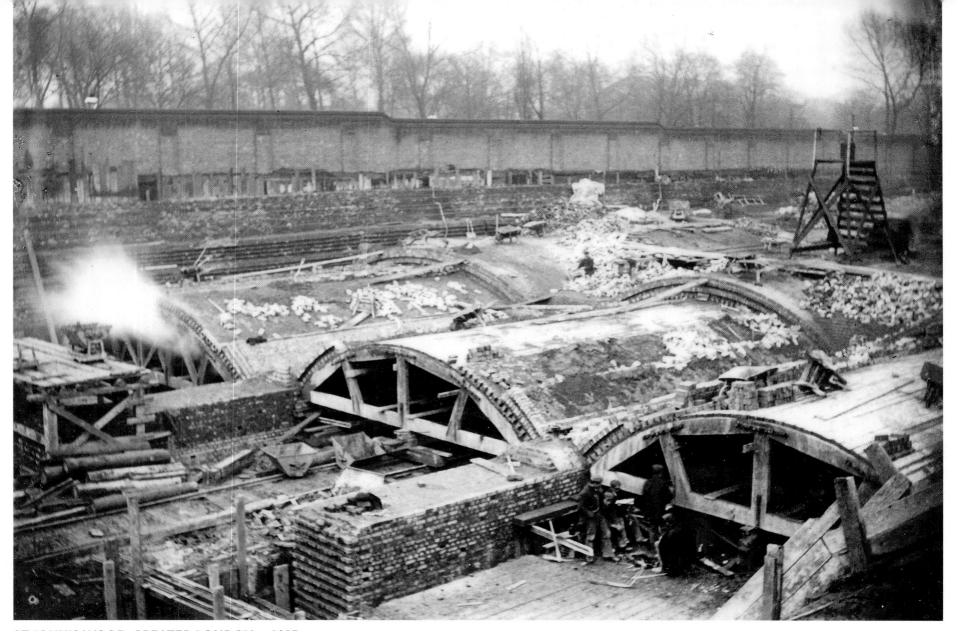

ST JOHN'S WOOD, GREATER LONDON, c 1897

Much to the annoyance and protestation of W G Grace and his fellow cricketers, the GCR opted to build the London Extension directly beneath Lord's Cricket Ground. Eventually the cricketers conceded when they were promised a brand new pitch. This photograph shows the construction work in progress. The tunnels were built by the 'cut and cover' method, rather than by boring, and this is shown to good effect here. The wooden centrings are in place and the brick courses are being built up. The scale of the work can be judged by the group of navvies gathered in the bottom right of the picture. When finished, the area would be covered over and the new cricket pitch laid. [L1341]

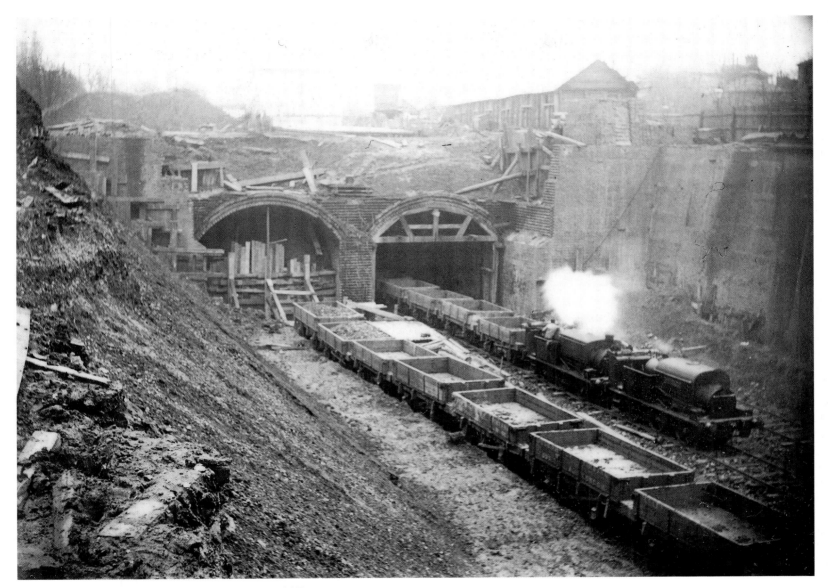

ST JOHN'S WOOD, GREATER LONDON, c 1897

This photograph shows the construction of the twin-arch 'cut and cover' tunnel at Wellington Place, the road that ran alongside Lord's Cricket Ground. It is a fine illustration of railway construction at the end of the 19th century, featuring many of the elements one would expect to find on such a project. The double-heading contractor's locomotives are both products of the Hunslet Engine Co of Leeds. The leading locomotive is named *Henry Appleby*, while the other is named *Hunslet* after its builder. Work on the interior of the tunnels must be progressing well, although the façades have still to be built. [L1317]

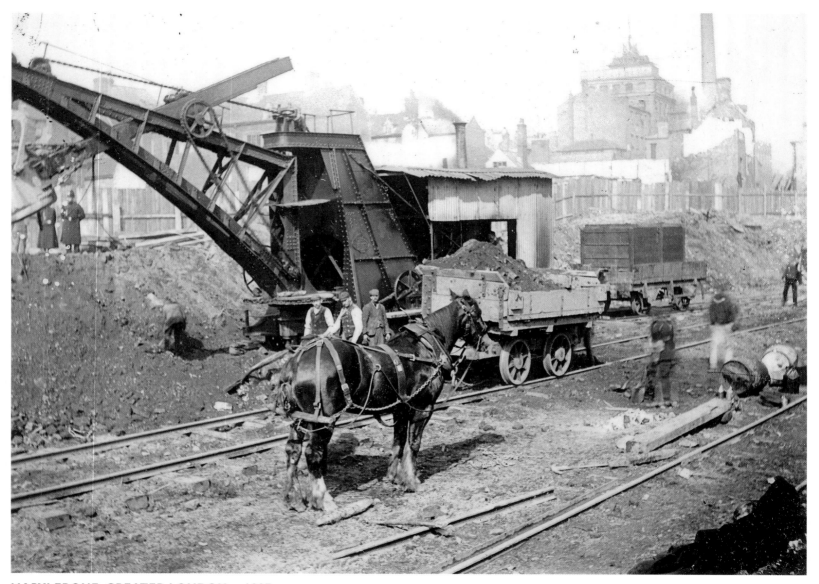

MARYLEBONE, GREATER LONDON, c 1897

This steam-powered Dunbar-Ruston excavator was photographed by Newton at work in the vicinity of Marylebone Station. The navvies took great care of the machines they were responsible for, along with the numerous horses that were employed to haul tipping wagons. The coat of this horse shines in the sunlight, a testament to its well-being. Note the two policemen keeping a watchful eye on proceedings by the fence on the left. [L1316]

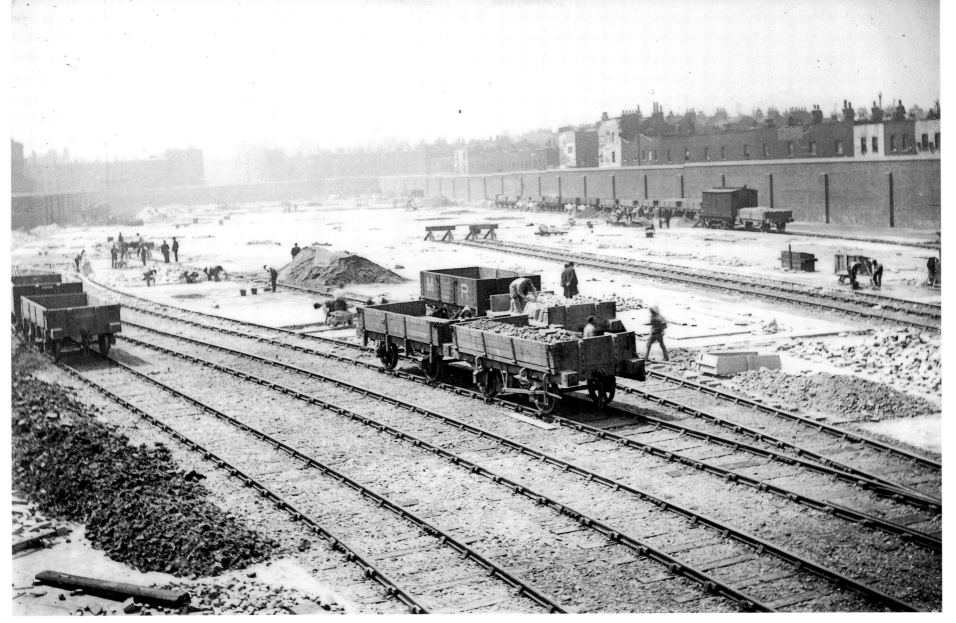

MARYLEBONE, GREATER LONDON, _c_ 1896

The site of the future Marylebone Station appears huge without the train shed and platforms that would eventually form the London Extension's terminus. Levelling the area would have been a massive undertaking and required the demolition of a number of private residences in order to clear the site. Compulsory purchase was a necessity to create the new railway and the GCR was obliged to build new housing for the displaced residents, which was usually of a far higher standard than their previous homes. The various tracks and sidings that enter the photograph from the right were used to bring in materials and were connected up to the Metropolitan Railway in West Hampstead. [L1315]

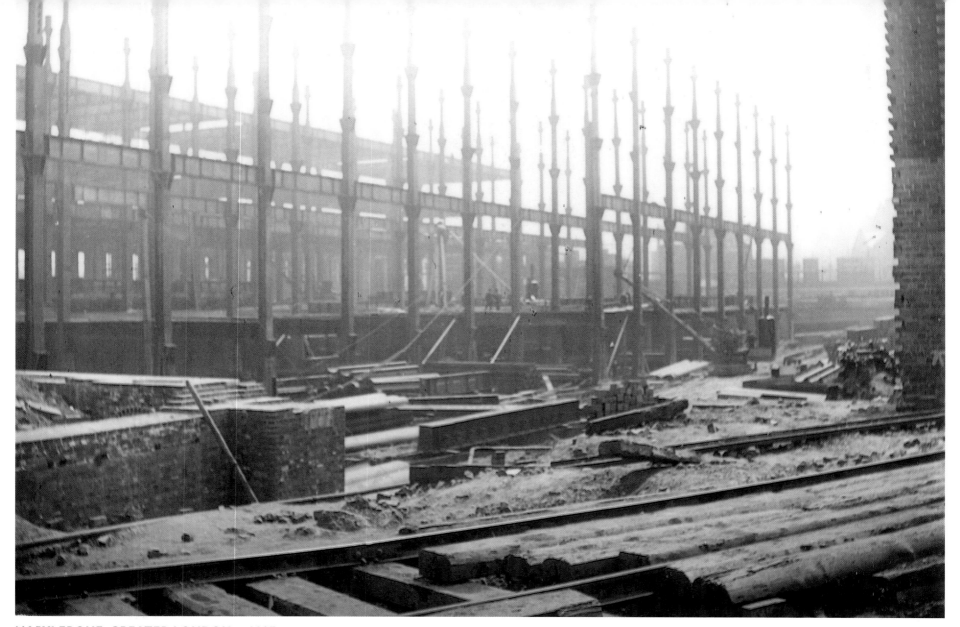

MARYLEBONE, GREATER LONDON, c 1897

In spite of being considerably smaller than the other north London termini of Paddington, Euston, St Pancras and King's Cross, the facilities at Marylebone were extensive. As the line emerged from Lodge Road Tunnel, the goods yard opened up on the west side with the main goods offices on Broadley Terrace and a coal depot on Carlisle Street. The goods shed, seen here under construction, was almost as large as Marylebone passenger station and used the same steel construction techniques. These facilities provided much needed revenue for the GCR. [L2229]

HOTEL GRAND CENTRAL, MARYLEBONE, GREATER LONDON, c 1900

The Hotel Grand Central – the magnificent showpiece of the London Extension's terminus at Marylebone – is shrouded in scaffolding that bears the promise of 'all the latest sanitary improvements'. The building was designed by R W Edis and, in accordance with late Victorian standards, was a lavishly decorated and beautifully executed piece of craftsmanship. The GCR themselves had insufficient funds to build the hotel they desired. However, Sir John Blundell Maple, the furniture magnate, purchased the site from them on the understanding that a hotel would be built and duly obliged with this marvellous testament to the golden age of railways. [L2230]

The navvy community

The construction of the GCR provided work for around 10,000 men. Many were itinerant labourers who travelled around the country from job to job, often with their families in tow. It was a hard life, but navvies were a proud and independent group. In common with many large civil engineering projects, the contractors on the GCR built temporary settlements for their workers. Although the huts were simple, prefabricated structures, they offered the navvy community a level of accommodation that compared favourably with working-class housing elsewhere. Moral and religious welfare was looked after by a number of voluntary societies, chief of which was the Navvy Mission Society (founded 1877), whose missionaries were active along the construction route. At the end of the project the men dispersed, the settlements disappeared and the mission was wound up. Though they were not to know it, the job of a railway navvy was soon to become a thing of the past too.

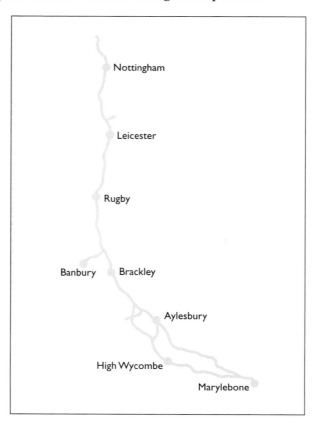

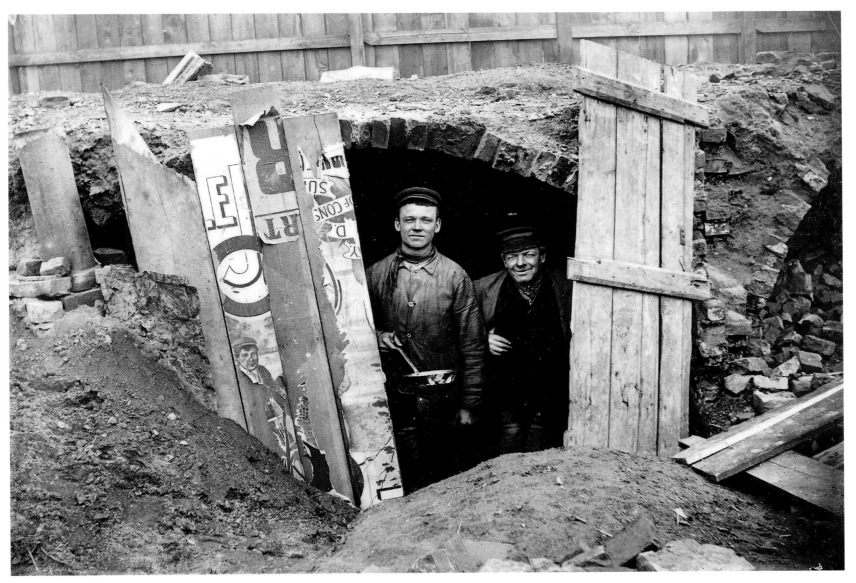

NOTTINGHAM, NOTTINGHAMSHIRE, c 1897

Putting the cellar of a demolished property to good use, these navvies are enjoying their breakfast on the site of Nottingham Victoria Station. Ramshackle hovels like this were found along the whole line, where the navvies could shelter in poor weather or even hide their beer from prying Customs officials. The life of a navvy was undeniably hard, but they considered it to be a good life. [L1571]

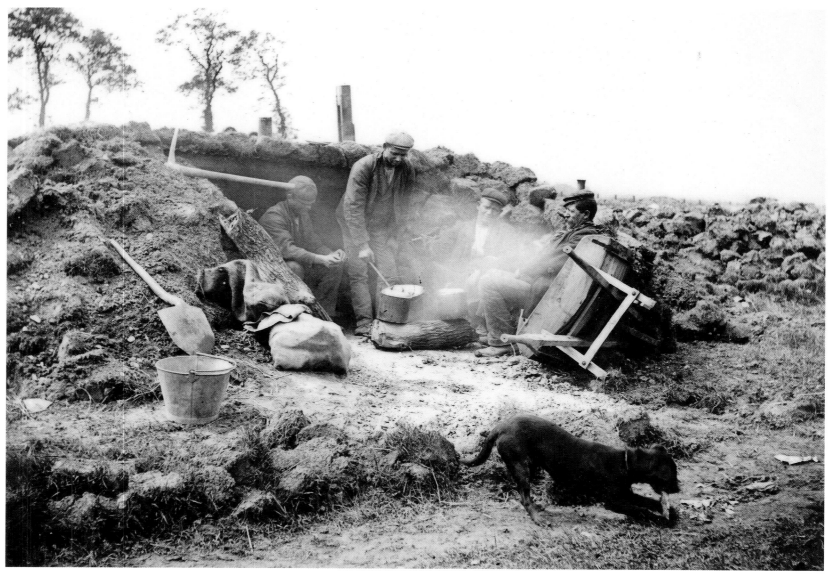

TAKING A BREAK NEAR HELMDON, NORTHAMPTONSHIRE, c 1897

After a hard morning's graft these four navvies have their lunch in a turf hut. It is a fascinating example of how the navvies put the huge quantities of earth moved during the railway's construction to good use. [L1240]

SHED NEAR CALVERT, BUCKINGHAMSHIRE, *c* 1897

The size and shape of this temporary wooden shed near Calvert suggests that it cannot be anything other than a privy. Beside it, a navvy appears to be breaking up a plank with a pickaxe, or perhaps creating a cesspit. [L2908]

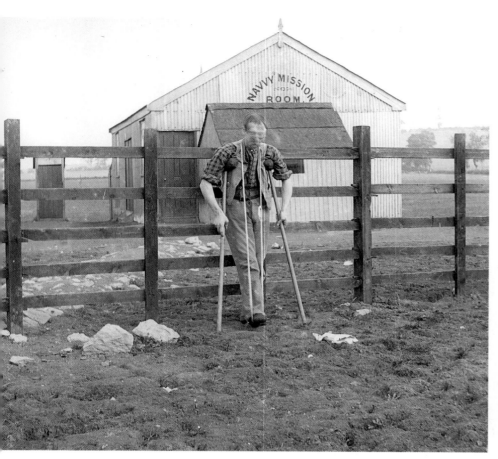

AN INJURED NAVVY AT FLECKNOE, NORTHAMPTONSHIRE, *c* 1897

At this temporary building the navvies and their families could attend the services and Sunday school conducted by a lay preacher of the Navvy Mission Society. The man on crutches is a Mr Birch. Perhaps he sustained his injury while at work on the nearby Catesby Tunnel, for in spite of the significantly better working conditions that existed at the end of the 19th century, tunnel construction remained one of the most hazardous tasks a navvy could undertake. [L3127]

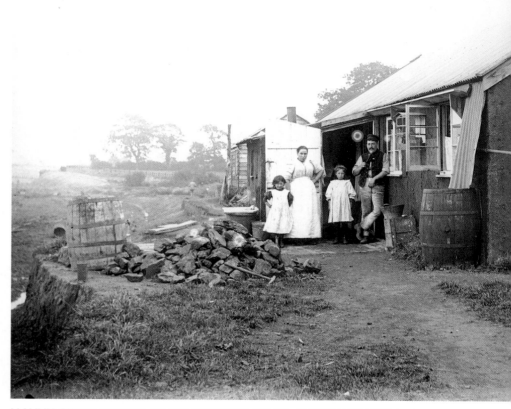

NAVVY SETTLEMENT AT HILMORTON ROAD, RUGBY, WARWICKSHIRE, *c* 1897

In line with current practice, the contractors on the GCR built temporary settlements for their workers. At least on this section of the GCR, the huts were built of weatherboarding on a timber frame. Elsewhere they were often made of corrugated iron and settlements were consequently known as 'tin towns'. Here Mr T Blagden poses with his family beside their hut at Hilmorton Road, in this case erected by the contractor T Oliver & Son. [L3076]

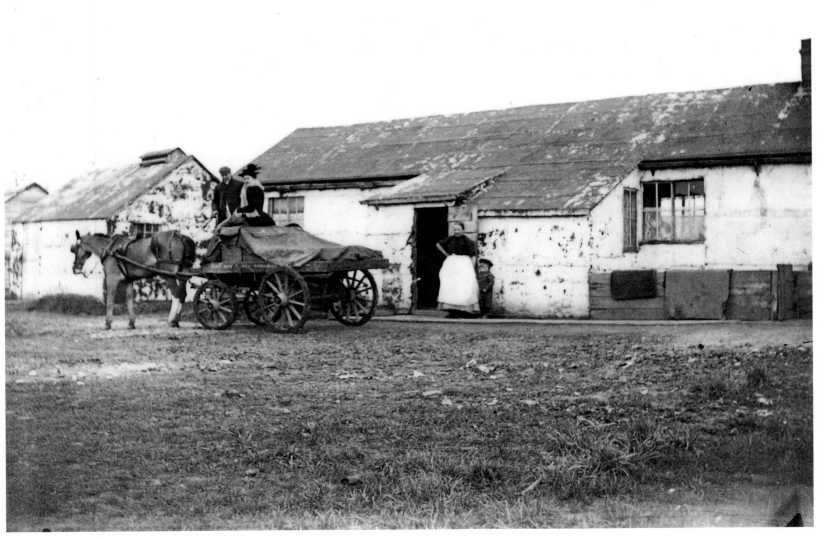

NAVVY SETTLEMENT NEAR SWITHLAND, LEICESTERSHIRE, *c* 1897

In this photograph a family poses for Newton's camera outside their hut at a navvy settlement near Swithland. By today's standards this accommodation is certainly primitive, but it compared favourably with the cottages of the rural and urban poor and allowed the navvy to live with his family in relative comfort. [L2446]

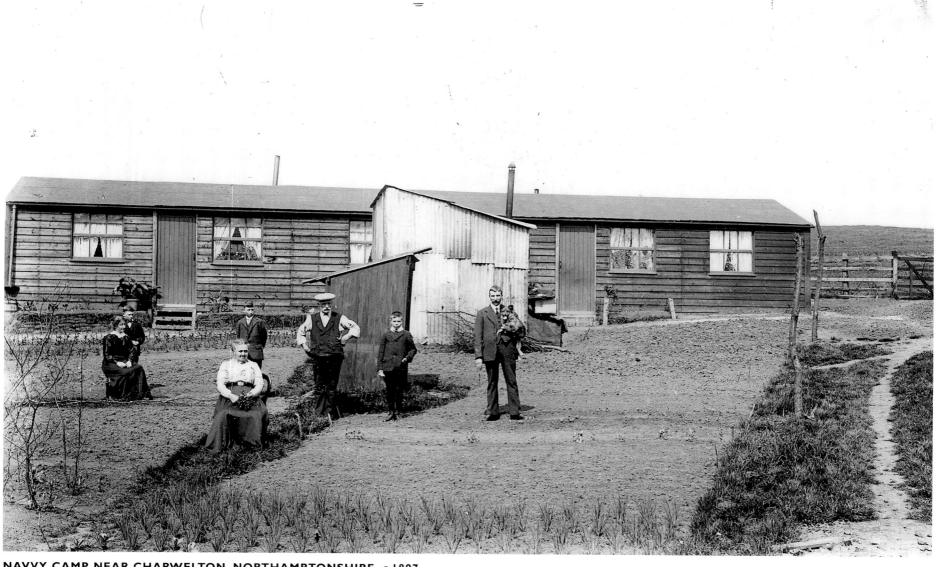

NAVVY CAMP NEAR CHARWELTON, NORTHAMPTONSHIRE, _c_ 1897

The Victorians were very aware of status and therefore different grades of accommodation were often provided for managers. These supervisors' cabins and gardens were at a camp near Charwelton. Garden plots were often provided for all grades to grow food. [L1560]

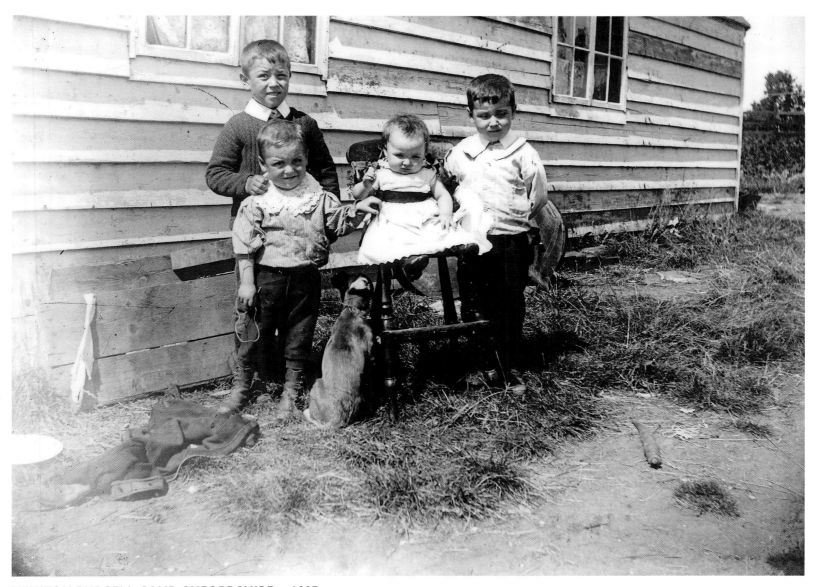

NEWTON PURCELL CAMP, OXFORDSHIRE, *c* 1897

Although a navvy settlement would have accommodated a high proportion of single men, navvies increasingly travelled with their families so that it would also have housed a significant number of family groups. These four children and their dog, photographed outside a hut at Newton Purcell Camp, appear to be well dressed, a reminder that navvies were comparatively well paid and these settlements were far from being slums. [L1577]

INTERIOR OF A NAVVY HUT NEAR CALVERT, BUCKINGHAMSHIRE, JUNE 1897

As this photograph testifies, the huts provided by the contractors were well built and could be made quite comfortable. That said, this particular example – complete with chaise longue, carpet and a fine chest of drawers – would not have been home to an ordinary navvy, but rather to a high-ranking member of the construction team. [L2832]

INTERIOR OF A NAVVY HUT NEAR NEWTON, WARWICKSHIRE, *c* 1897

This cabin is thought to have been photographed near Newton. Plain but wholesome, these relatively comfortable surroundings would be home to a foreman or supervisor and his family. With pictures on the wall, a plant in the window and a range for cooking and heating, the occupants of this dwelling have clearly made themselves a home. [L2367]

INTERIOR OF A HUT NEAR CALVERT, BUCKINGHAMSHIRE, JUNE 1897

The temporary accommodation erected by the contractors appears remarkably spacious in this photograph, although this is probably the interior of a foreman's hut. As the pram standing by the table demonstrates, this man had his family living with him. [L2432]

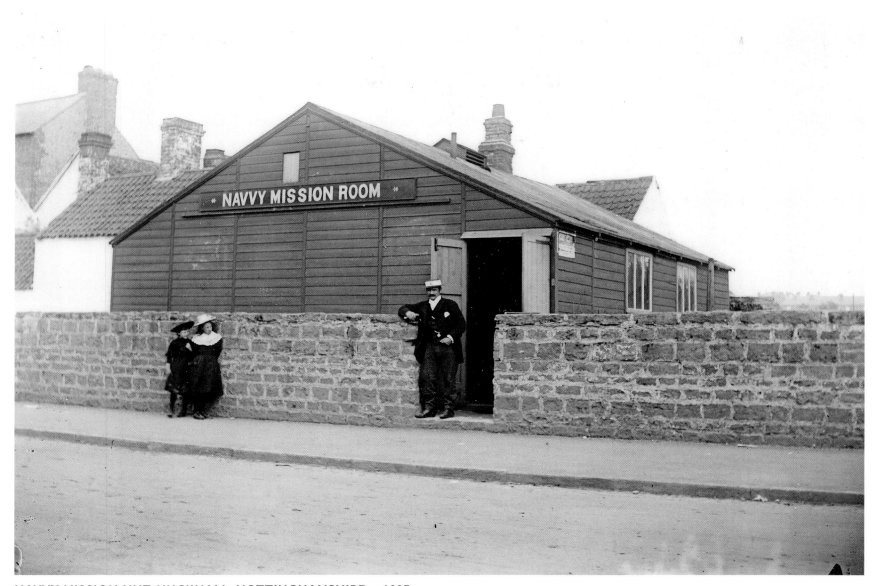

NAVVY MISSION HUT, HUCKNALL, NOTTINGHAMSHIRE, c 1897

The purpose-built mission hut at Hucknall served the navvies working on Contract No. 1. The man by the door is probably the missionary himself, D Smith, who was also responsible for Bulwell. The missions were used by the whole navvy community, not just for religious purposes. The two children may be on their way to attend Sunday school. [L1244]

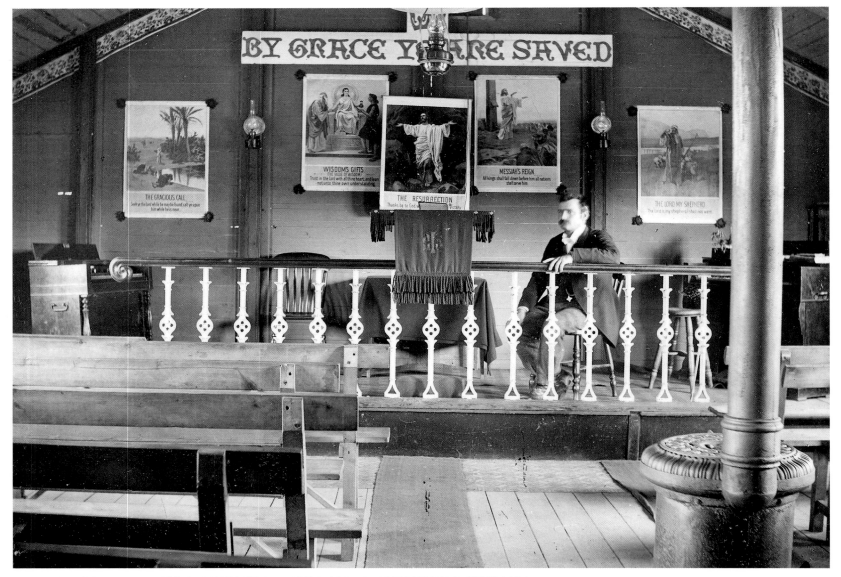

INTERIOR OF NAVVY MISSION HUT AT BULWELL, NOTTINGHAMSHIRE, JULY 1897

This mission hut was built for the navvies working on Contract No. 1. Pictures depicting the life of Jesus Christ adorn the walls above the altar, with captions such as 'The Gracious Call' and 'Messiah's Reign'. The mission's motto, 'By Grace Ye Are Saved', is painted prominently behind the pulpit. A man – possibly the missionary D Smith – sits with his hand resting on the altar rail looking at the central pulpit. The pews are simple wooden benches and a cast-iron stove, the only source of heating, stands in the centre of the floor. [L1224]

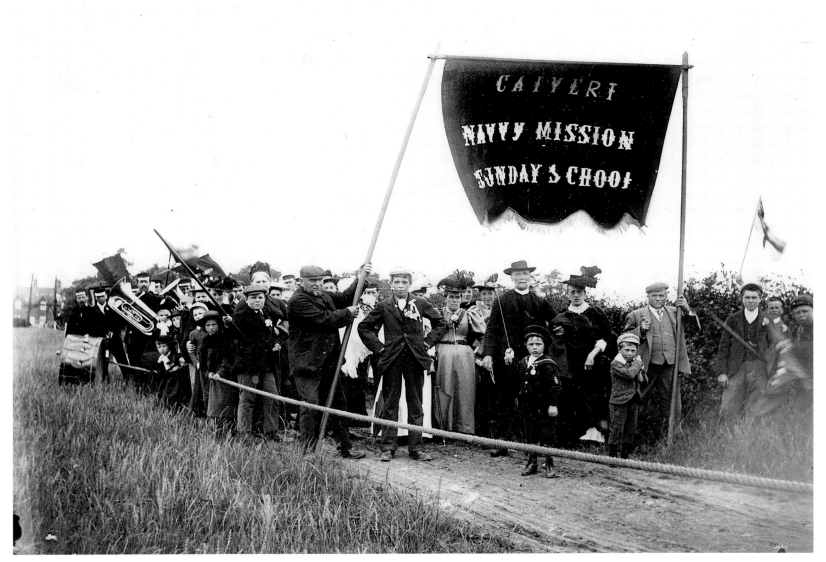

SUNDAY SCHOOL PARADE, CALVERT, BUCKINGHAMSHIRE, *c* 1897

This remarkable photograph shows the Calvert Navvy Mission Sunday School having a parade. The Navvy Mission Society provided premises and missionaries to give religious instruction and this photograph suggests that many missions were repaid with a strong and popular following. The Calvert Mission served the navvy community working on Contract No. 6. [L1245]

The National Monuments Record

The National Monuments Record (NMR) holds 3,926 glass negatives taken by Alfred Newton & Son. Two-thirds of these photographs relate to locations near to the Great Central Railway and its branch lines. Other subjects in Devon and Cornwall are also well represented, along with small numbers of images from other counties. All this material may be consulted online at www.english-heritage.org.uk/viewfinder. Images prefixed by AA, BB or OP in this book are reproduced by permission of English Heritage.NMR.

The NMR is a major public archive maintained by English Heritage. It is one of the largest publicly accessible archives in Britain and is the biggest dedicated to the historic environment. Its unparalleled collection of images, old and new, has been growing for 60 years. Set up as the National Buildings Record in 1941 in response to the threat to historic buildings from aerial bombardment during the Second World War, it immediately began its own recording programme as well as collecting historic negatives and prints. In 1963 it came under the auspices of the Royal Commission on the Historical Monuments of England and in 1999 was transferred to English Heritage. Today the collection comprises more than 8 million photographs and other archive items (including measured drawings and survey reports) relating to England's architecture and archaeology. It continues to accept major collections of national importance and is a repository for material created by English Heritage's staff photographers. The collection may be consulted at the National Monuments Record offices in Swindon (telephone 01793 414600 for details).

The Record Office for Leicestershire, Leicester & Rutland

The Record Office holds some 2,564 of Sydney Newton's glass negatives, comprising the bulk of his monumental record of the building of the Great Central Railway's London Extension. Most of these negatives have been printed for consultation at the Record Office and 1,741 images are available to view on the *Three Centuries of Transport* website (www.railwayarchive.org.uk). Images prefixed by L in this book are reproduced by permission of the Record Office for Leicestershire, Leicester & Rutland.

The Record Office is a service provided by Leicestershire County Council in partnership with Leicester City Council and Rutland County Council. The Record Office collects, preserves and provides access to a wide range of resources that document the history and culture of Leicestershire, Leicester and Rutland. Its extensive collections, which occupy some 8km of shelving, range from medieval charters to yesterday's local newspaper, and include archives, books, newspapers, maps, video and sound recordings, as well as photographs. The Record Office offers a range of services including free public access, on-line catalogues, paid-for copying and research services, exhibitions and displays, and is also increasingly involved in community archives work. For more information see the Record Office web pages (www.leics.gov.uk/index/community/museums/record_office) or telephone 0116 257 1080.

Sources consulted

The S W A Newton Collection can be browsed online at:

The Last Main Line (for the Record Office for Leicestershire, Leicester & Rutland's images) www.railwayarchive.org.uk

Viewfinder (for the NMR's images) www.english-heritage.org.uk/viewfinder

Numerous sources have been used while researching this volume. The authors wish to acknowledge the following:

Bevan, B 2006. 'Village of the dammed: Upper Derwent's tin town and planned navvy settlement', *Derbyshire Archaeological Journal*, 126, 103–26

Bryan, T 1991. *The Golden Age of the Great Western Railway 1895–1914*. Sparkford: Patrick Stephens Ltd

Cossons, N 1963. *Contractors' Locomotives, G.C.R.* Leicester: Leicester Museums

Fell, J 2000. *Three Ells in Hellidon* (published by the author)

Finmere & Little Tingewick Historical Society 2001. *The Millennium History of Finmere*. Finmere: Finmere & Little Tingewick Historical Society

Foxell, C 2002. *Memories of the Met & GC Joint Line*. Chesham: C Foxell

Hawkins, M 1991. *The Great Central: Then and now*. Newton Abbot: David & Charles

Hooton, T 1994. *Chearsley: Living through history: The life and times of a small village in Buckinghamshire*. Aylesbury: Chearsley News

Kelly's Directories (for Buckinghamshire, Leicestershire, Northamptonshire, Nottinghamshire, Oxfordshire and Warwickshire), various dates

Leleux, R 1976. *A Regional History of the Railways of Great Britain: Volume 9, The East Midlands*. Newton Abbot: David & Charles

Navvy Mission Society, various dates. *Annual Report of the Navvy Mission Society* (particularly Volume 1 for 1877–8 and Volume 16 for 1893 to Volume 20 for 1897–8)

Paul, J A 2003. *3000 Strangers: Navvy life on the Kettering to Manton Railway*. Kettering: Silver Link

Pevsner, N, various dates. *Buildings of England* series (for Buckinghamshire, Leicestershire, Northamptonshire, Nottinghamshire, Oxfordshire and Warwickshire)

Roult, L T C 1971. *The Making of a Railway*. Bath: H Evelyn

Sanders, W 1903. *A Digest of the Results of the Census of England and Wales in 1901: Arranged in tabular form, together with an explanatory introduction*. London: C & E Layton

Thompson, F 1985 [1973]. *Lark Rise to Candleford: A trilogy*. Harmondsworth: Penguin (Publication note: *Lark Rise* was first published in 1939 and the three volumes were first issued under the present title in 1945.)

Index of places illustrated